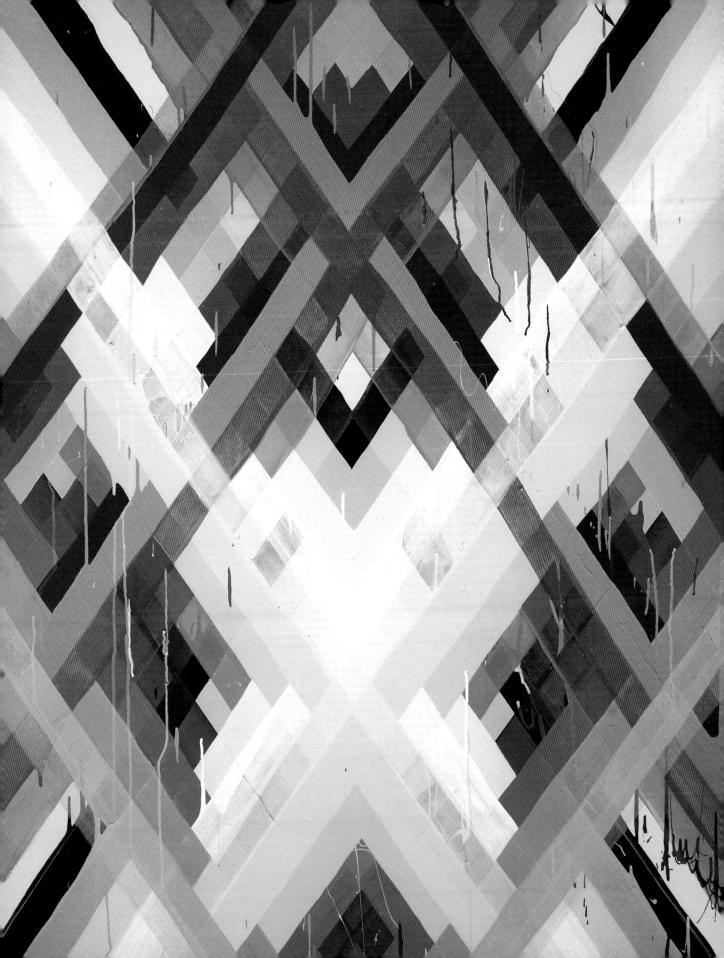

First published in the United States of America in 2013
First edition

Gingko Press, Inc.
1321 Fifth Street
Berkeley, CA 94710
email: books@gingkopress.com
www.gingkopress.com

ISBN: 978-1-58423-541-5

Printed in China

Edited by: Hannah Stouffer
Writers: Hannah Stouffer, Eric Beltz
Assistance by: Mona Palmer, Laura Hines
Special Thanks: Gwynn Vitello, Eric Beltz

Previous Page Image by Maya Hayuk
Opposite Page Image by Roid
Cover Image by Andy Gilmore

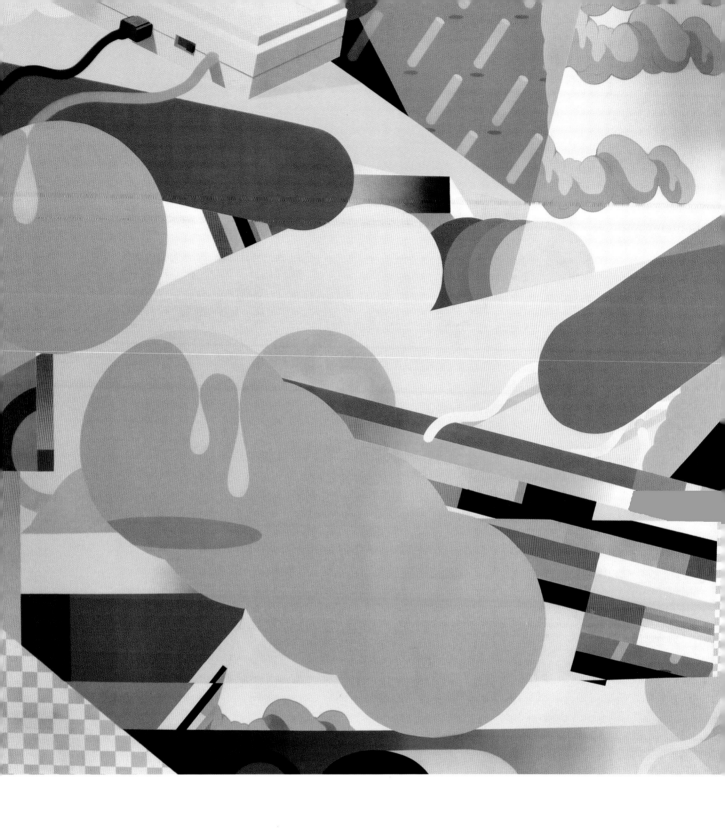

CONTENTS

Image by: Steven Harrington

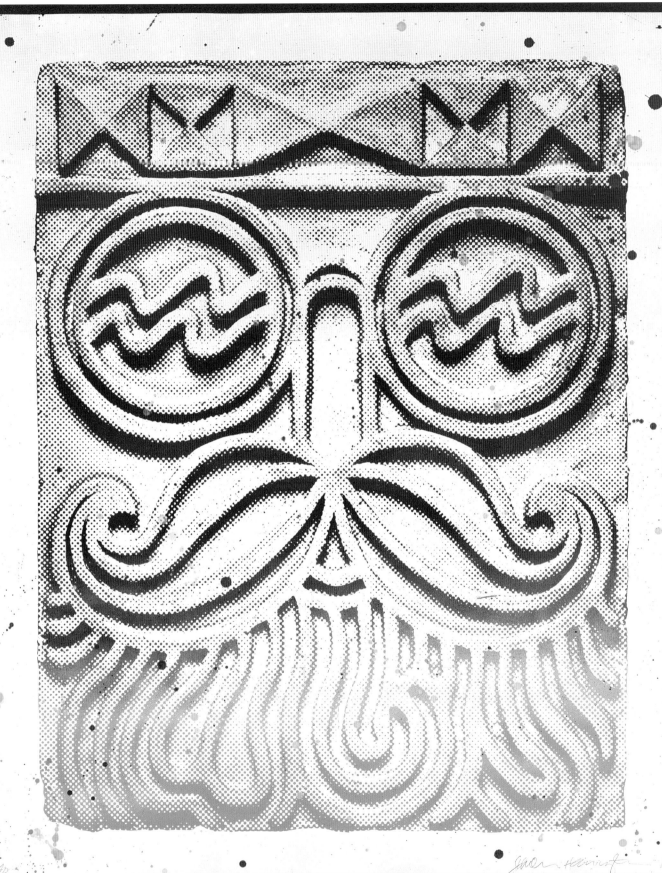

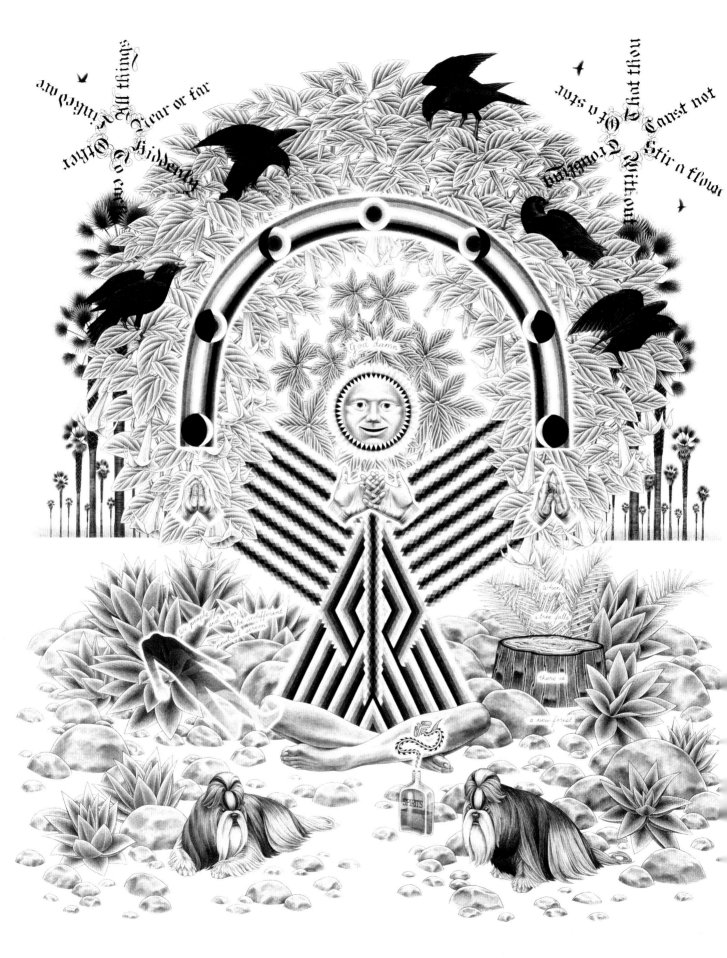

INTRODUCTION

The Psychedelic Landscape
Eric Beltz

Glassed in by the dome of the sky our lonely souls are fixed at the center of a world that is irrevocably shrinking before our very eyes. This condition was created by linear perspective, a Renaissance-era mathematical attempt to describe the underlying forces of perception. 19th century landscape painting in America harnessed the awe and wonder of nature in its ineffable immensity and similarly suggested that there was some force responsible for its beauty. In both cases we have a collision between the far off and the up close, the horizon line and the eye of the witness. In painting the collision is literal as there is but one surface for all planes of depth to occupy. That is part of the thrill of illusionistic space, your eye is fooled as it moves through imagined dimensions.

In the foreground of many 19th century landscape paintings was something else: finely rendered plants. They served as specimens, intimately detailed, close, and knowable. Contrasted with the grandness of rivers, forests, gorges, and mountains, these weeds portrayed rational humility. To view the work of the Creator is to look from a great distance. To study a piece of this creation is to look down by your feet. As America expanded into the western landscape there was a great need to know the plants. The Department of Agriculture was formed in the mid 1800s to provide aid to states that studied and eradicated dangerous plants. Here we have a beginning of the marginalization of potent plant life. What makes a plant potent is also what can make it poisonous, medicinal, or even psychoactive. Many of the cultures overlaid by this expansion used these plants in medicine and ritual. This theme of botanical erasure coincided with cultural erasure, and the context within which these plants were used was lost or degraded.

In the early 20th century indigenous culture around the world and their plant use was studied and written about by Weston La Barre, Richard Schultes, R. Gordon Wasson, and others. This literature preserved traditions but also (unintentionally in most cases) promoted their appropriation by new peoples. A significant episode of this came after a 1957 article in Life Magazine which exposed a Mazatec mushroom cult to a modern American audience, the same time LSD was making its way out of the lab. These new elements, branded "psychedelics", infused the adopted culture and inspired new behaviors, new questions, and new attempts to understand the world.

Looking back to the foreground of the landscape painting, we see the humble weed as a signifier of world history, religious beliefs, cultural borrowing, and governmental attitudes. Some harm, some heal, and others transport the imagination into fantastical dimensions. This last group helps to collapse or even confuse that distance between the ineffable and the rational so we can switch places with the horizon and look back at ourselves. The art that results reveals a shift in attitudes, a re-evaluation of visual conventions, and in some cases an attempt to rebuild a cultural context within which to study, understand, and experience the psychedelic landscape.

8/14/13
Santa Barbara, CA

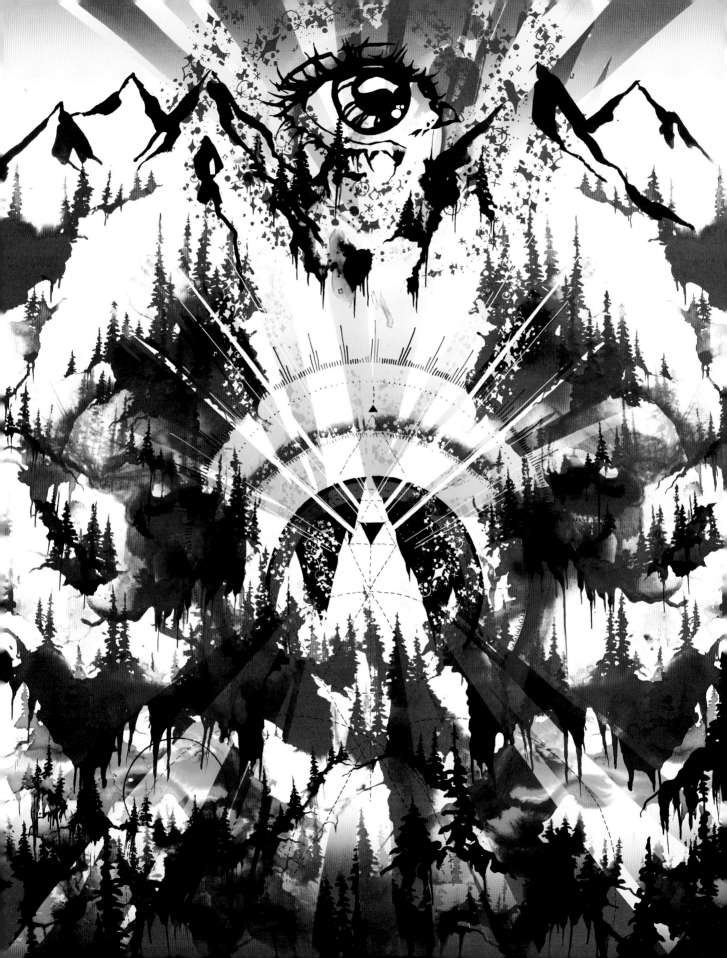

FOREWORD

The Revival of Psychotropic Aesthetics
By Hannah Stouffer

A common perception of psychedelia art is based heavily on the kaleidoscopic and hallucinogenic imagery of the 60s and 70s, when it emerged into popular culture due to the era's radical political and social movements, as well as the introduction of psychedelic substances. Its presence saturated the visual language with the near illegible text, curvilinear shapes, optical vibrations and textures in intensely discordant colors. Across all creative mediums, psychedelia attempted to recreate an experience that resembled an altered state of perception. The emergence of psychedelic drugs into the mainstream and their social significance as agents of unity and enlightenment in the face of cultural and political turmoil, by the mid-60s, had a demonstrable effect on the cultural output of the era. Manifested by the popularity of an accompanying psychotropic aesthetic, it entered the mainstream and remained a dominant style of art, fashion, and music through the 1970s, and resurgence of psychedelia is common in the modern area as well, with some arguing that it never left.

By definition, a psychedelic experience is characterized by an expansion of consciousness or the liberation of one's mind, signifying the onset of a new form of understanding or the creation of new, innovative ideas. Psychedelic states can come about through an array of experiences, including changes of perception, hallucinations, synesthesia, focused consciousness, hypnotic states, and other mind alterations. These can be elicited by various techniques, such as meditation, sensory stimulation or deprivation, and most commonly by the use of psychedelic substances. While it is not necessary for artists to use psychedelics to attain similar consciousness-expanding experiences, some artists have demonstrated that a tangible way to obtain psychotropic visions is to ingest psychedelic drugs for creative purposes.

As a culture, we are still seduced by the heavily distorted graphics and surreal imagery of the psychedelic era. Its visual and metaphysical influences continue to strongly resonate in the current culture, especially through the work of contemporary artists and designers who draw on the classic works of the genre. Each artist in this book practices an entirely unique kind of psychedelic art based on their own experiences and perceptions. Some creatives recreate similar visual aesthetics from the original movement, such as Steven Harrington, Scott Blamer, and Ryan Travis Christian. With the evolution of technology and the influence of new media, other artists such as Andy Gilmore and Jetter Green employ a similar language while using contemporary techniques. Others like Roid, Skinner, and Maya Hayuk instead forge their own interpretations of the psychedelic aesthetic through the use of type treatments, bright colors, and visual intensity. There is a range of visionary artists that draw directly from psychoactive agents to inspire and develop their work, though not all artists in this book would care to be confined by a definition.

This resurgence of psychedelia embodies a mindset similar to that of the movement's origins, the desire for unity alongside an urge for personal freedom and detatchment, mirroring the social aspirations and political unrest of the 60s and 70s. This era epitomized the pursuit of harmony, heightened political awareness, and empathy, and a similar mindset is currently reemerging in the popular culture. We are now seeing a resurgence of psychedelia in the visual culture that reflects an era of radical thought and revolutionary action. Perhaps this psychedelic renaissance comes from a sense of nostalgia for a once rebellious and idealistic time, or perhaps it is a direct desire to reincorporate its principles into our own lives. No matter the case, freedom through escapism and personal development by expansion of the creative mind is available to all, and to all a good flight.

2013
Los Angeles, CA

JONATHAN ZAWADA

LOS ANGELES, CA USA

Jonathan Zawada is a graphic designer and creative director who works across the music, publishing, fashion and corporate industries from his home in Sydney, Australia. He has become best known for his varied approach to the discipline of design, his personal ventures (including the mathematical style guide, Fashematics and TRU$T FUN!) Running parallel to Jonathan's career as a graphic designer is his work as a practicing visual artist. Working across oil painting, drawing, sculpture and installation he participates in exhibitions regularly in galleries around the world.

FACT

1. The average person today consumes almost three times as much information as what the typical person consumed in 1960, according to research at the University of California, San Diego.
2. No matter what the technology, a sustained 2.3% energy growth rate would require us to produce as much energy as the entire sun within 1400 years. - Tom Murphy
3. I generally wake up before 6am

INDULGENCES Video games & vodka.
NECESSITIES Annie, Pip, Phatskull, my Nook, The Science Show podcast.
STUDIO ESSENTIALS Plants and music.
VISIONS Big waves, tall buildings, tufts of grass between paving stones.
INSPIRATIONS Mati Klarwein, Giorgetto Guigiaro, Harm van den Dorpel, Paul White, Tom Beddard, Peter Saville, Yusaku Kamekura.
INFLUENCES Paying the rent.
COLOR Copper and navy.
MEDIUM The computer followed by oil paint.
UTOPIA McKenzies Bay, Sydney, Australia.
NOISE Mostly radio shows about science or history, The Science Show on RN, Planet Money, In Our Time with Melvyn Bragg, Benjamin Walker's Theory of Everything.

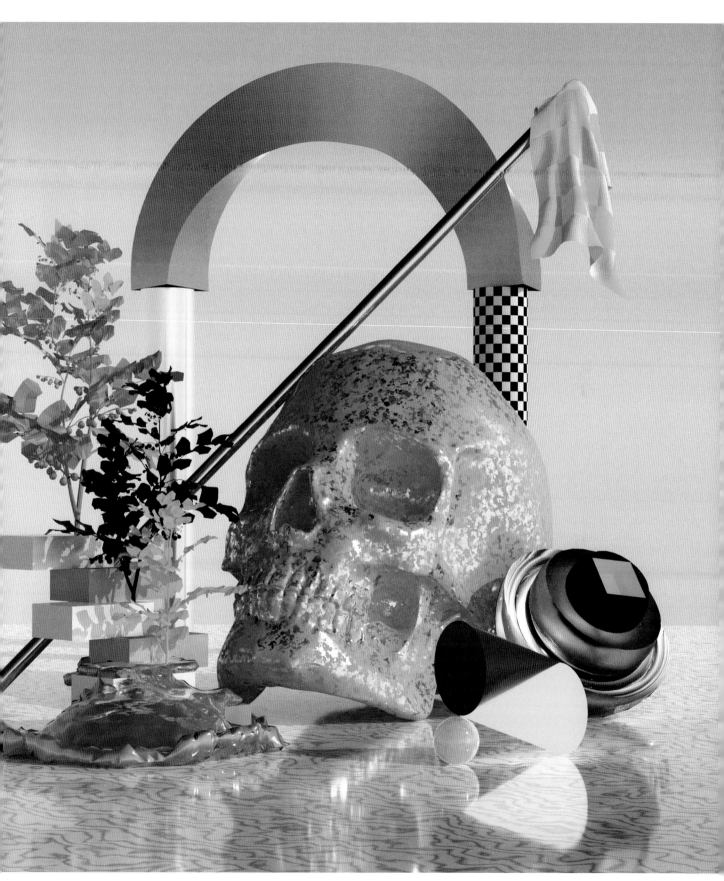

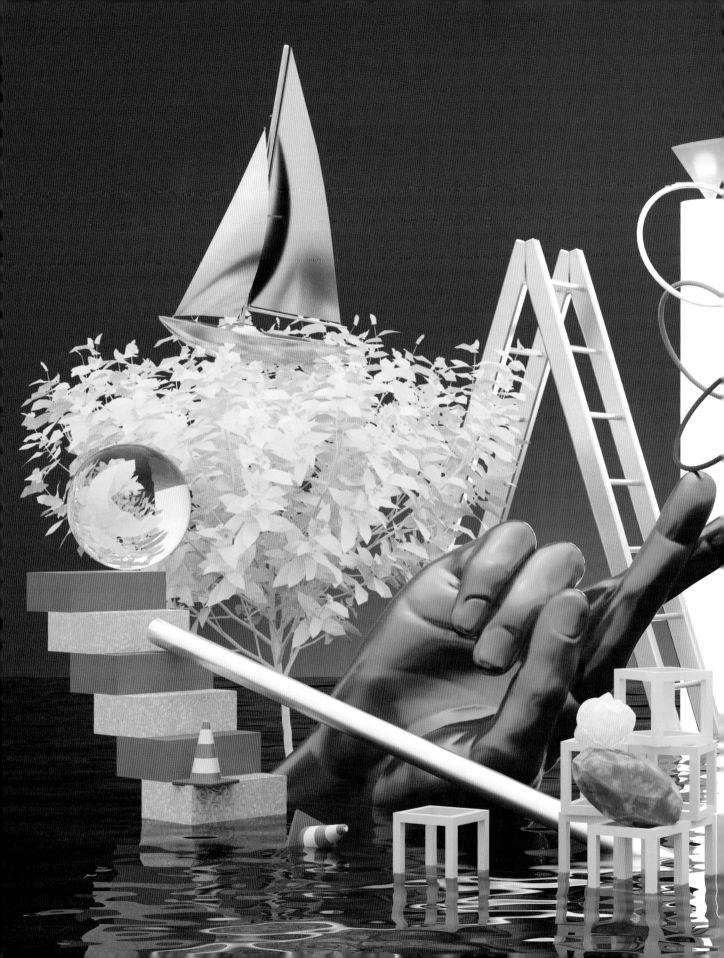

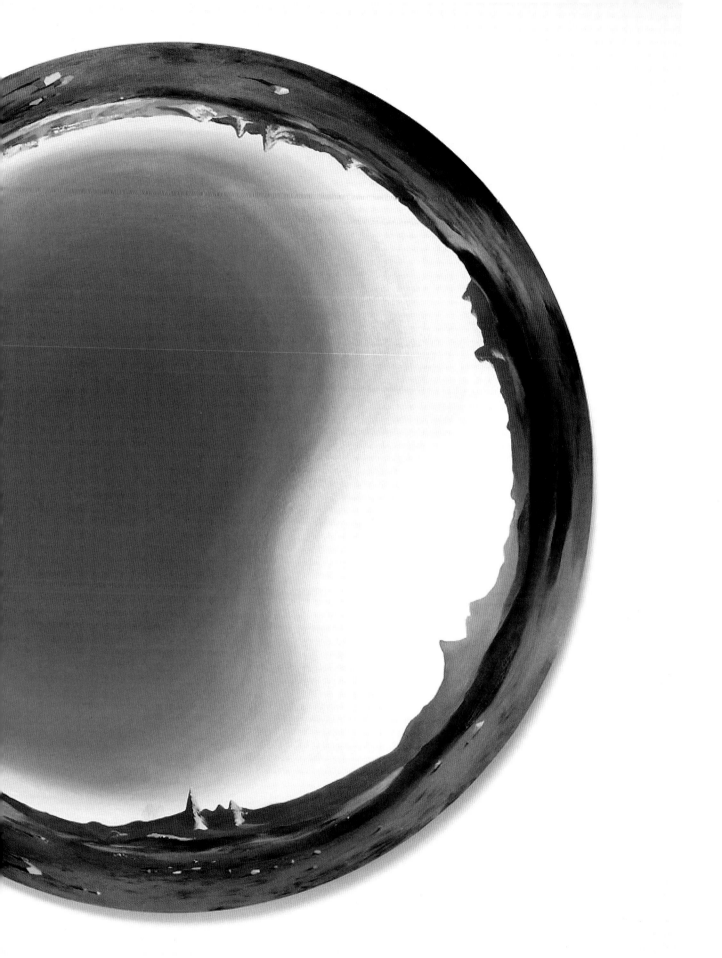

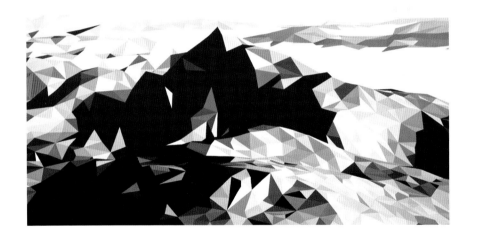

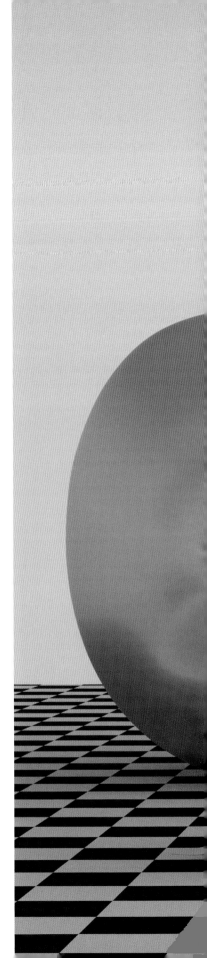

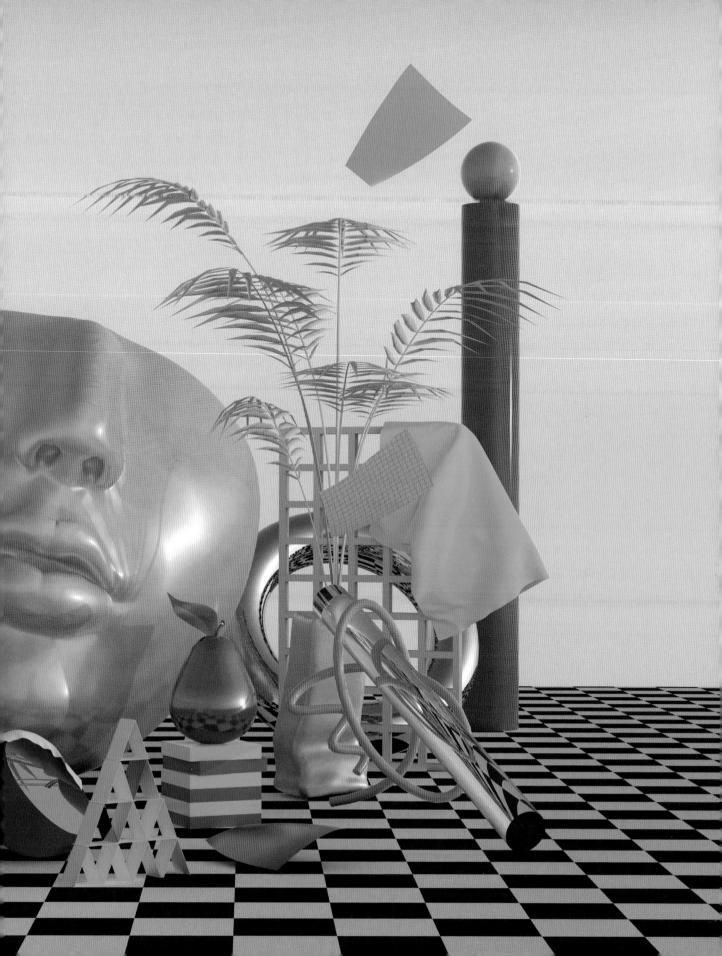

KARINA EIBATOVA

Vienna, Austria / St.Petersburg, Russia

Karina Eibatova was born in the late 80s in Leningrad, Russia. Her portfolio reveals a versatile artist, who is equally adept at both colourful, surrealist explorations and traditional approaches as well. Karina's work is connected to the notions of nature, peace, the magic of reality and love. Influenced by earth and space, she delicately transforms floral motives into her own surreal, psychedelic scenes, rebelling against the remorseless actions of society and the continual destruction of the environment.

Karina was fond of drawing since childhood. She studied classical art disciplines in St. Petersburg, Russia, followed by a fine art education in Sweden, and contemporary art in Moscow. In 2011 she entered the Academy of Fine-Arts (Akademie der bildenden Künste) in Vienna.

FACT
1. Several years ago I made a taboo against drawing people, because I wanted to concentrate on nature.
2. I feel that the world is overwhelmed with pictures of the beautiful girls, so that's why I decided to go to the other direction, though my choice is very unstable in terms of earning a living.
3. Creating CD album covers is my favorite part of my profession! I really appreciate sound and am inspired by music…

INDULGENCES Being messy, lazy and too crazy.
NECESSITIES Nature, love, music, yoga and drawing.
STUDIO ESSENTIALS Dark chocolate, good music and an orthopedic chair.
VISIONS Sunrise over the earth from space.
INSPIRATIONS Space, mountains, volcanos and the ocean.
INFLUENCES Oceanariums, crystals and cats.
COLOR I am drowning in turquoise!
UTOPIA Balaklava (Crimean republic in Ukraine)
NOISE Contemporary psychedelic folk, ambient; Connan Mockasin, Balam Acab + audiobook Fahrenheit 451, medium volume.
PSYCH If you are in trouble, take a look at a planet from outerspace. All you need is the universe!

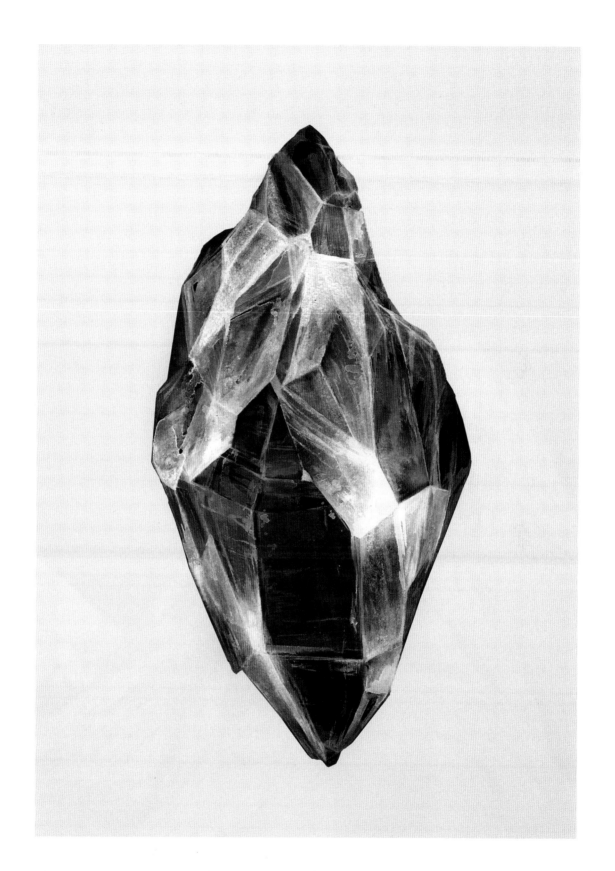

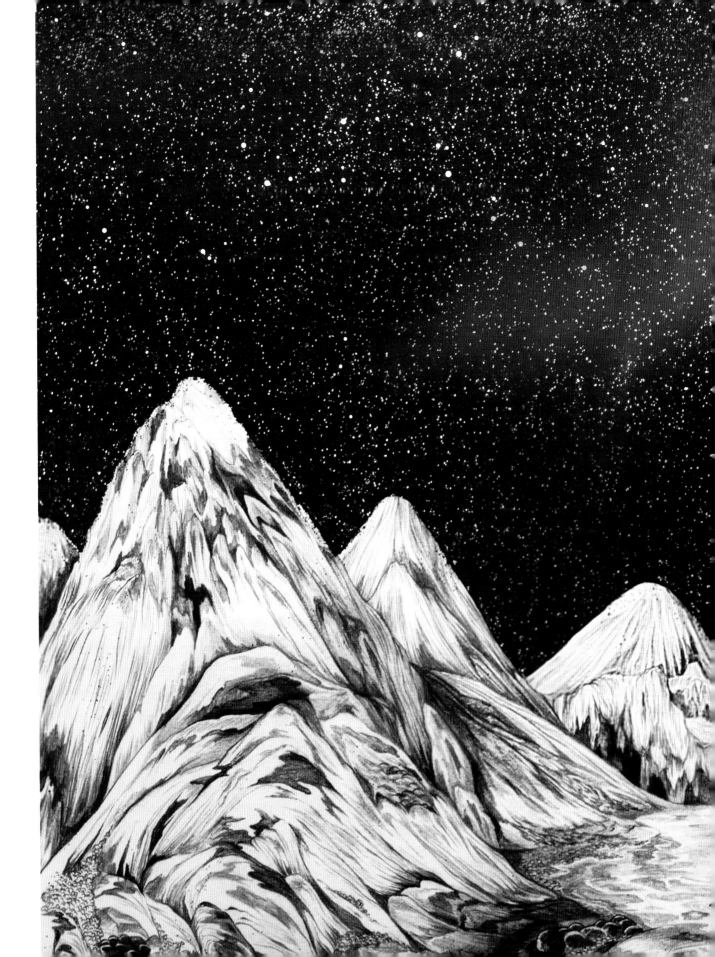

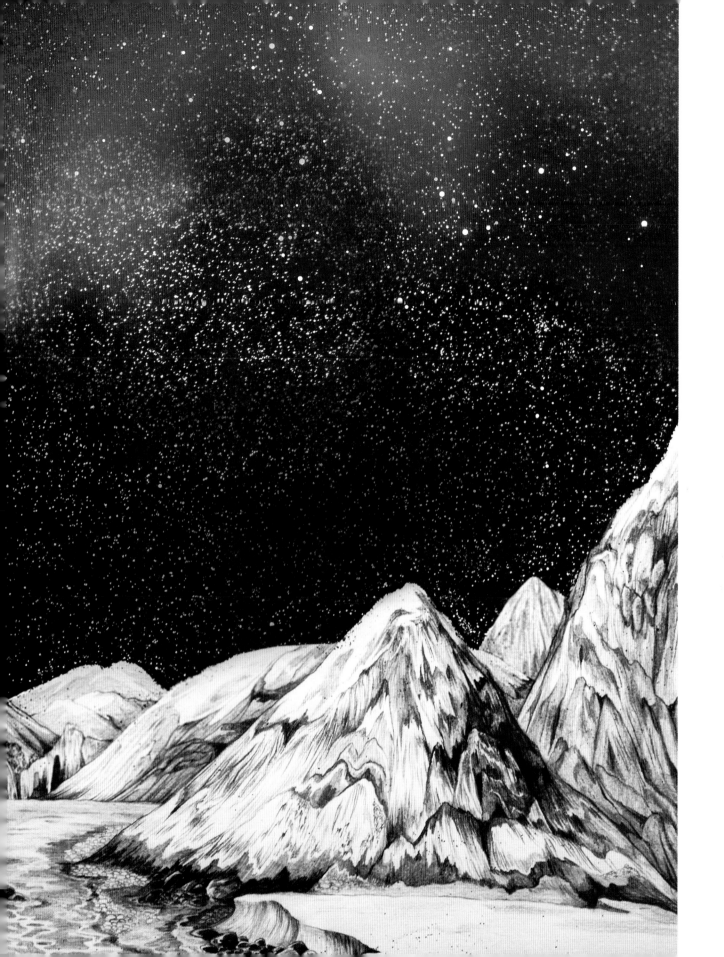

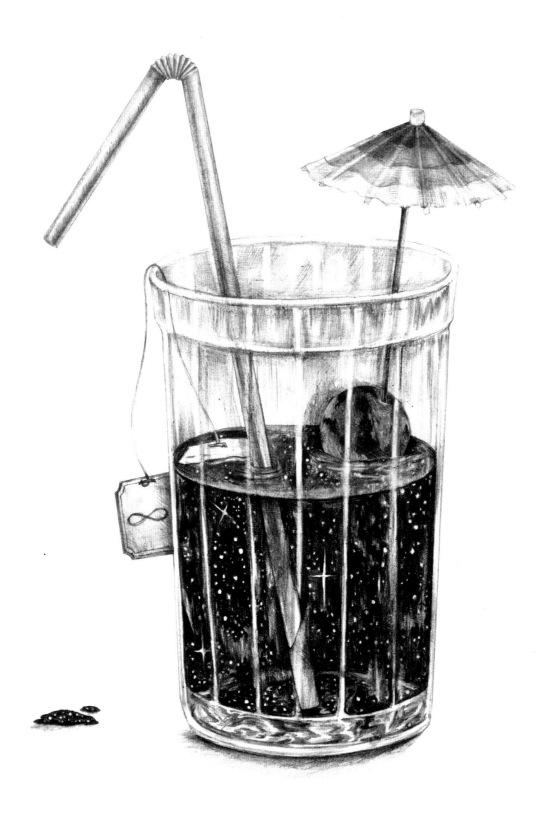

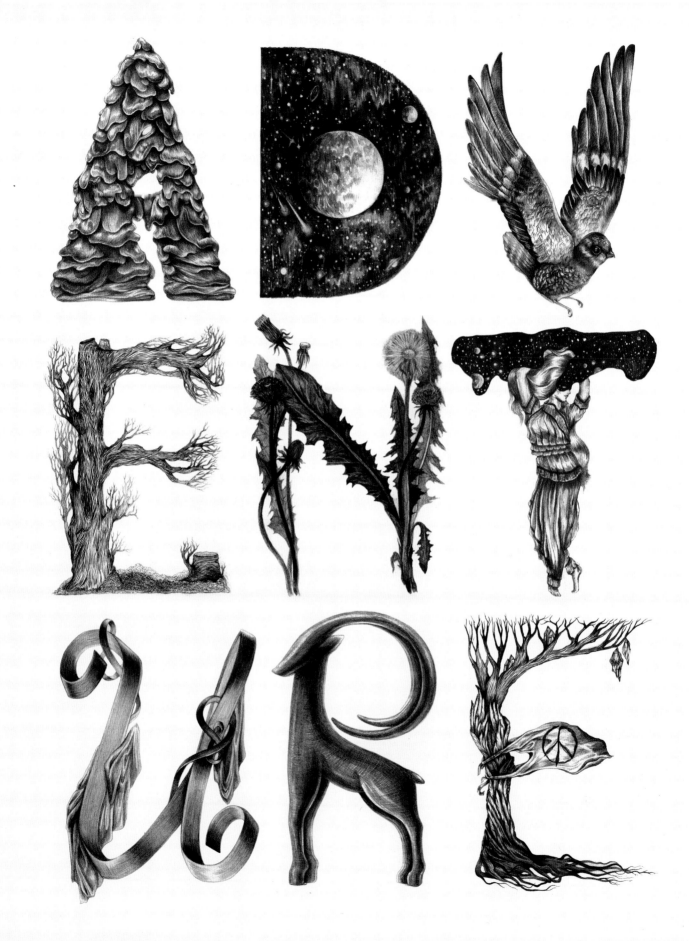

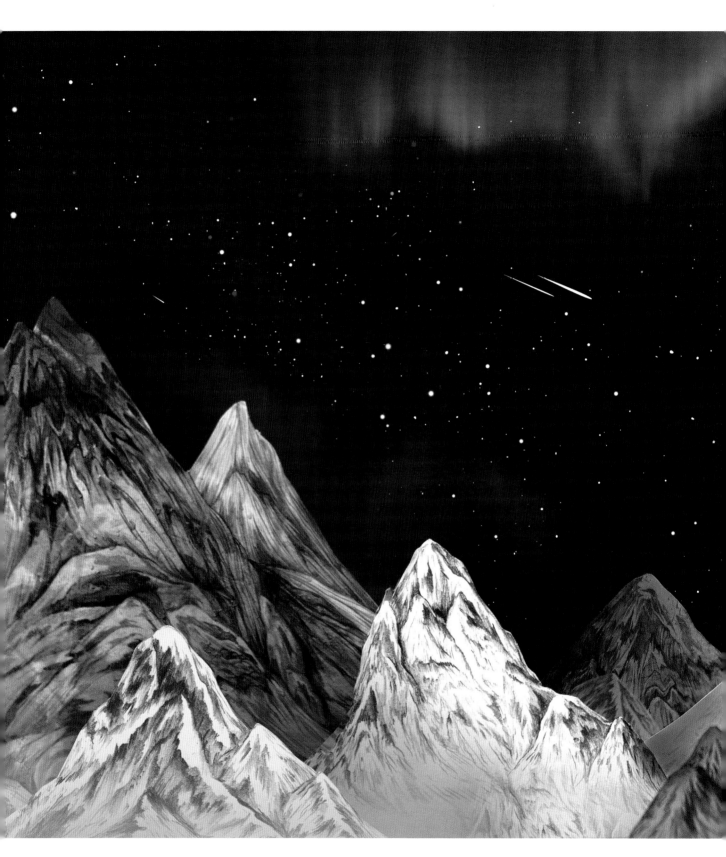

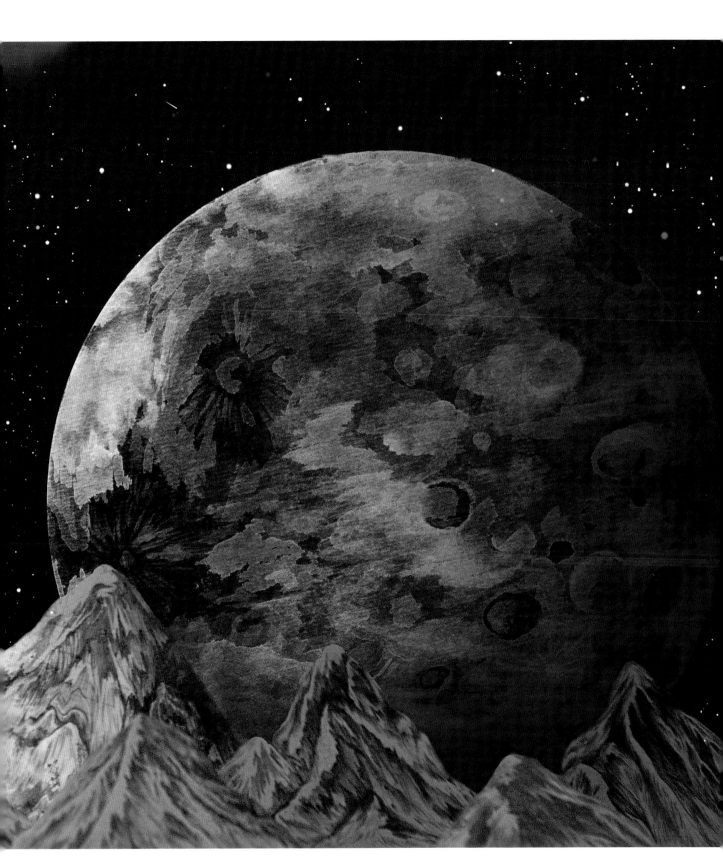

DEANNE CHEUK

NEW YORK, NY USA

Deanne Cheuk is a New York-based art director, illustrator and artist from Perth, Western Australia (the most isolated city in the world). She works predominately on paper with charcoal or watercolor – her artwork always touches on nature, utopia, space and being, often distorting realistic representation into fantasy. She got her first job as a magazine art director at the age of 19 - the same year that she graduated with a degree in graphic design from Curtin University.

Since then, Cheuk has art directed or designed numerous publications, including Tokion Magazine. Cheuk's art direction has been heavily influenced by her illustrative work and she is renowned for her illustrative typography. She has been commissioned by top international companies, including American Express, Dell, Lane Crawford, Levi's, Microsoft, Nickelodeon, Nokia, Nike, Converse, Olay, Sprint and many others.

FACT
1. I know Pi to 46 decimal points.
2. I can say the alphabet backwards.
3. I have a terrible memory for anything else.

INDULGENCES Spending.
NECESSITIES My husband, my daughter, love, art, food.
STUDIO ESSENTIALS A kneadable eraser.
VISIONS Nothingness.
INSPIRATIONS I'm inspired by everything around me.
INFLUENCES Nature.
COLOR Black & White.
MEDIUM Charcoal.
UTOPIA Anywhere it's quiet, sunny, and by the water.
NOISE Dead silence.
PSYCH Once I stood under a full moon and watched the forest grow up my legs and across my arms through the tips of my fingers and we became one.

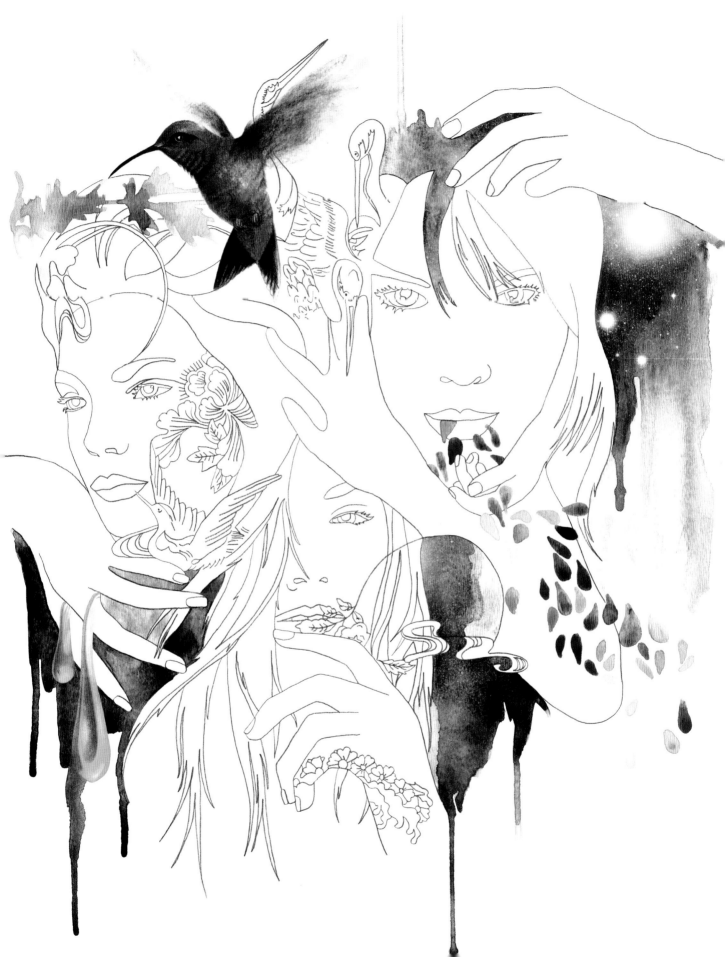

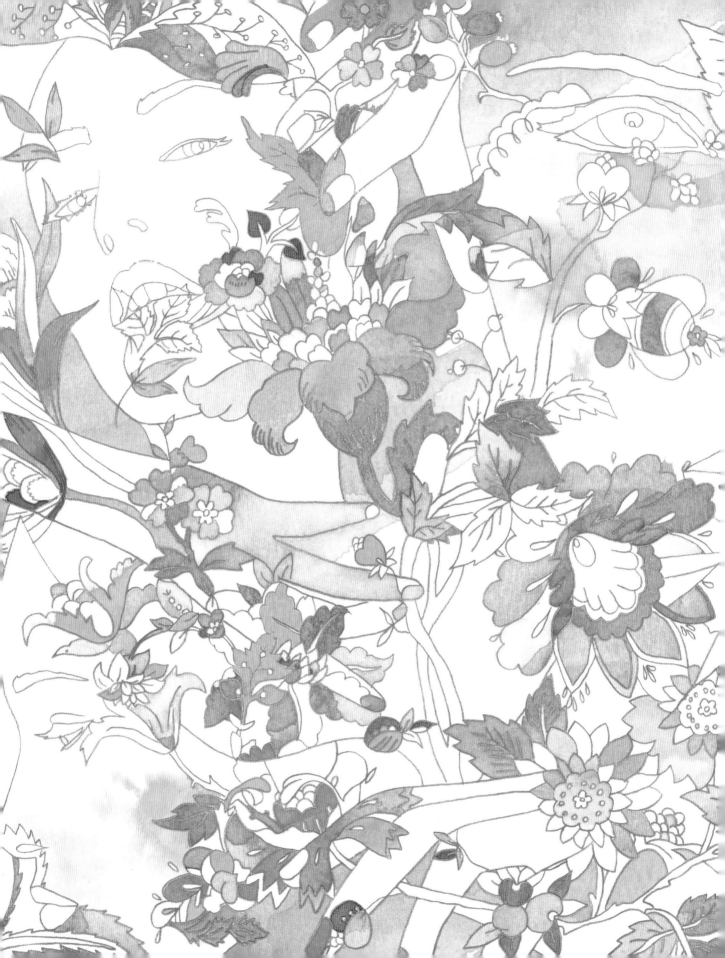

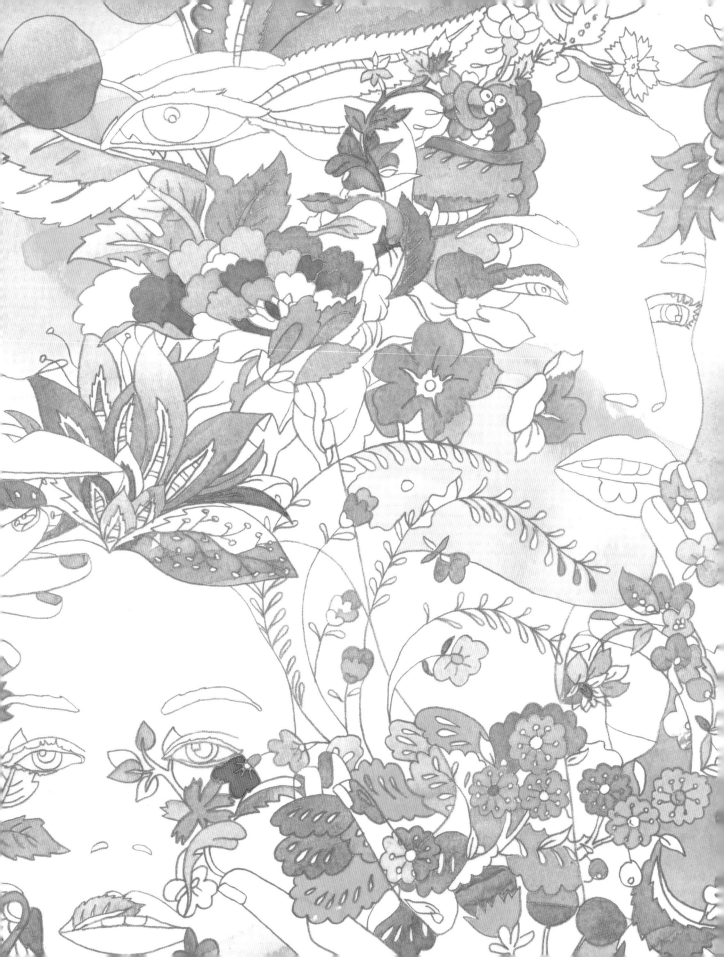

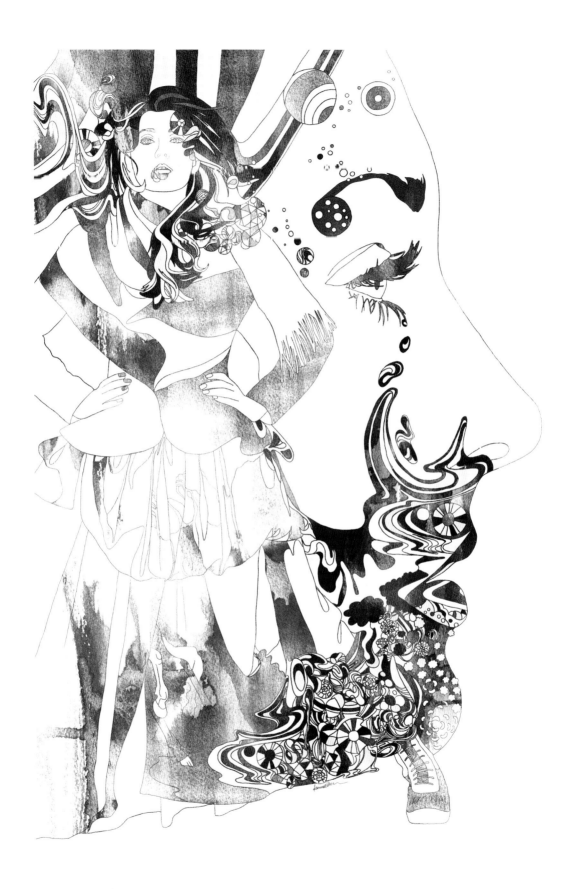

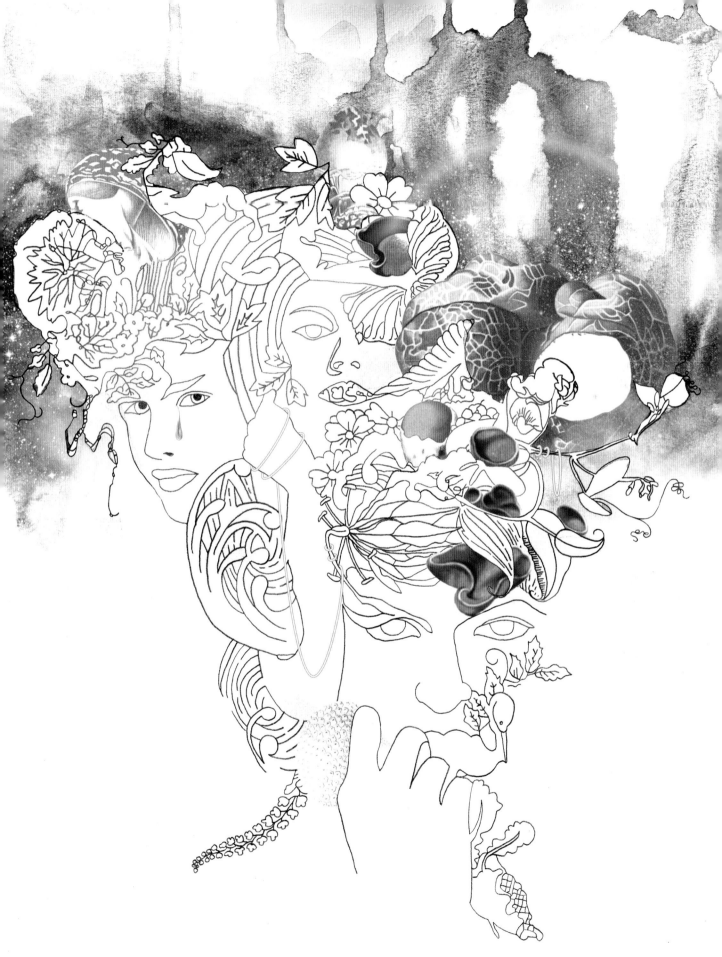

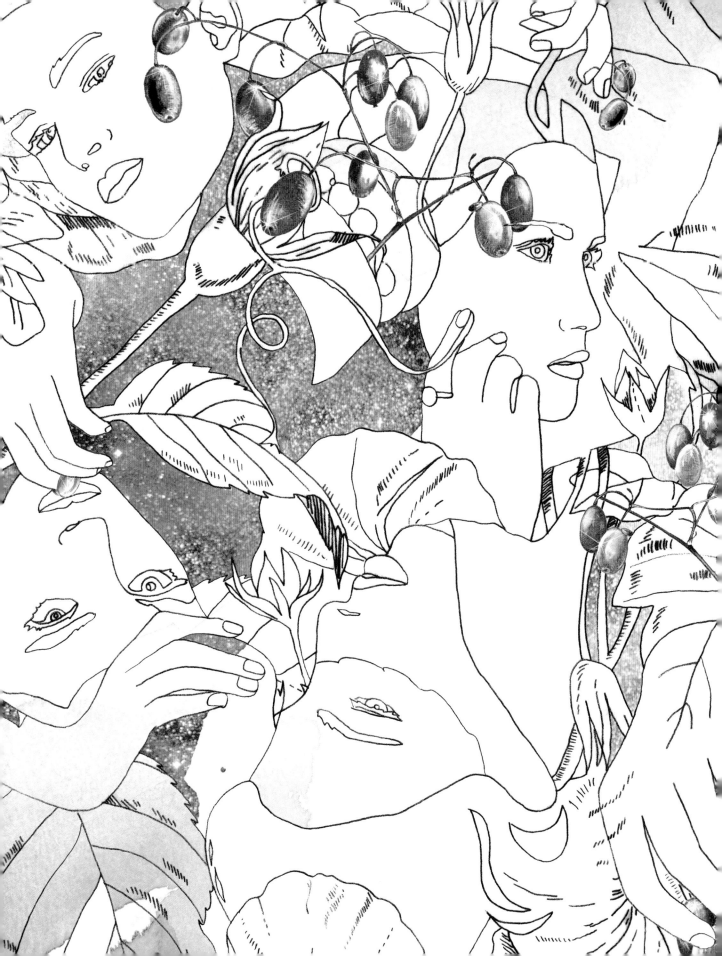

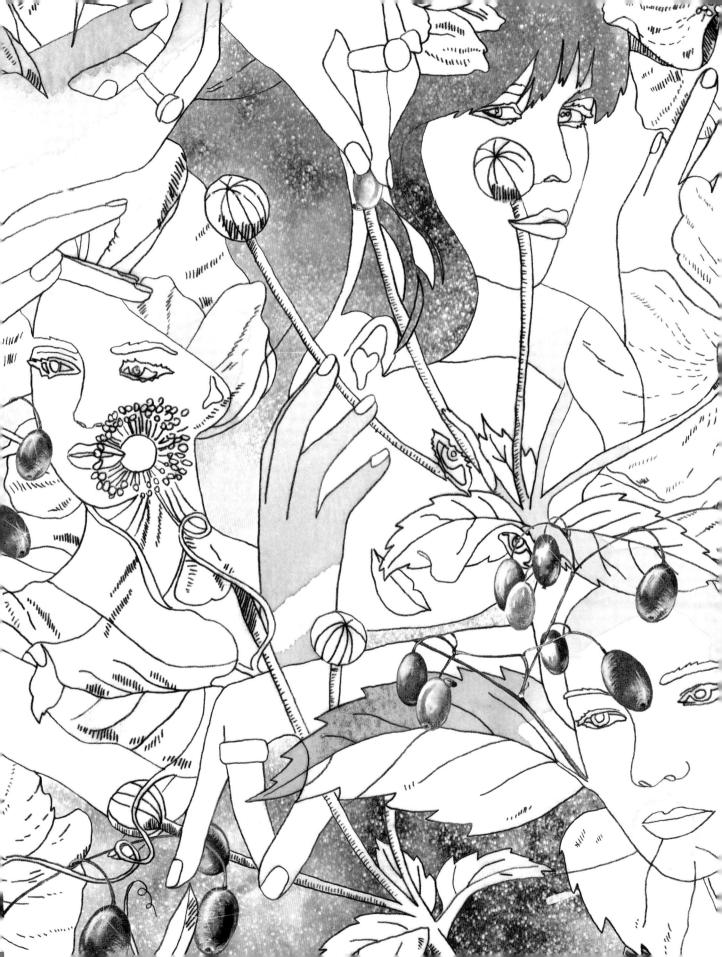

PEARL HSIUNG

LOS ANGELES, CA USA

The space that Pearl C. Hsiung explores lies between representation and abstraction and is often a site for humorous commentary and material experimentation. Her intensely colorful large-scale canvases, small studies, and performance videos challenge the banality of the pristine images that dominate postminimalist contemporary art. Even so, her compositions draw on the histories of painting, alluding to European fauvism and surrealism, Chinese landscape painting, American abstraction, and pop aesthetics. A hard line brings to mind the work of twentieth-century painters such as Ellsworth Kelly or Frank Stella while at the same time evoking comic books or advertising; a spattered, misty background simultaneously signals high-end expressionism and mural art produced from a can.

FACT
1. Born in Taichung, Taiwan.
2. Lives in Los Angeles, CA.
3. Has a brother named Michael.

INDULGENCES These are private.
NECESSITIES Making art, work. Making art work.
VISIONS Personal, abstract, banal, absurd, crude, sensual, infinite, unknowable, dynamic, transmogrifying...
INFLUENCES Water, wind, fire, stone, smoke, people, media.
COLOR CMYK.
MEDIUM Painting, video, drawing, installation, sculpture.
UTOPIA Yet to be determined!
NOISE Various.
PSYCH The first psychedelic experience that I can remember happened when I was an infant. Lying down in my parent's bedroom, I could see a continuous chain of ghost-like visages circling inside a chrome doorknob on their closet door. I remember staring at it without blinking, at first in disbelief, and then in pleasure. Since then I have had several occurrences that could be classified as psychedelic, some that I cannot remember but more that I can. The catalyst for them ranges from the impact of high stress, fever, pleasure, mania, meditation, exhaustion, or psychedelic substances. For me, one of the most meaningful aspects of these experiences is that they are powerful reminders that reality is defined by our perceptions. In such events, the mind, body and psyche express the infinite forms of consciousness and this creates pleasure in its freedom.

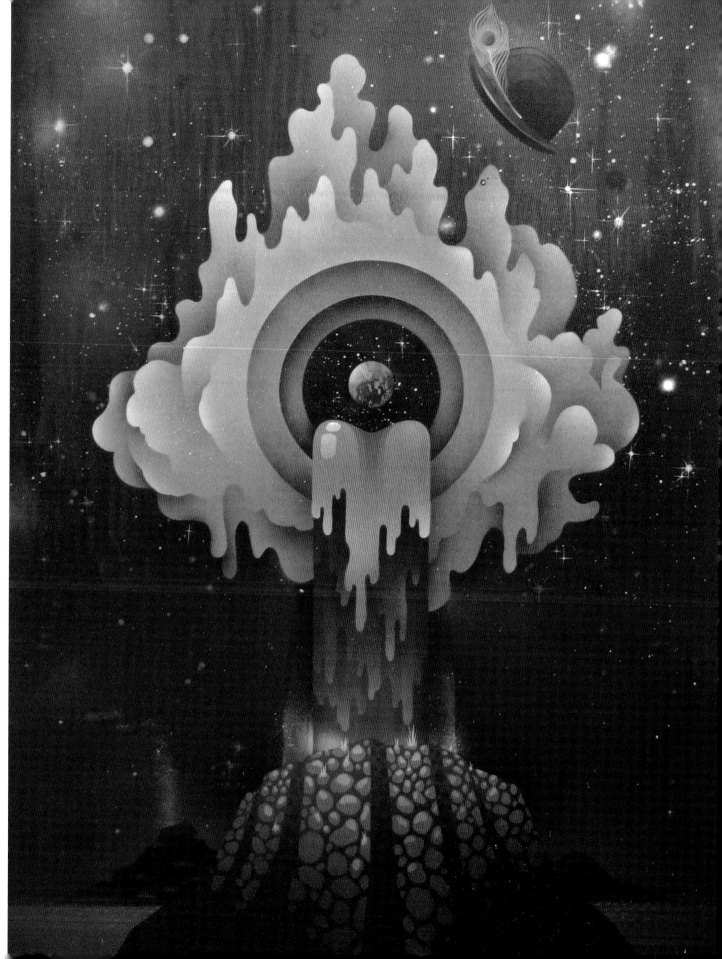

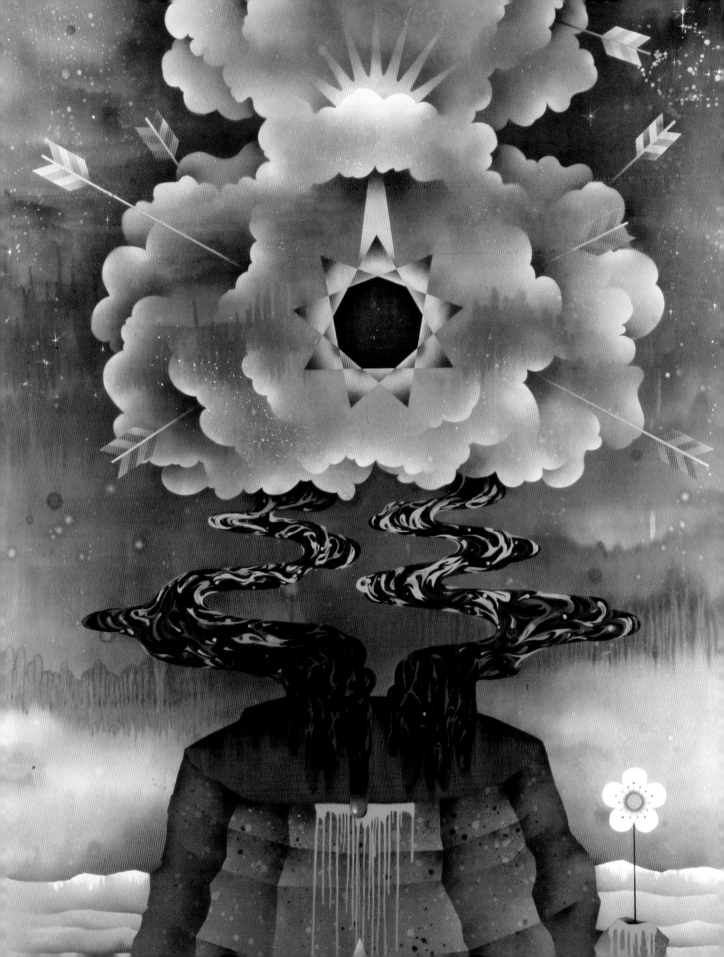

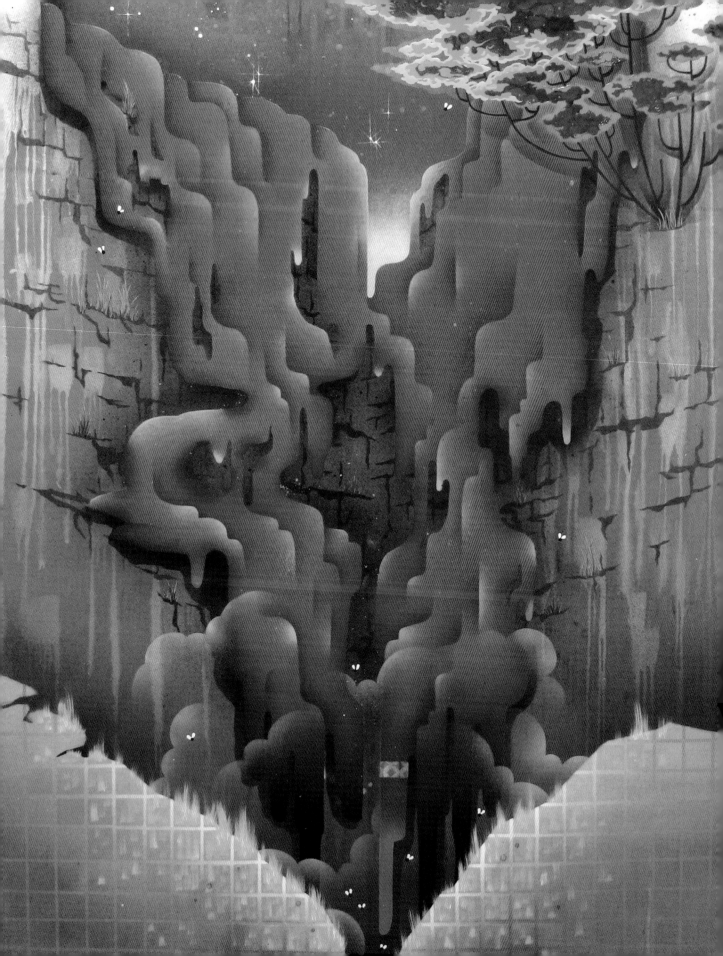

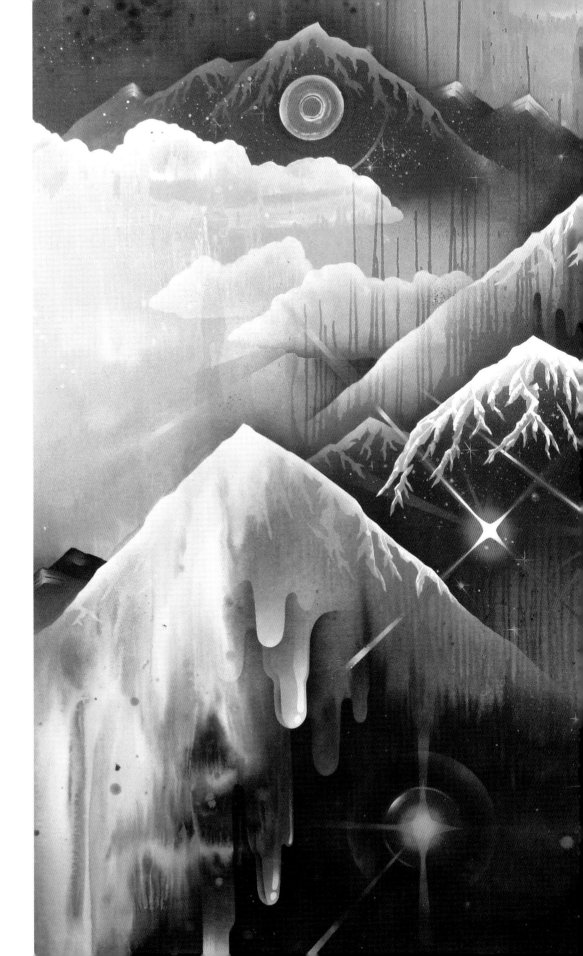

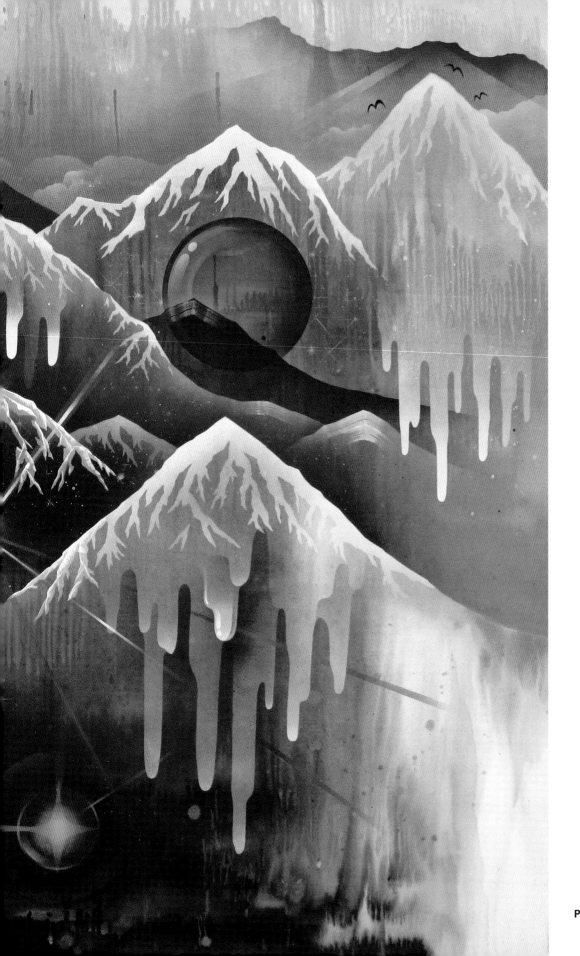

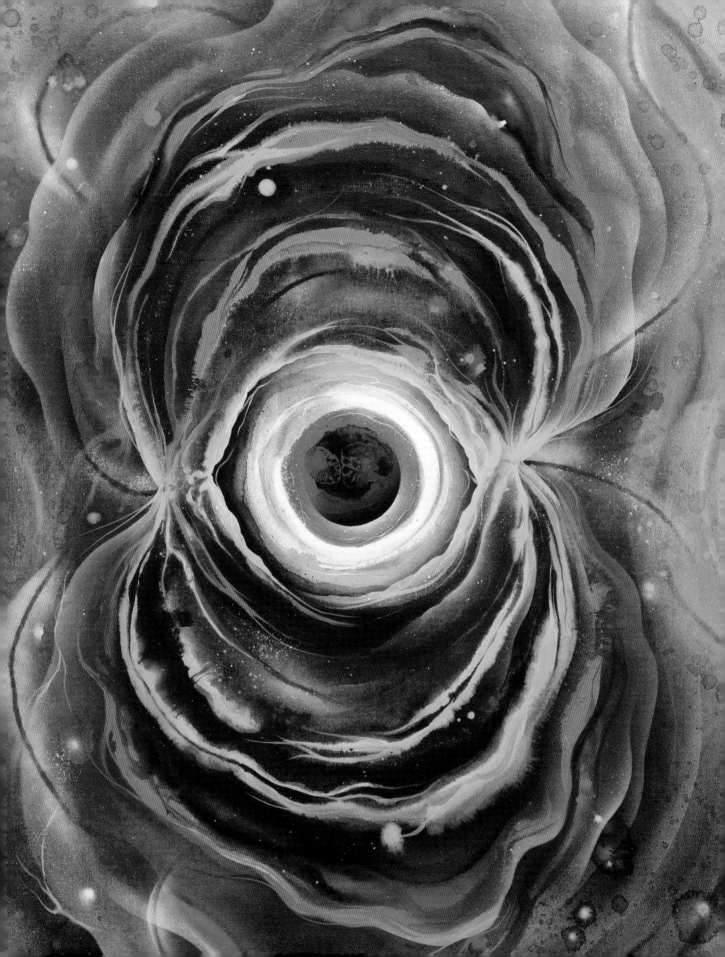

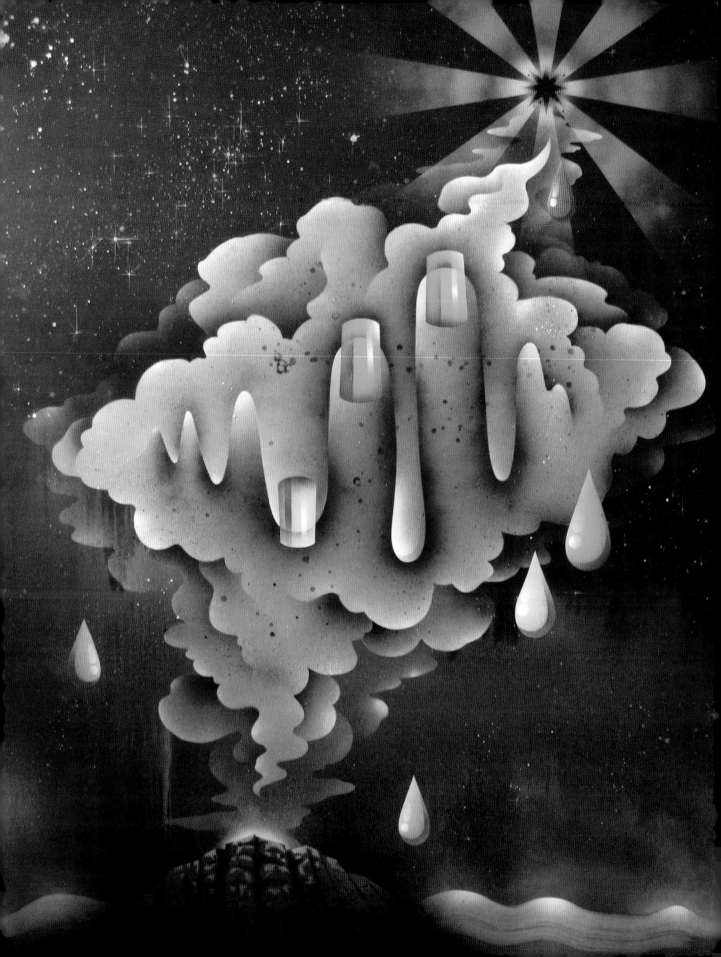

JETTER GREEN

VISTA, CA USA

Born and raised in San Diego, Jetter grew up in a home with artistic parents. His talents were nurtured, which eventually led him to attend Art School where he developed his technical trade. The countless psychedelic works he witnessed at art and music festivals, later inspired him to create his own. When feeling inspired, he disconnects from the outside world and immerses into his creative space to articulate his visions through the computer.

FACT
1. I'm an only child.
2. I make solo dance party videos of myself during lunch.
3. I love to tickle.

INDULGENCES Searching for RV's and gypsy wagons, coconut water, truffle popcorn, vitamin D, frisbee, swap meets & thrift stores.
NECESSITIES Sleeping with 4 pillows, hair ties, my incredible wife, Sarah Green-bean, my cats and the love and support of my parents.
STUDIO ESSENTIALS Nag Champa, Almonds, Alkaline Water, Tea Tree toothpicks and my crystal pyramid and Tetrahedron.
VISIONS I don't remember what I dream about at night, but I'm working on it. I am very intrigued by the lucid dream world.
INSPIRATIONS Succulent geometries, the horizon, multi-leveled mountain ranges, new growth on a fruit tree, patterns in the sky, the visible light spectrum, cracked desert floor, starry nights, skewed perception through water, Hubble imagery.
INFLUENCES Bo Jackson, the full moon & national parks.
COLOR Gradient earth-tones.
MEDIUM The Computer (Enter/Delete machine).
I enjoy printing on canvas, wood, metal and fabrics
UTOPIA Working in the garden and playing in my TeePee with my tribe at Verde Ranch
NOISE I enjoy pushing the 'shuffle' button. Anything from Peter Gabriel, Hugh Masekela, Solar Fields, Black Mountain, White Flight, Turtle Wing Dream & Hajears.
PSYCH These experiences have been a catalyst in my creative process. They have opened my eyes, my heart and my mind by unveiling a greater sense of what is real. They've provided me with a new lens to view the world around me, which in turn has fueled and inspired me to create this art. I have also gained incredible knowledge of my art through these experiences. I've come to realize that these shapes, patterns, and geometries in my pieces are the building blocks of life, which has helped me understand our universal oneness.

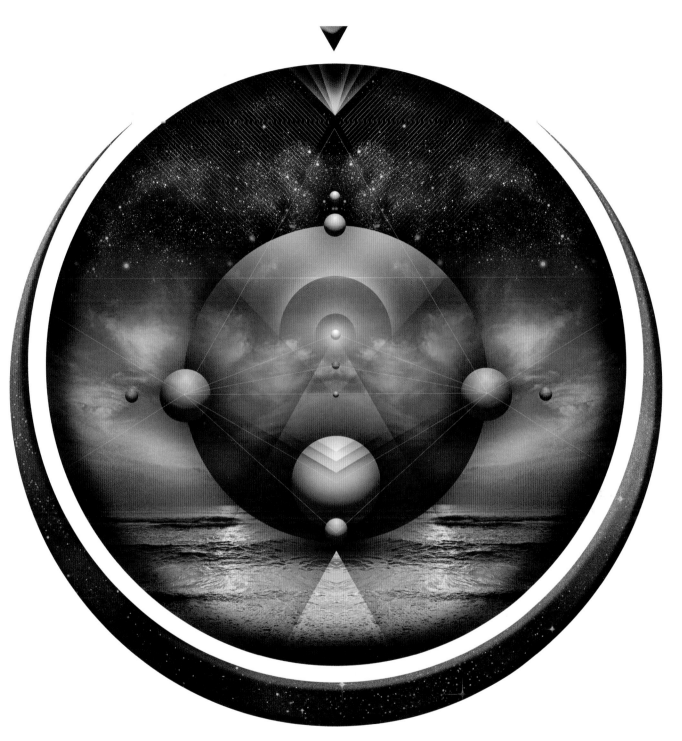

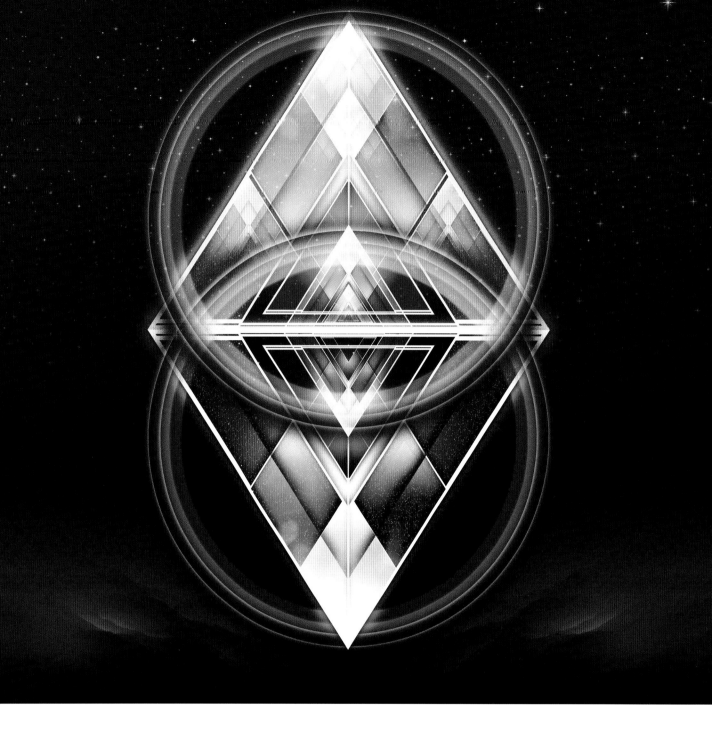

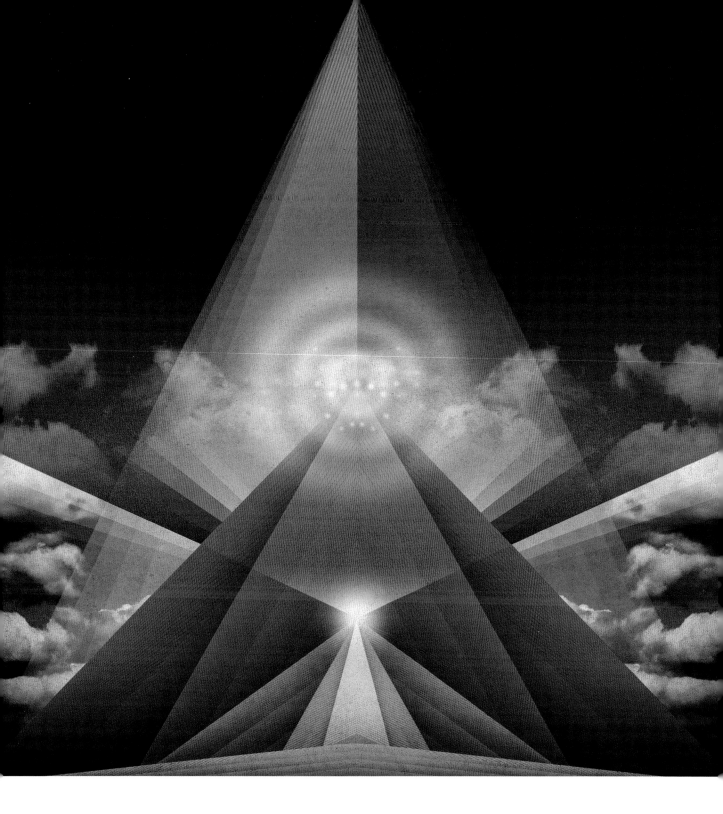

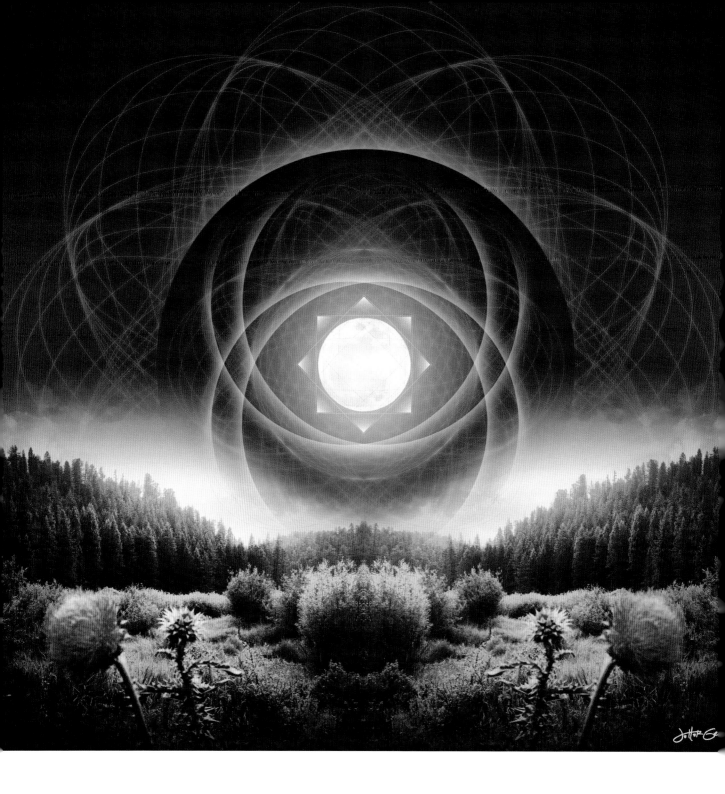

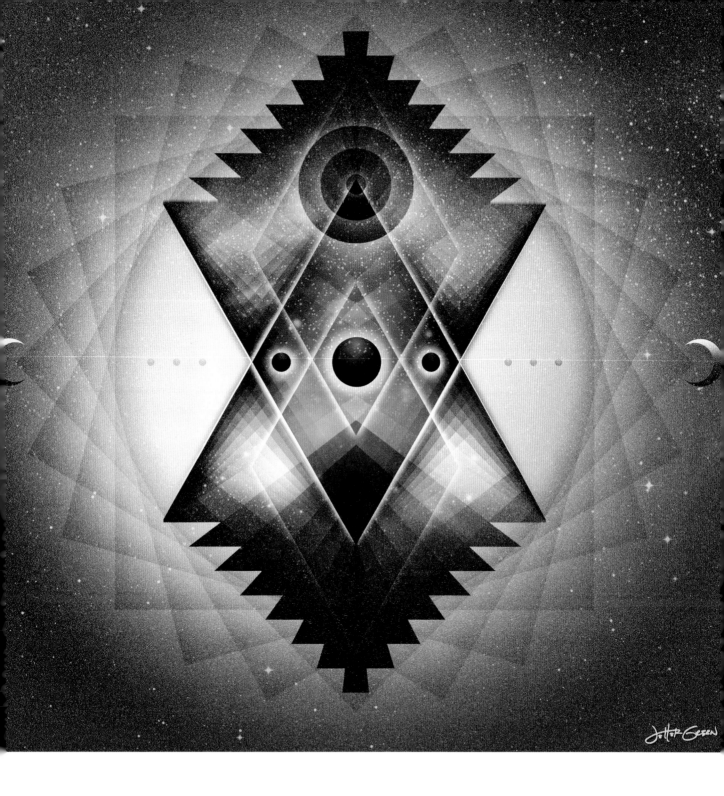

MARK WHALEN

LOS ANGELES, CA USA

As complex as the cosmos or the workings of the human mind, Whalen's pieces resemble elaborate puzzles or labyrinths of fantasy and forecasted worlds – these multifaceted scenarios of discovery, roleplaying and problem solving that expose humanity at its most bizarre. They are almost an experiment into what would occur by amalgamating current ideologies, myths and spiritualties. Thick, seductive layers of clear glossy resin create a post-modern plane for the artist to explore spatial possibilities and relativity within the narrative.

FACT
1. Since i moved to LA 5 years ago i have never wanted to leave, I love this place.
2. When it comes to painting I have a obsessive compulsive nature.
3. I will drop what I'm doing to watch a basketball game.

INDULGENCES Probably the same as my necessities! Ha!
NECESSITIES Coffee, Meat Pies, the NBA, happy hours and BBQ.
STUDIO ESSENTIALS My Laptop, (I watch movies and documentaries while i paint), my notebook and coffee.
VISIONS I never remember my dreams, I only remember probably 5 a year if i'm lucky. But I always have visions for paintings, they are continuously popping into my head in weird places. Never while I'm painting or relaxing, it's usually when I'm occupied doing something else.
INFLUENCES Architecture, modern design, geometry, nature and unusual objects.
INSPIRATIONS Books, documentaries and good times.
COLOR Fluorescents and deep blues.
UTOPIA Right now, Los Angeles, California. I never get sick of this place.
NOISE Love all kinds, been listening to The Shins Album ' Wincing the Night Away' as of late.

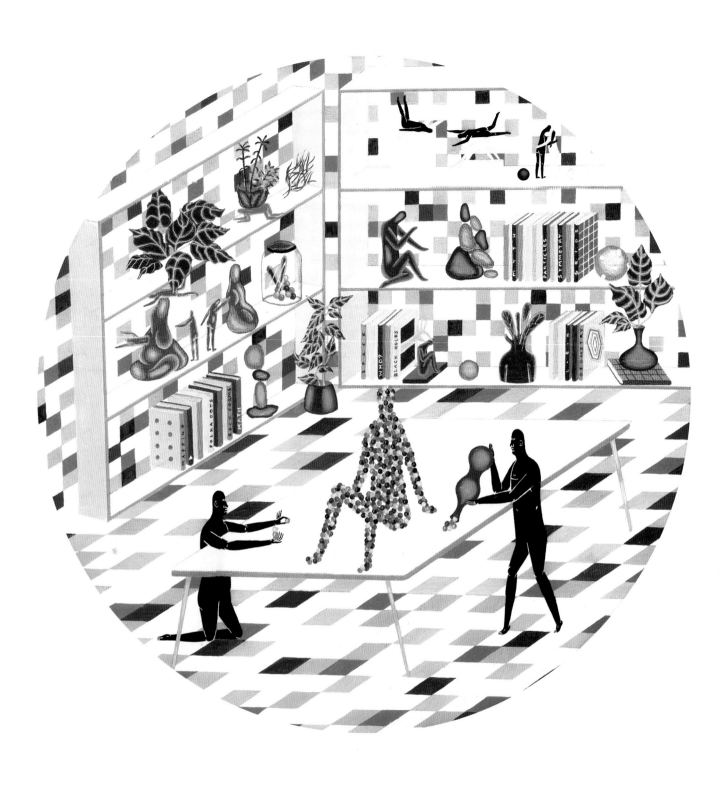

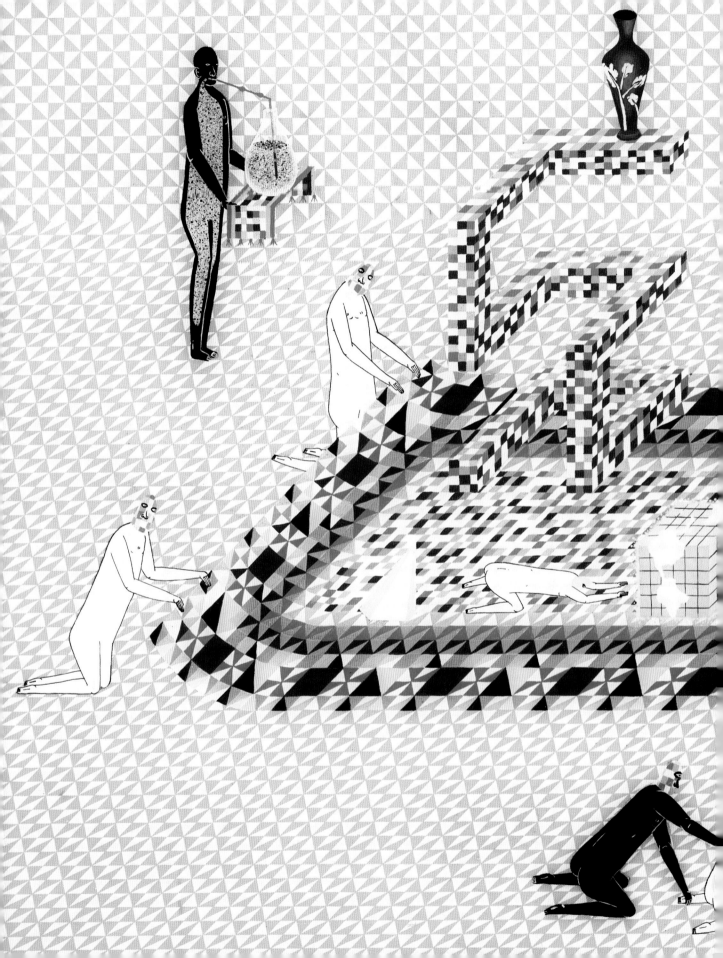

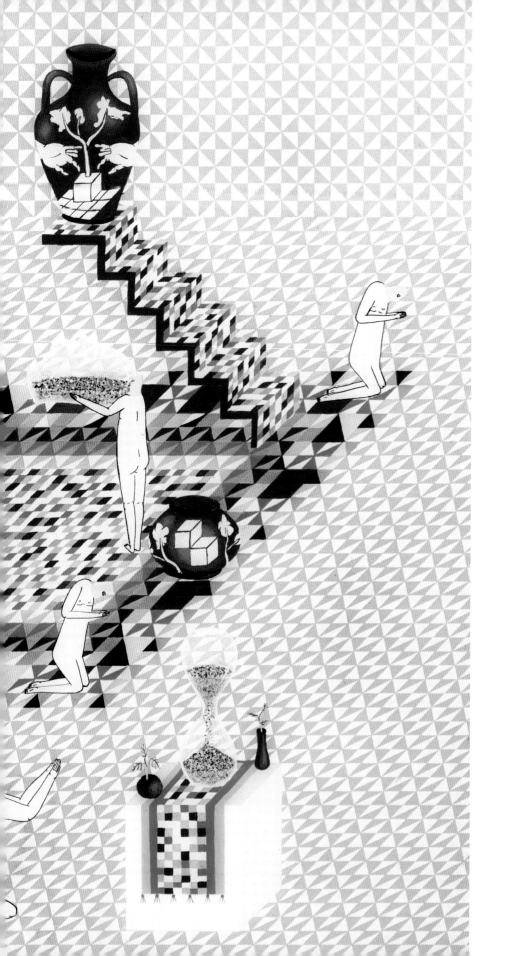

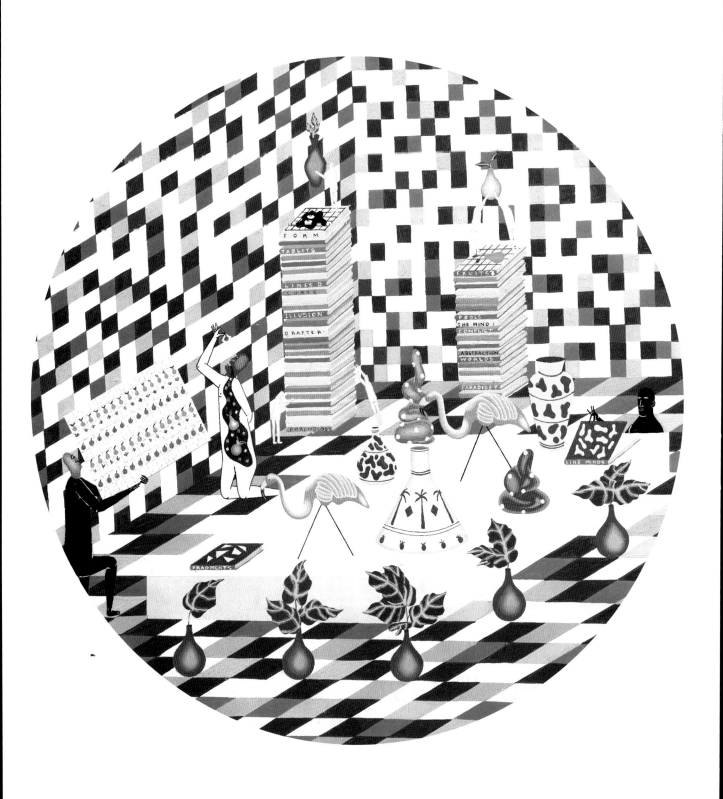

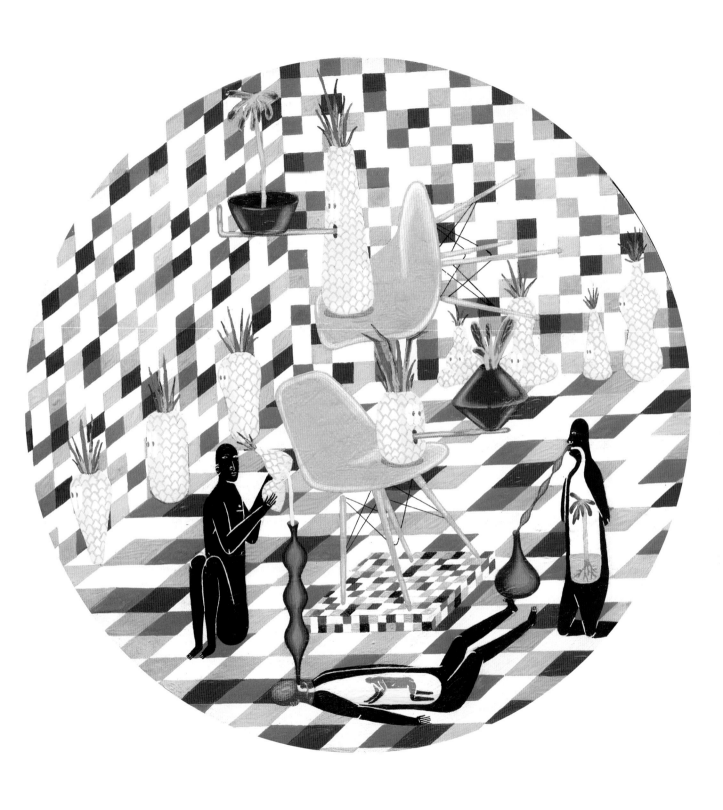

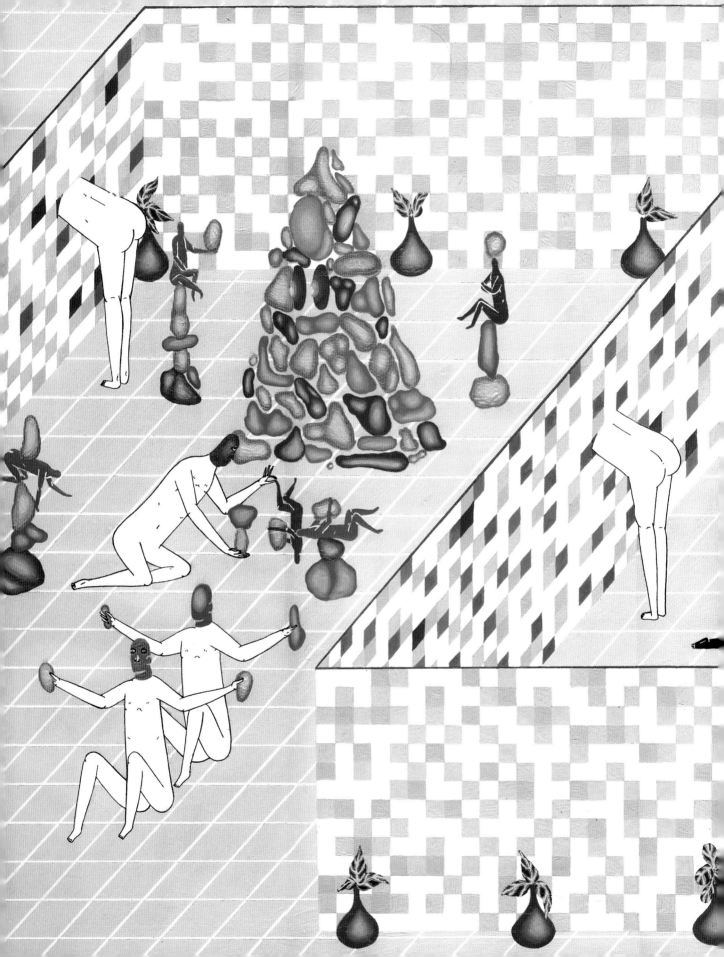

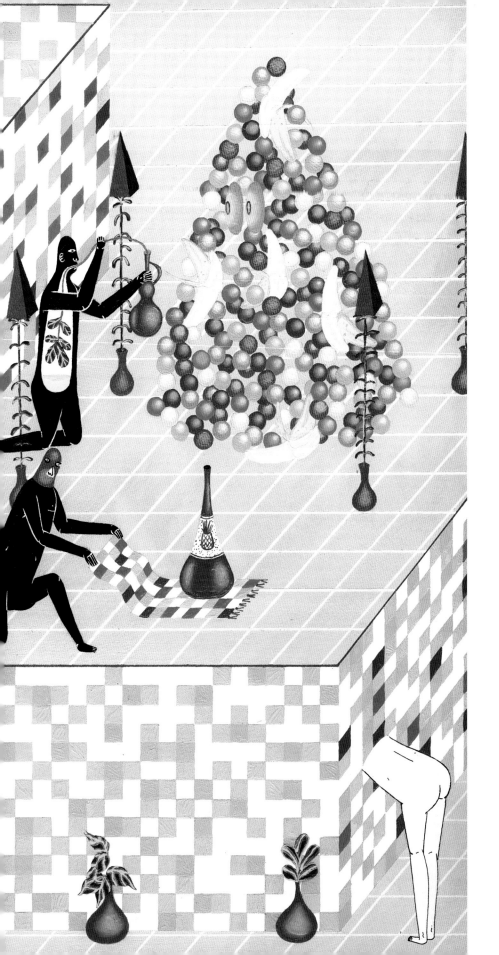

PATRICK KYLE

TORONTO, CANADA

Patrick Kyle is an Artist from Toronto, Canada. His illustrations have appeared in The New York Times, Bloomberg View, Transworld Skateboarding and others. Patrick has exhibited work in Canada, Europe, Australia and The United States. His comic book series "Black Mass" was nominated in both the Doug Wright Awards and Ignatz Awards in 2012. His most recent comic "New Comics #1" was released in May 2013.

FACT
1. I'm a human.
2. I drew a monthly science fiction comic between May 2012 and July 2013 called "Distance Mover".
3. I published a graphic novel called "Black Mass" last year under my own imprint, Mother Books.

INDULGENCES Expensive beer and sourdough bread.
NECESSITIES Expensive beer and sourdough bread.
STUDIO ESSENTIALS Lots of paper, ink, brushes, matte medium, fluorescent paints, nice lighting, a good scanner.
VISIONS I have a lot of dreams about weird complicated buildings that I get lost in and other dreams where everyone changes identities constantly. Dreams are complicated and hard to verbalize. I try to convey dream logic and atmosphere in my work.
INSPIRATIONS Comics are my biggest influence.
INFLUENCES I like atmospheric black metal and other noisy music, dramas, plotless fiction, short stories, 70s Doctor Who.
COLOR I like colours bright and saturated. I like choosing colour combinations that clash or seem garish.
MEDIUM Brush and Ink mostly.
UTOPIA New York.
NOISE I'm into a lot of different music and change it up all the time. I listened to nothing but Reggae for a few days while finishing up my last comic. I'm consistently a big fan of Black Metal, Punk and Noise. I'm mostly drawn to music that has low production and a very broad enveloping sound.
PSYCH I looked through a kaleidoscope once.

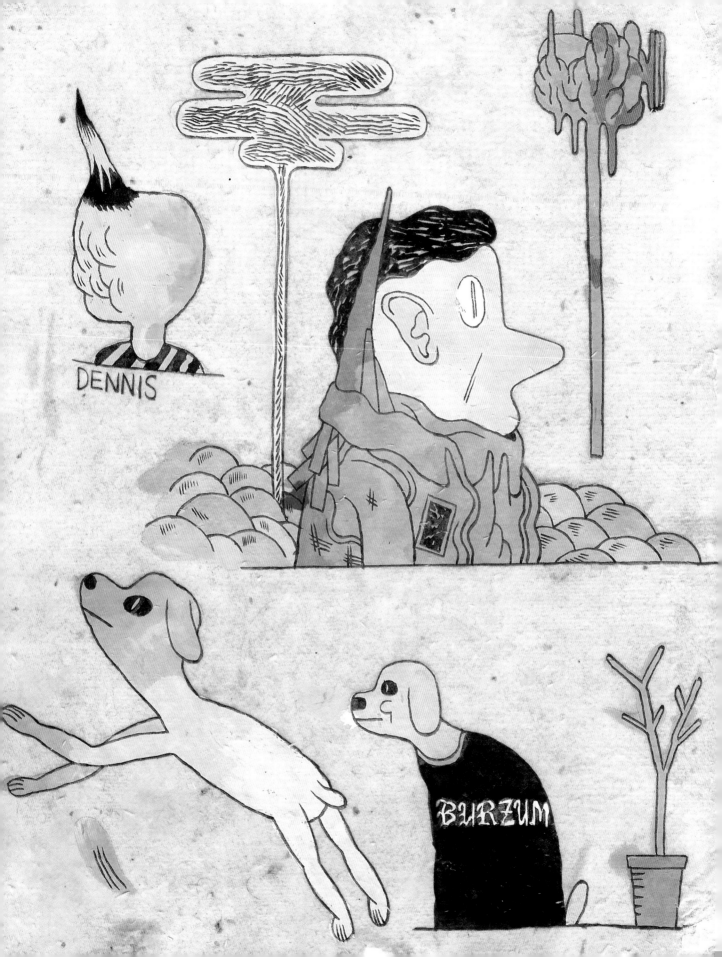

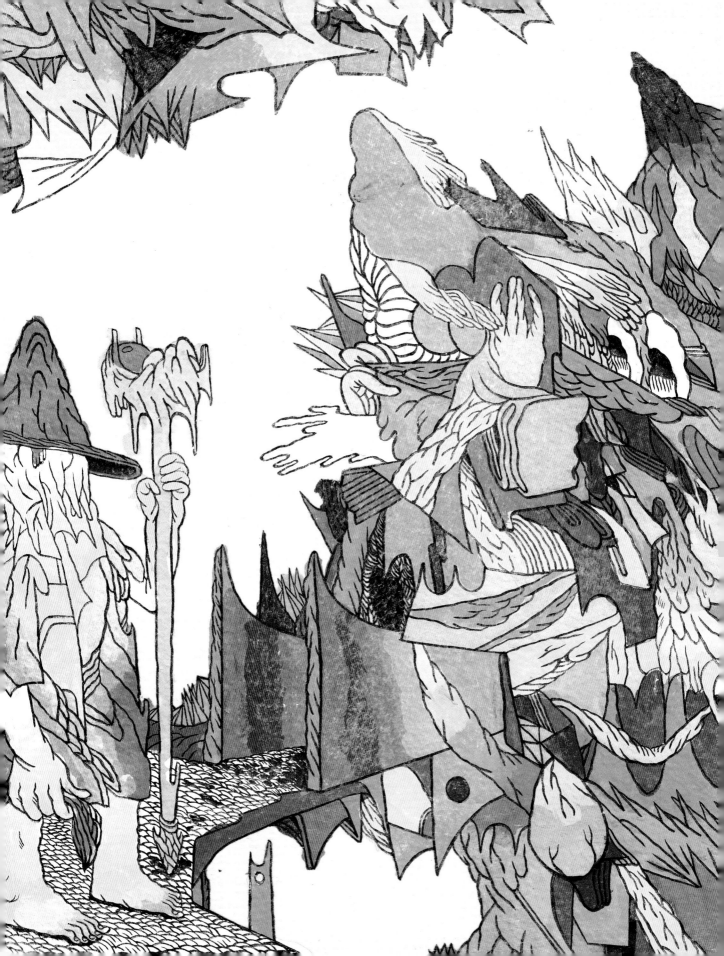

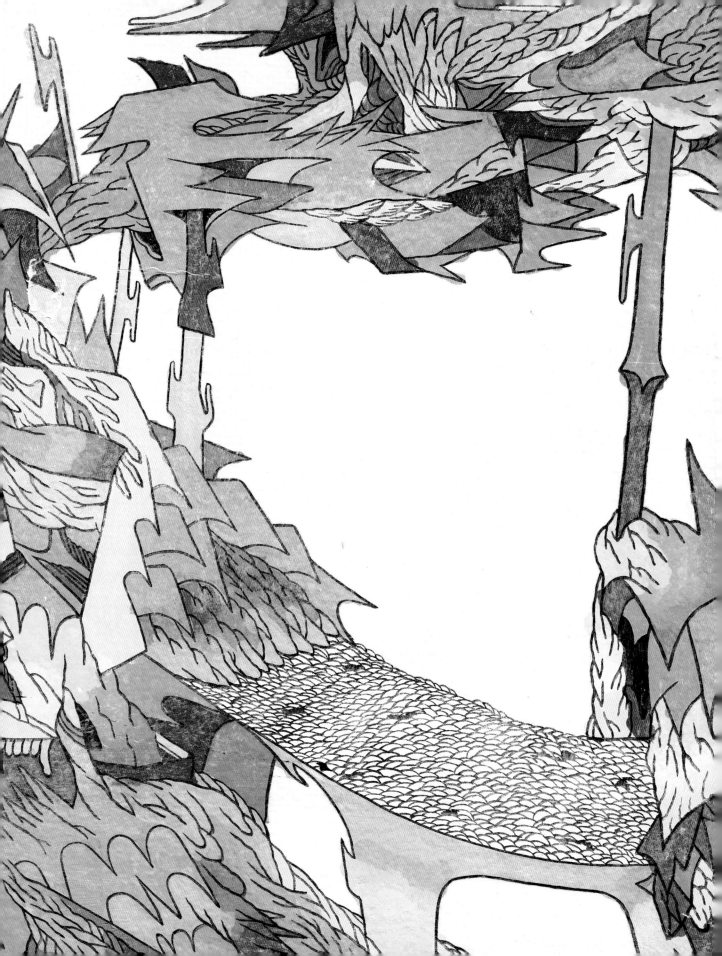

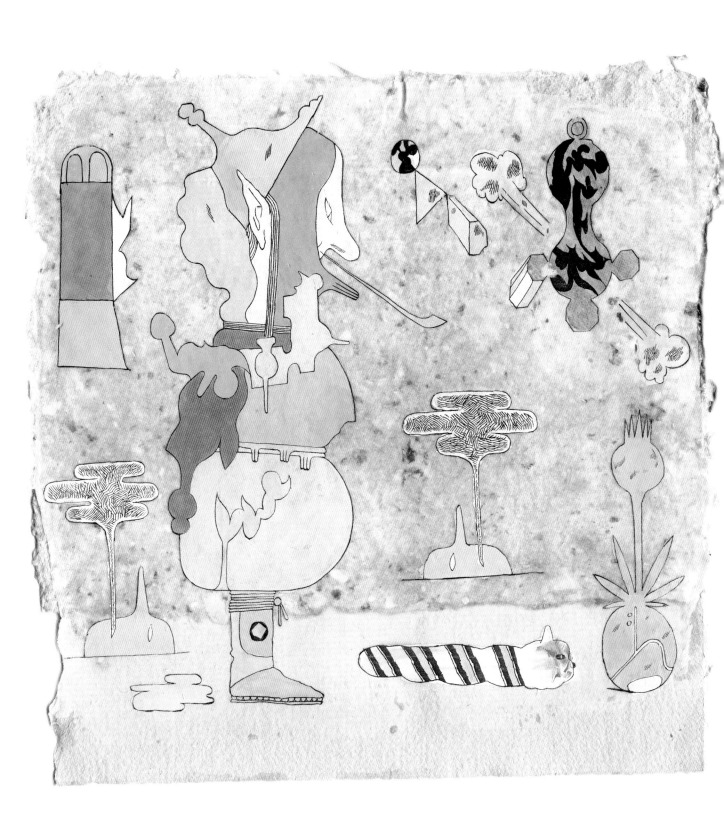

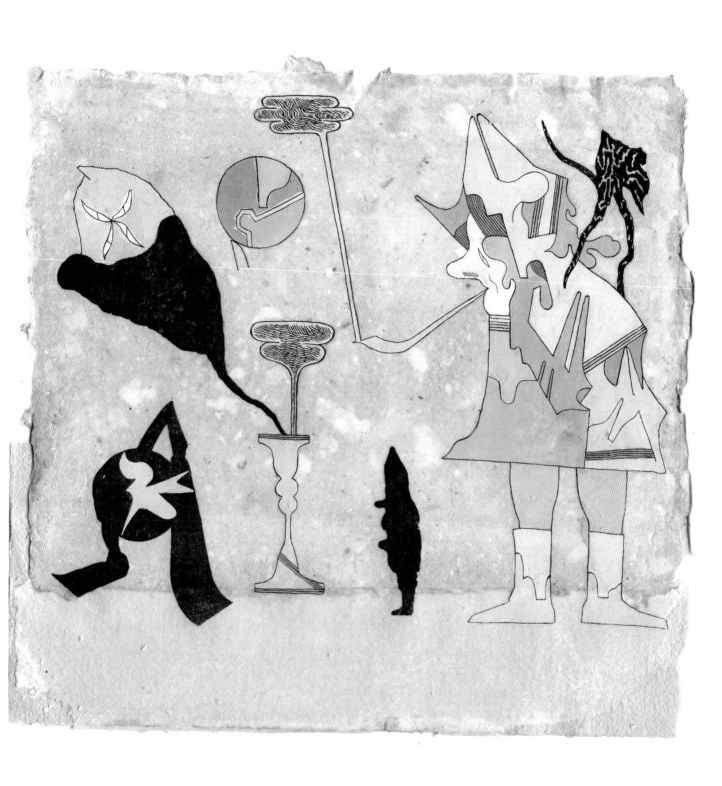

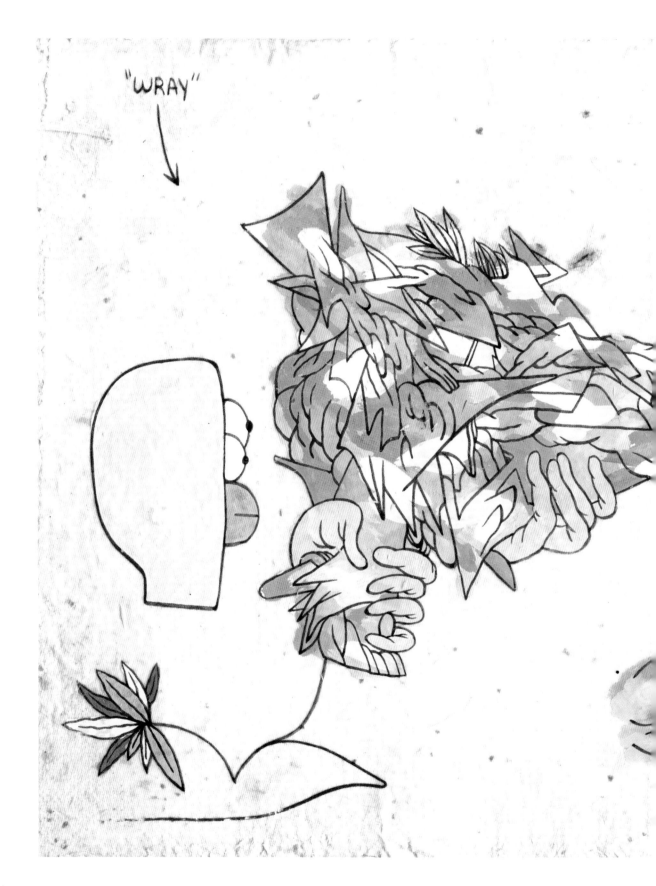

MAYA HAYUK

BROOKLYN, NEW YORK USA

With their symmetrical compositions, intricate patterns, and lush colors, Maya Hayuk's paintings and massively scaled murals recall views of outer space, traditional Ukrainian crafts, airbrushed manicures, and mandalas. Hayuk weaves visual information from her immediate surroundings into her elaborate abstractions, creating an engaging mix of referents from popular culture and advanced painting practices alike while connecting to the ongoing pursuit of psychedelic experience in visual form. She has painted her iconic outdoor murals all over the world. When not traveling, Hayuk maintains an active studio in Brooklyn, sketching in paint to inform the large-scale works. She sees her studio painting practice and mural making as both inversely relational and symbiotic.

Maya Hayuk was born in Baltimore, Maryland in 1969.

FACT
1. Time travel is real.
2. Love is real.
3. Women are real.

INDULGENCES HBO, all night party-party, sleeping in and really good beer.
NECESSITIES Music, love, progress, sleep.
STUDIO ESSENTIALS Music or NPR and light.
VISIONS Symmetry, craked symmetry and cracked-out symmetry
INSPIRATIONS Closing my eyes, airbrushed mail art, record covers, Ukrainian embrodiery and weavings, views from the Hubble Telescope, art of other artists who I admire.
INFLUENCES Music, time travel, the news.
COLOR Flourescent pinks and reds, the color of sunburnt skin, browns and aquas.
MEDIUM Water-based and oil-based paints on walls, canvas and panels.
UTOPIA My studio, in a cherry picker or in bed.
NOISE New, eclectic, loud. I like almost all music in variation and moderation. I love Lucky Dragons, Dan Deacon, Animal Collective, Black Dice, Oneida, Pink Floyd, shitty pop music, offensive rap from Brazil / funky Carioca etc.
PSYCH Yes. 100%. Totally. In variation and moderation.

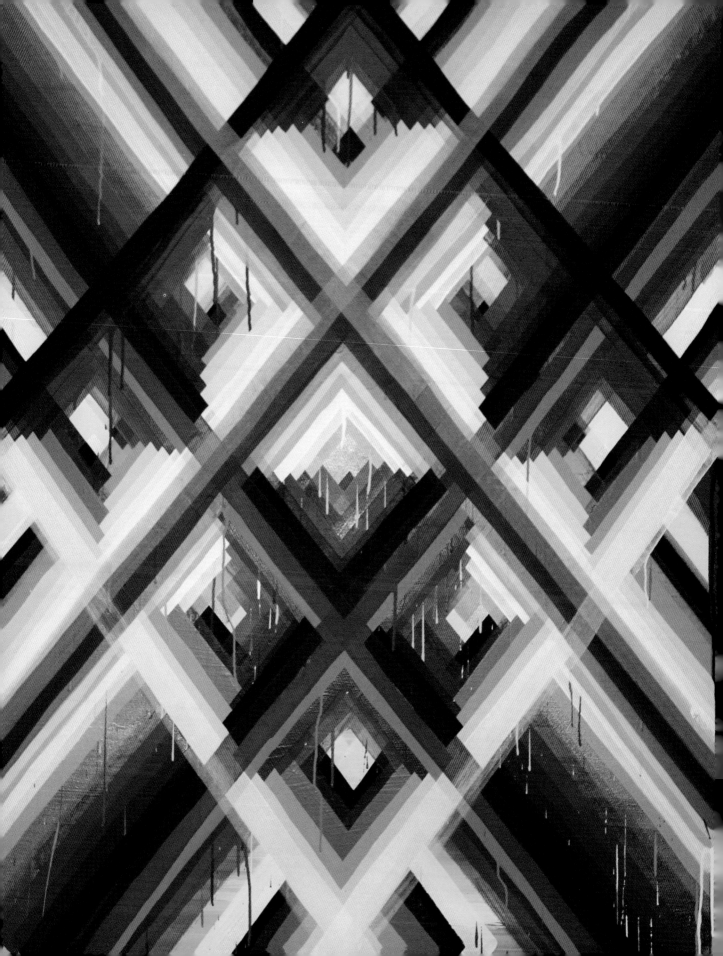

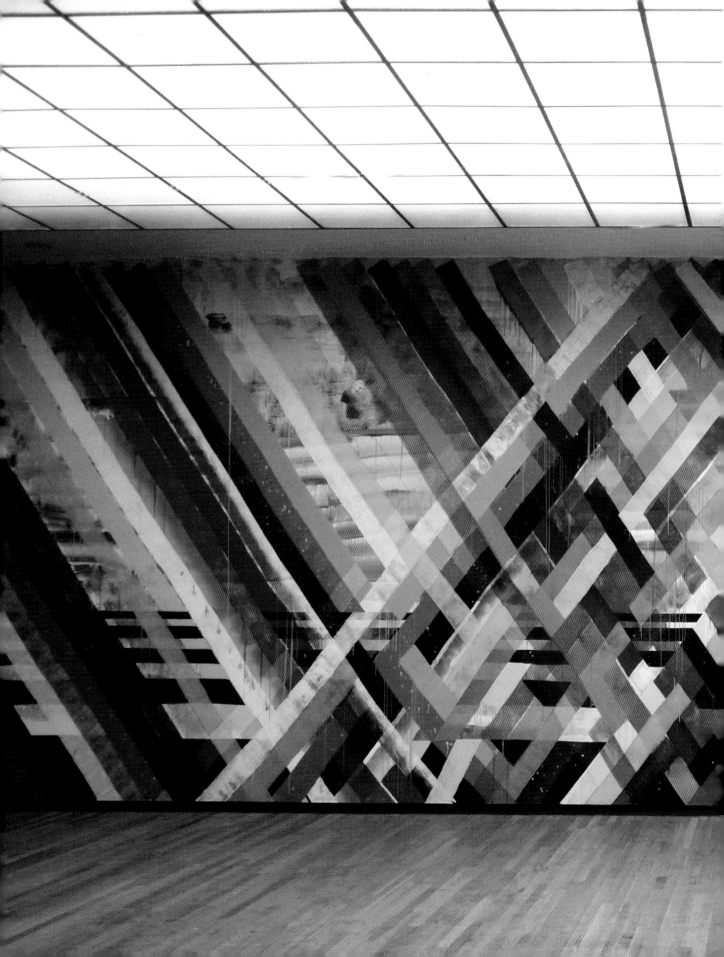

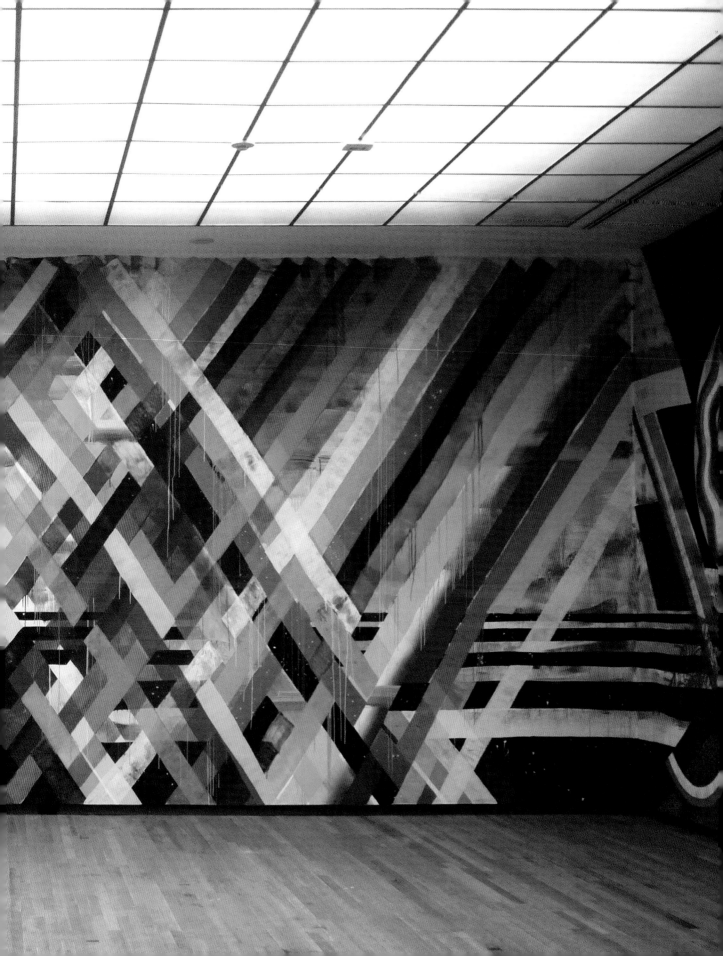

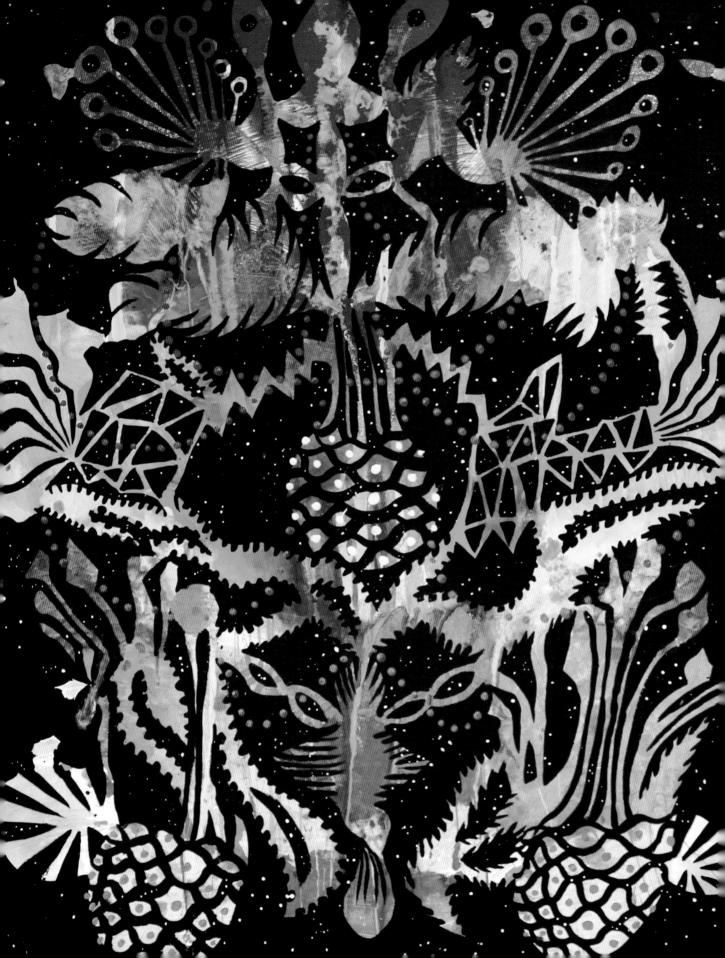

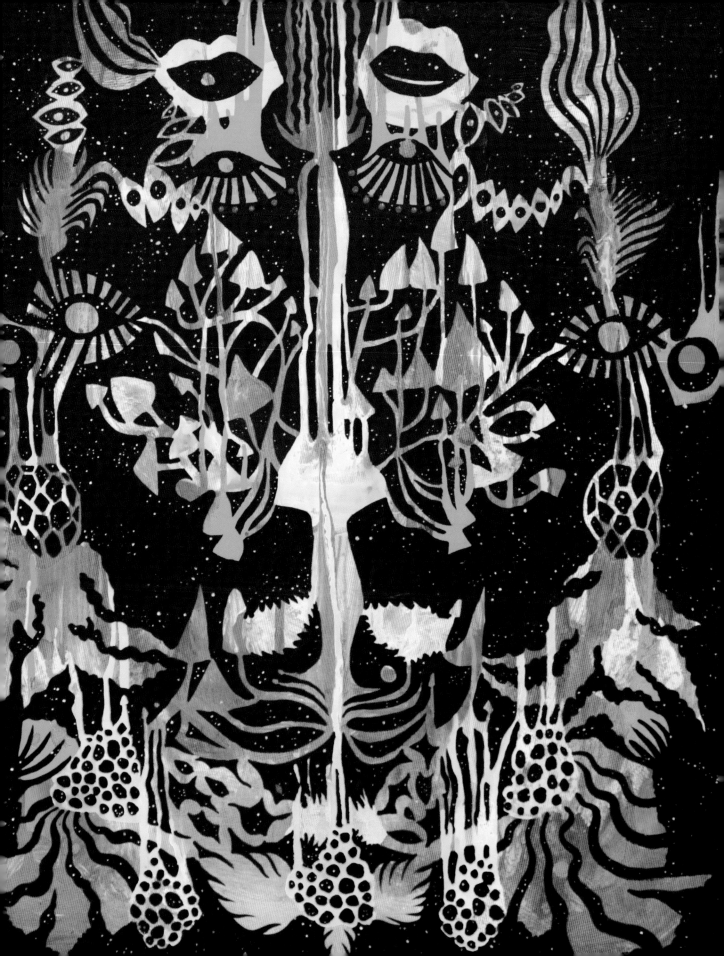

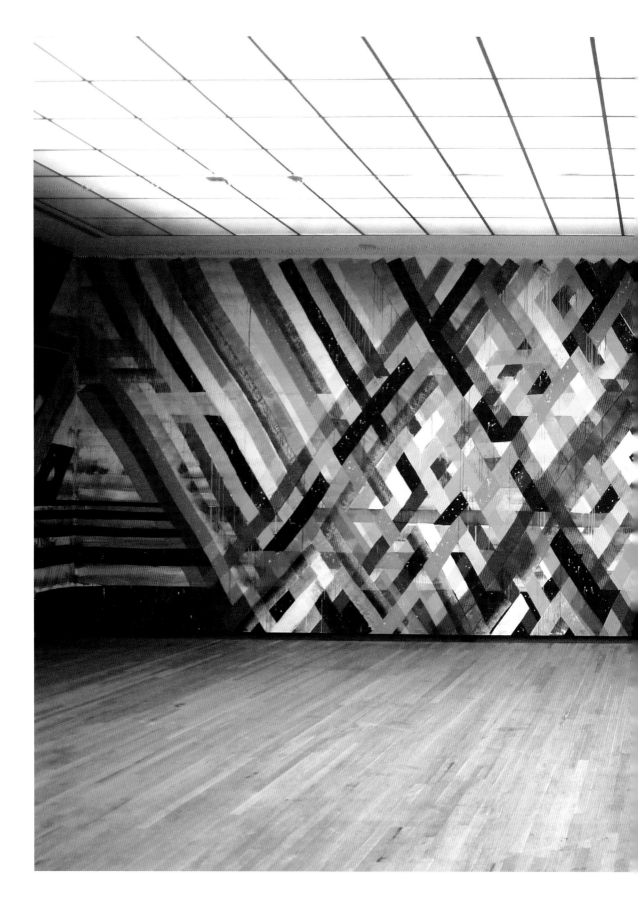

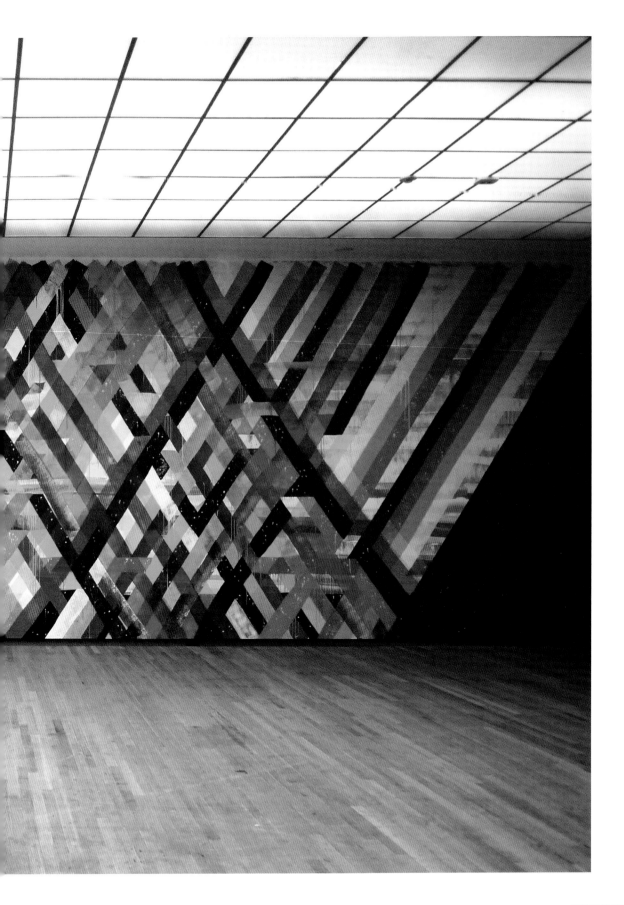

HANNAH STOUFFER

LOS ANGELES, CA USA

Inspired and influenced by both scientific and metaphysical beingness, Hannah Stouffer's work explores a never-ending pursuit of illustrating explosive, emotional transcendence. Through studies in traditional ontology, determinism, natural theology and universal science, Stouffer's work is an array of intricate embellishments, counterbalanced by shadowy, etheral themes. Born in Aspen, CO to wildlife documentarian Marty Stouffer and wife Diane, her upbringing was heavily influenced by our natural environment and her surroundings. Stouffer has maintained a strong presence in the illustration world while simultaneously exhibiting her work as both a commercial and fine artist.

FACT
1. Love. Lust. Gore.
2. Chaos. Myth. Fate.
3. Hot Cheetos and Takis.

INDULGENCES The great outdoors, dark, dark chocolate, radio bangers and pop culture.
NECESSITIES Space, mindless wanderings, references, support, isolation, stimulation, substance, clarity, faded denim, black leather, white cotton, metaphysical beingness, psych-metal and hip-hop.
STUDIO ESSENTIALS Infinite surface space, natural sunlight, a light breeze, black tea, coconut water, snacks, lots and lots of loud rap, metal and mash-ups.
VISIONS Holographic imagery, geometric metaphysics, neon prisms, rays of light, abstracted beingness and expanded consciousness
INSPIRATIONS Every single artist in this book, Leif Podhajsky, Aldous Huxley, Roger Dean, Gustave Dore, Hugh Prather, Andy Warhol, Donny Miller, Richard Colman, Cleon Peterson, Lisa Frank, Boris Vallejo and endless fantasy art
INFLUENCES Synesthesia, the life-cycle, heavily specific sub-cultures, Magick, the supernatural and the occult, endless travel, Ozzy, albinism, vintage paper goods and flea market finds.
COLOR Luminous red, neons, shades of black and pure white.
MEDIUM Ink, watercolor and hot pressed paper.
UTOPIA On the beach- anywhere in the world.
NOISE Yes. Always. Loud.
PSYCH Moderation, variation, experimentation. Infinity.

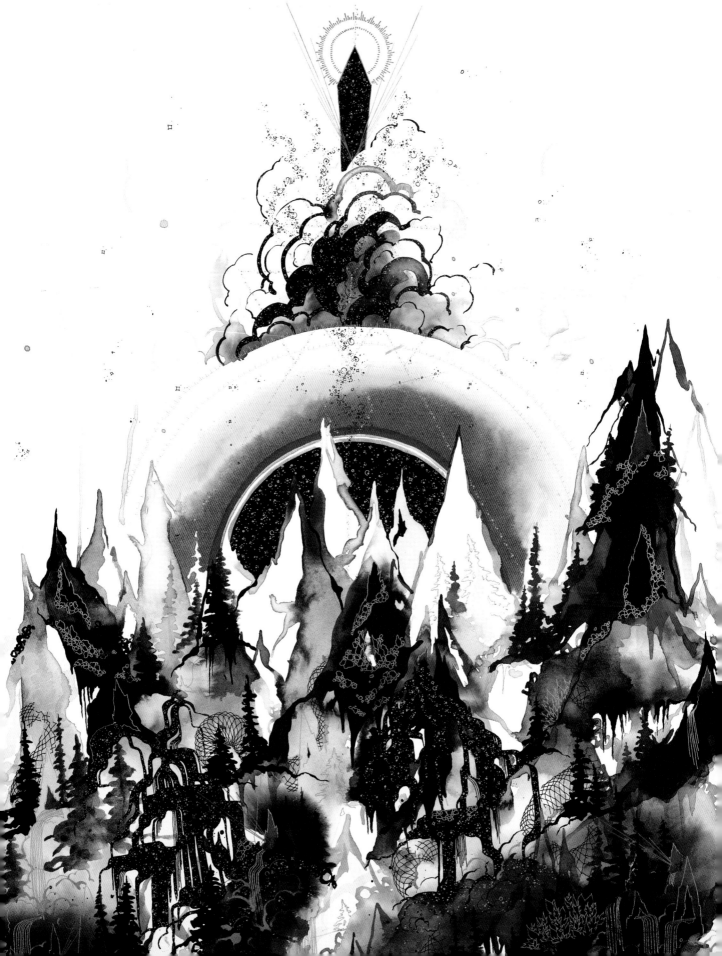

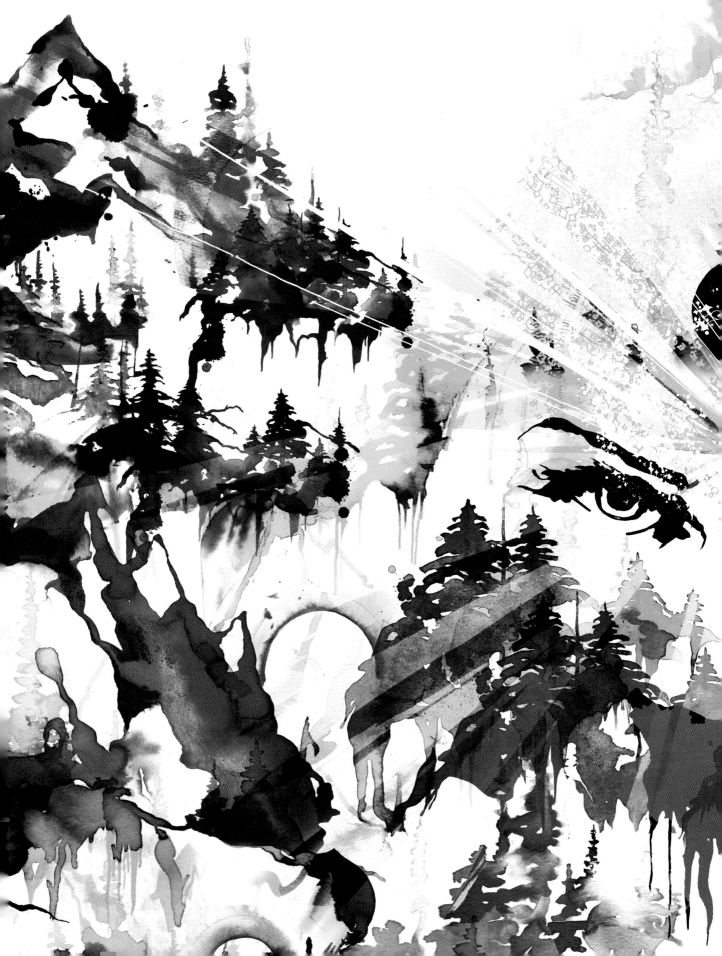

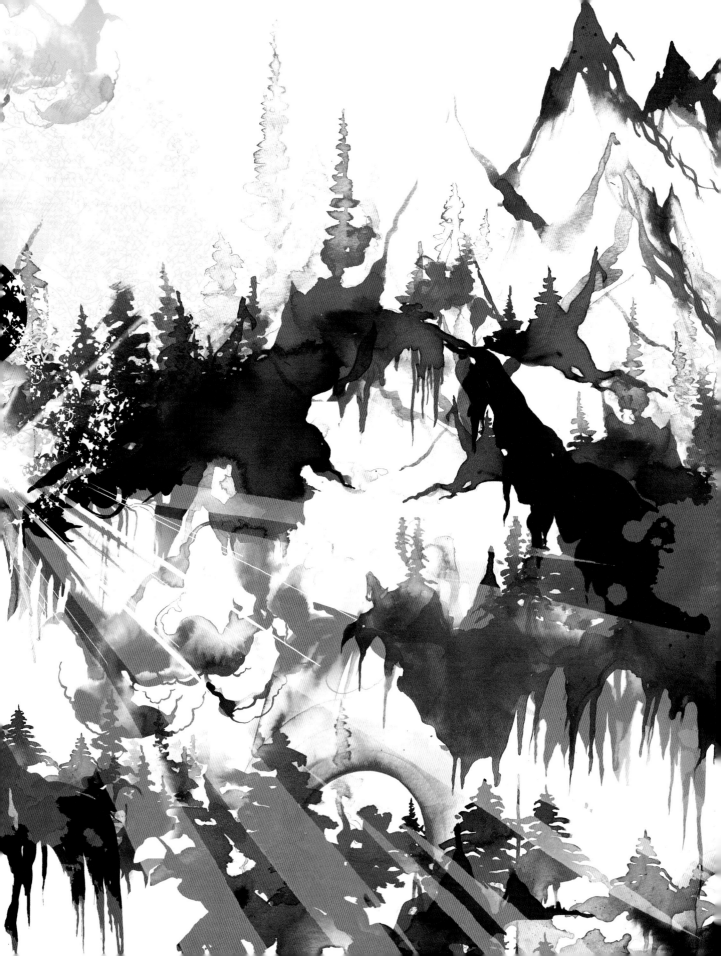

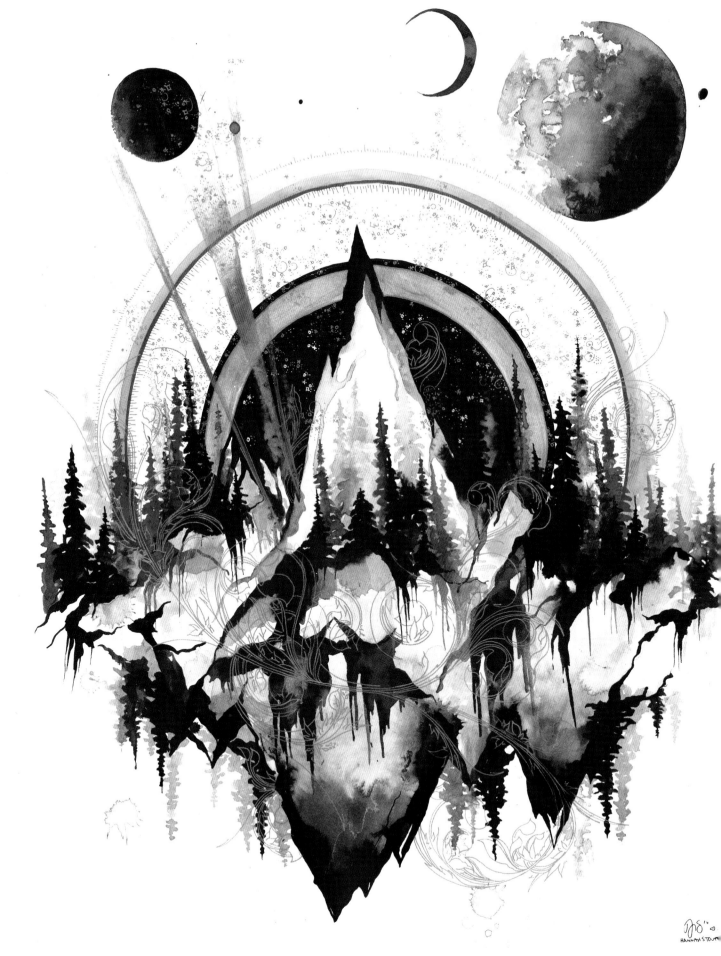

HANNAH STOUT

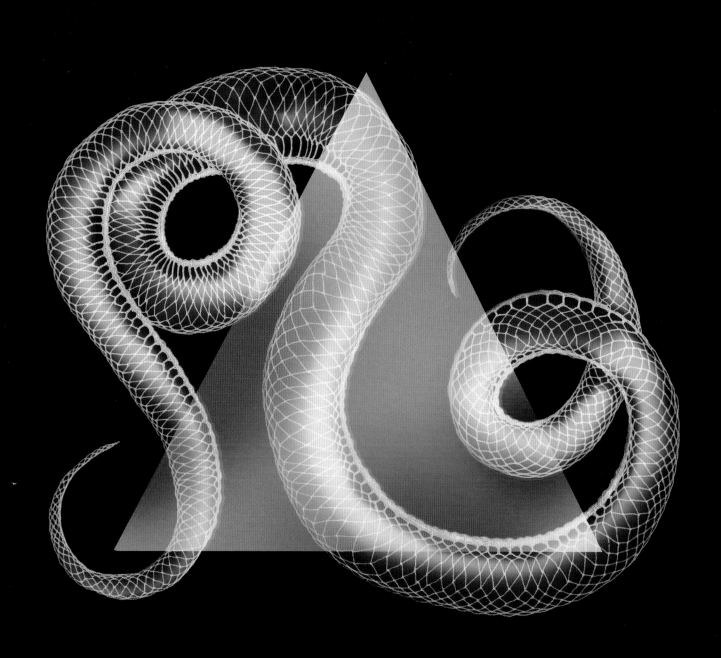

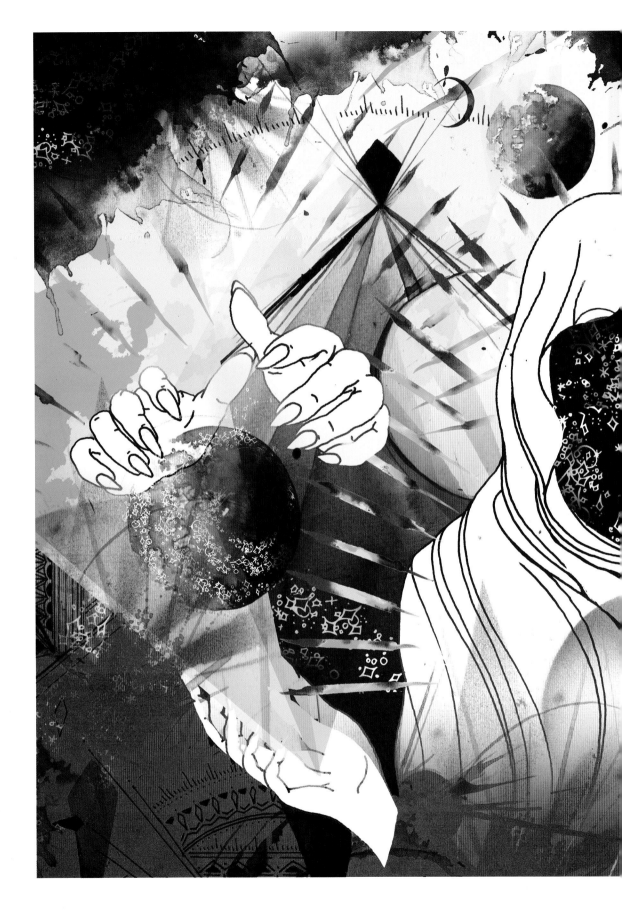

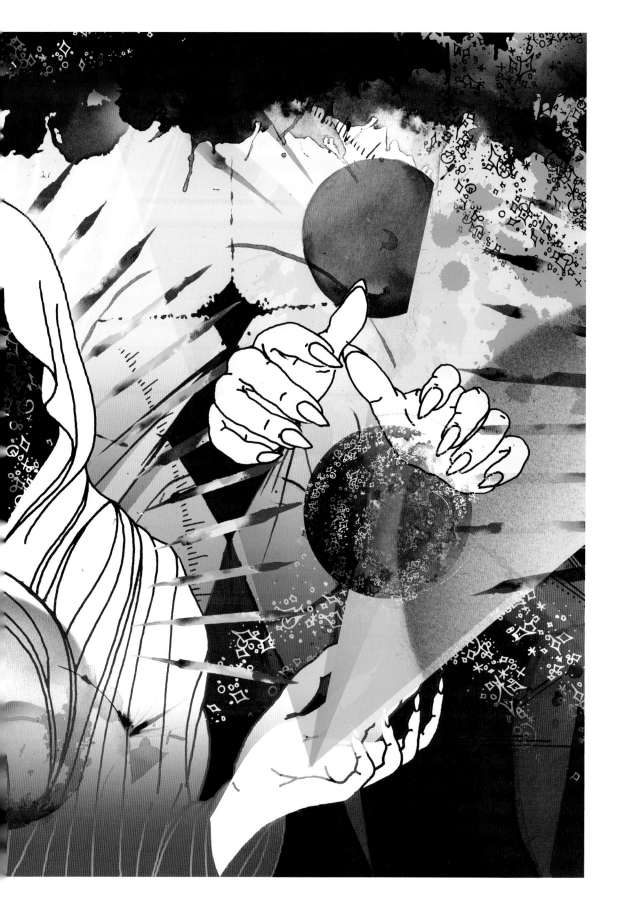

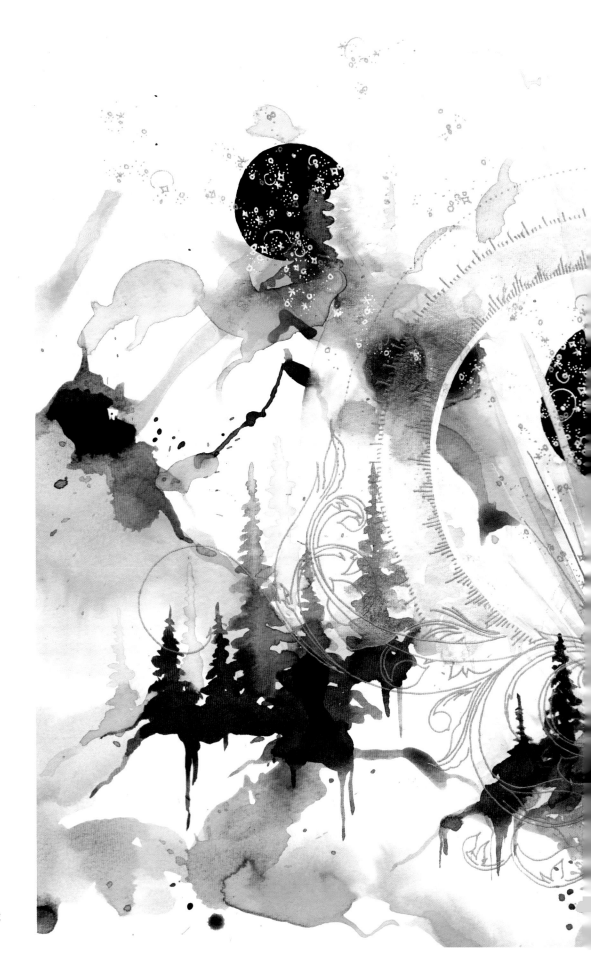

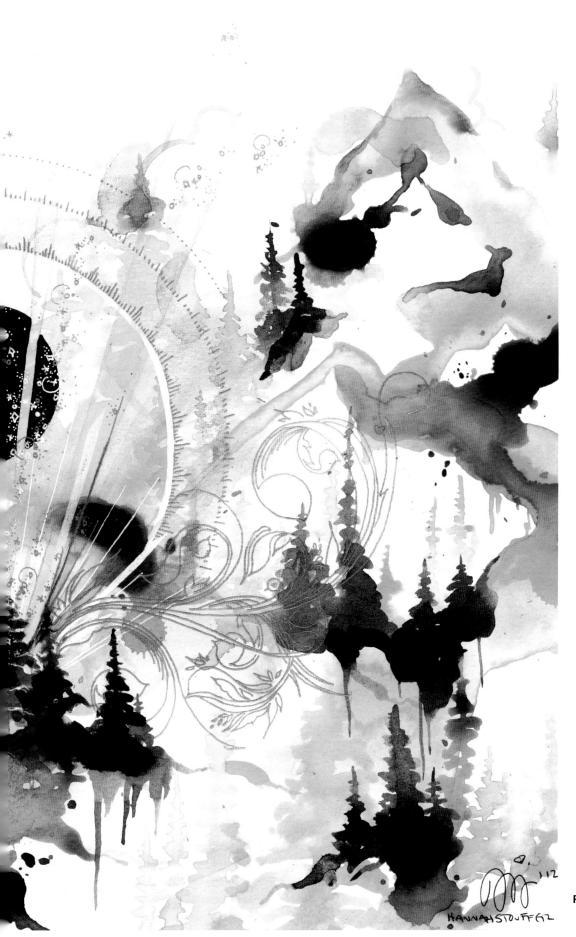

HANNAH STOUFFER

KILLIAN ENG

STOCKHOLM, SWEDEN

Kilian Eng is a Swedish graphic artist who mainly works in the field of Sci-fi and Surrealism. He is often drawn to work with colorful images that put extra attention on environments. Kilian has created artwork for bands around the world, mainly in the field of electronic music. Lately he has also worked in the medium of screen printed film posters. Besides creating commissioned work, Killian spends a great deal of time creating alternative realities through his personal drawings.

FACT
1. Favorite historical time period is the 17th century.
2. Think the superhero subject is very overrated.
3. Recently got a collection of retro video games as a payment for a job.

INDULGENCES Exotic snacks.
NECESSITIES Pens, books, music, pictures, tea.
STUDIO ESSENTIALS The radio.
VISIONS The finished version of my never ending animation project.
INSPIRATIONS Philippe Druillet, Francois Schuiten, Moebius, Eyvind Earle, René Laloux films and many more.
INFLUENCES Architecture in all its forms.
COLOR Black and bright colors like yellow and orange for contrast.
MEDIUM Mainly digital drawing.
UTOPIA My work space.
NOISE Ralph Lundsten, Sun Ra, Drexciya on a very modest level.

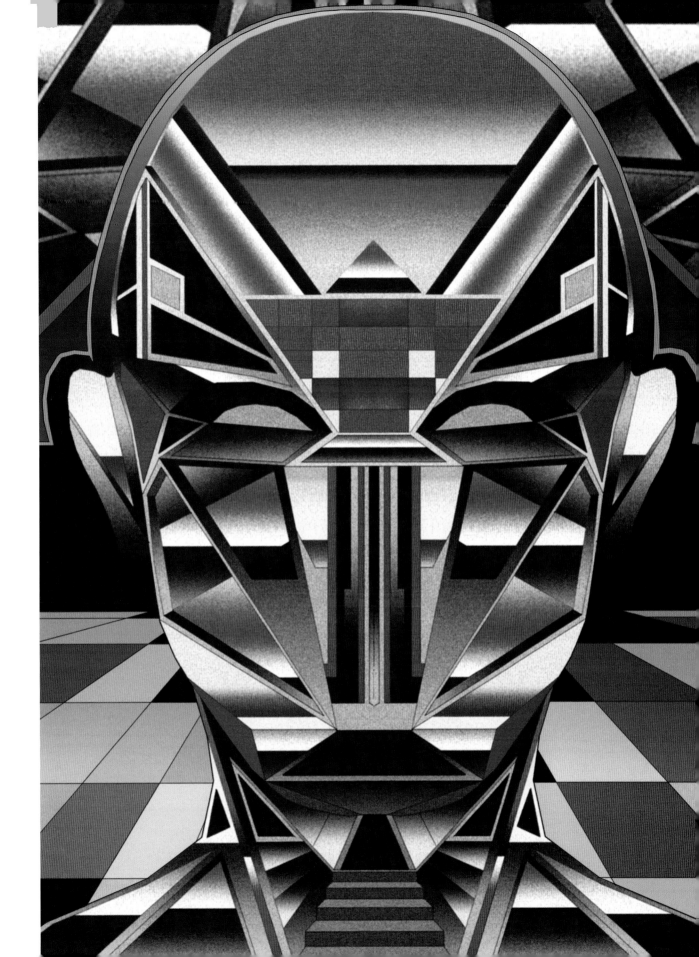

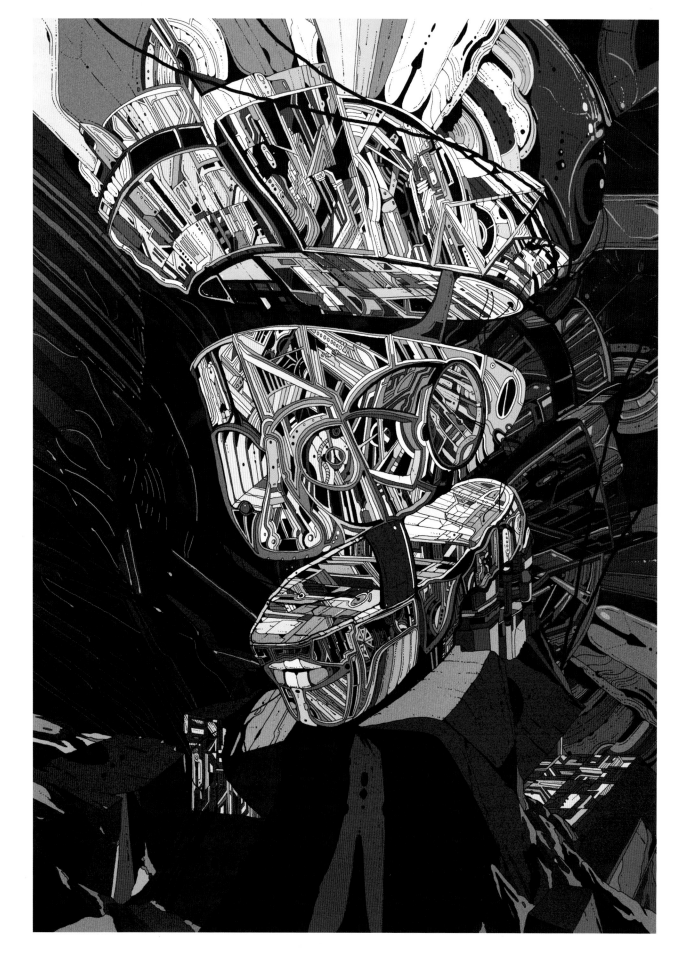

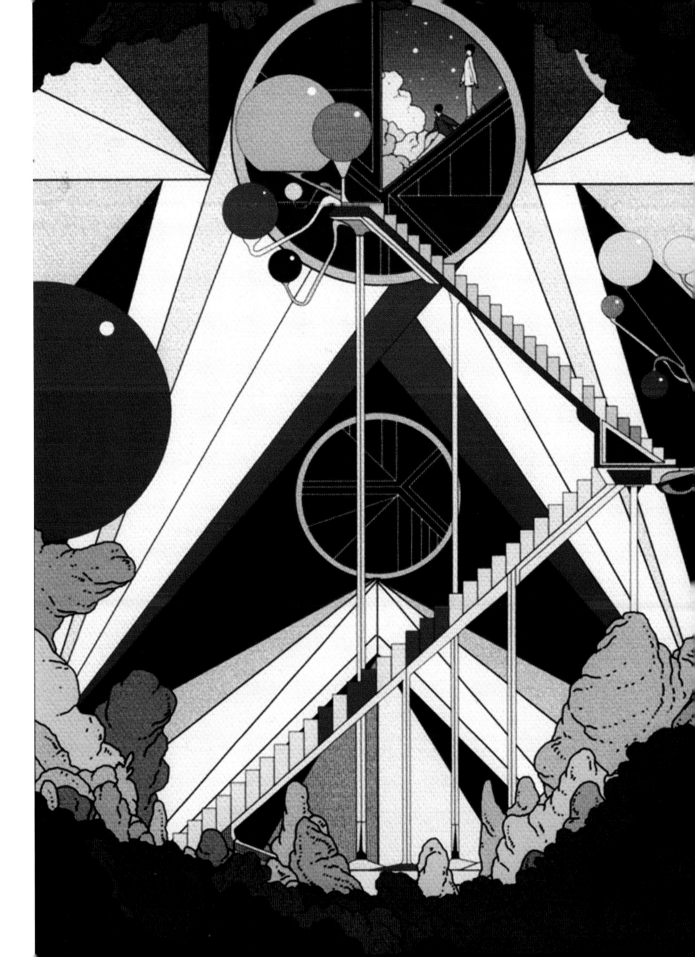

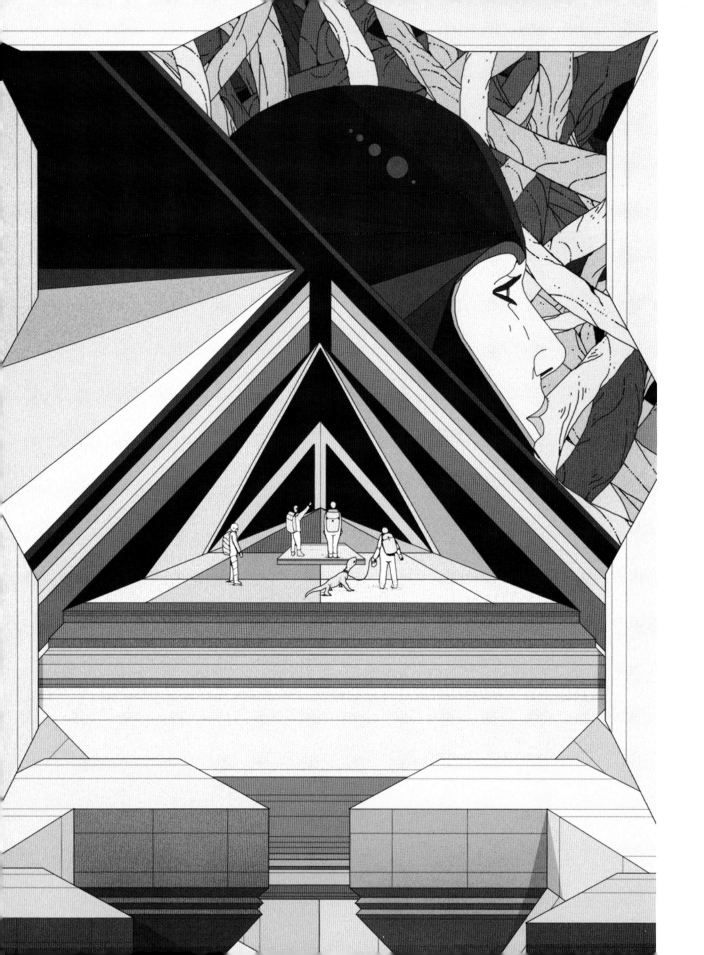

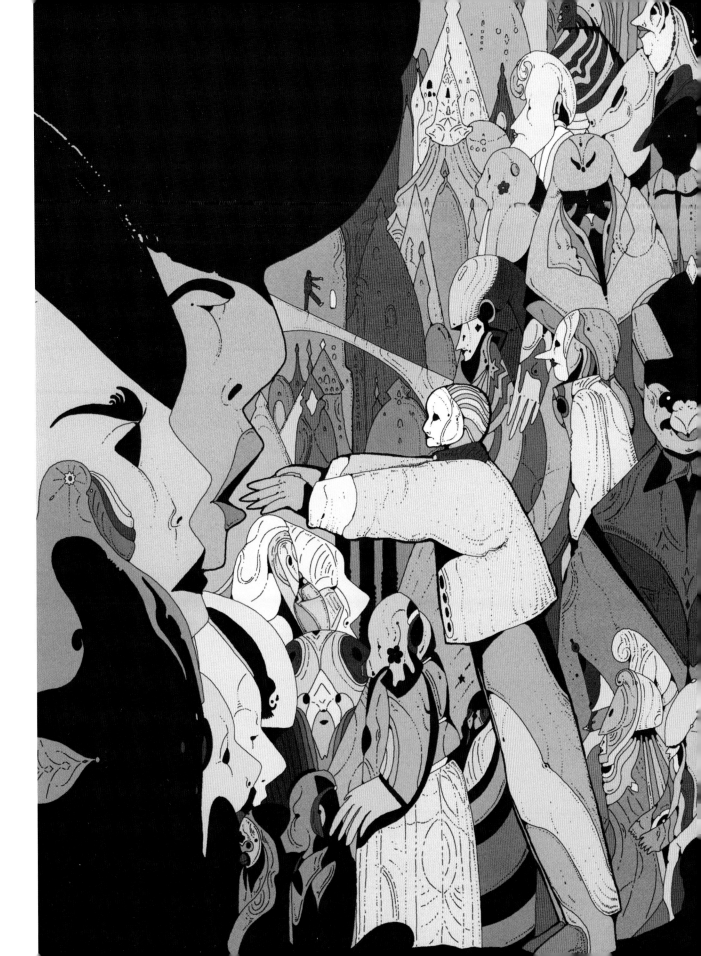

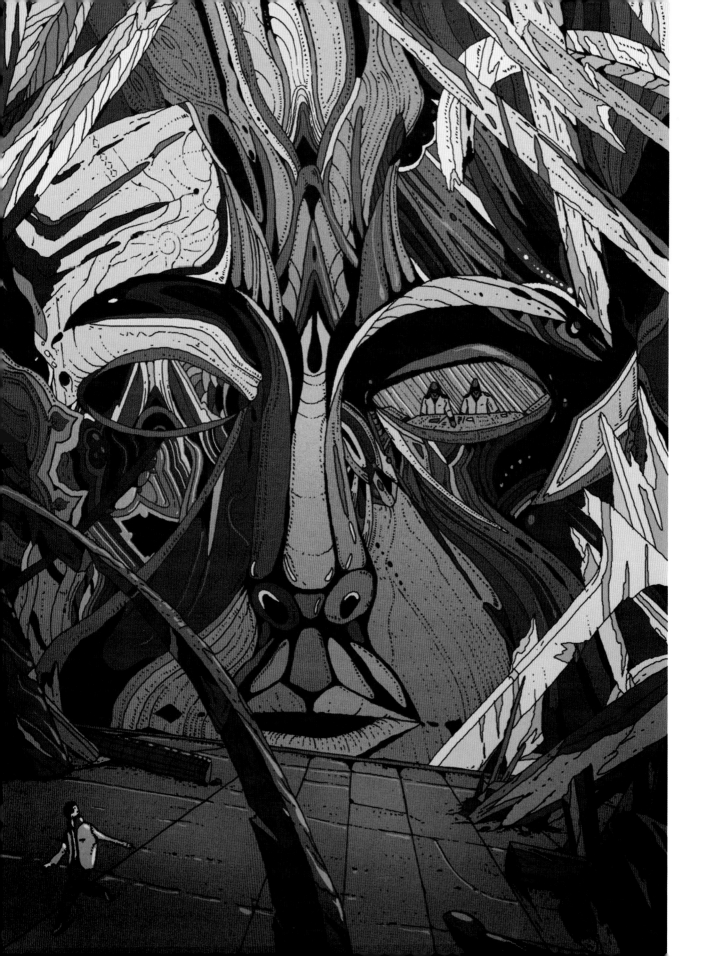

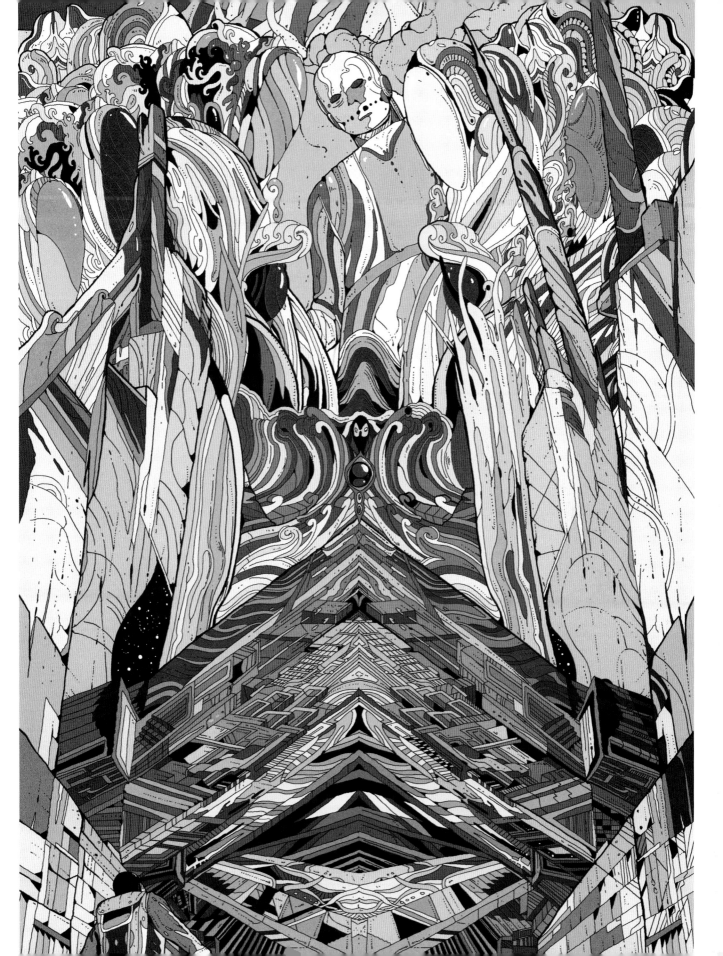

ROID

London Based artist Roid began painting the late 90's spending the last ten years building a solid international reputation for innovation and technical skill. After his sellout debut solo show in summer 2012 he is now working as a fine artist and creative director from his south London studio, continuing to influence and change the way people think about graffiti.

FACT
1. Life.
2. Death.
3. I read the other day that a number of astronauts reported space as smelling 'meaty and metallic'.

NECESSITIES Family, friends, good food, travel, music and dancing.
STUDIO ESSENTIALS Coffee, avocado on toasted rye bread, internet radio, protractor, mechanical pencils, airbrush, vinyl acrylics, gouache, spray paint, brushes and Klaus the cat.
VISIONS Halftones and sunset graphic line fades.
INSPIRATIONS Retro futurism, surrealism, sci-fi art, obsolete technology / machines / computer graphics, information graphics, exploded diagrams, tacky airbrush art and Japanese graphic design.
INFLUENCES I try to take a little something from everything I enjoy outside of work. This could be as simple as re-interpreting sounds or a quote... Science, Geometry, space, nature, music etc.
COLOR I tend to work with greyscales as a base i.e. turquoise greys and purple greys, using pastel tones of colours and fluorescent mixed with lots of white to create vibrance without it being too loud.
MEDIUM Gouache and vinyl acrylic mix on watercolour paper and vinyl acrylics on wood. It provides a flatness which has similar qualities and offers a finish closest to spray paint.
UTOPIA London has been and will most likely always be my home or at least base. Also, Pulau in the Perhentians.
NOISE Analogue house, Chicago and Detroit stuff, cosmic and Italo disco, New wave, Ebm.
PSYCH I experiment with Mushrooms and DMT from time to time. I enjoy both for different reasons. I find my trips on mushrooms now much more outwardly focused than acid or DMT and there's a degree of predictability and a level of control. I think that unfamiliarity with what I'm seeing and experiencing coupled with the short intense hit is what draws me to it.

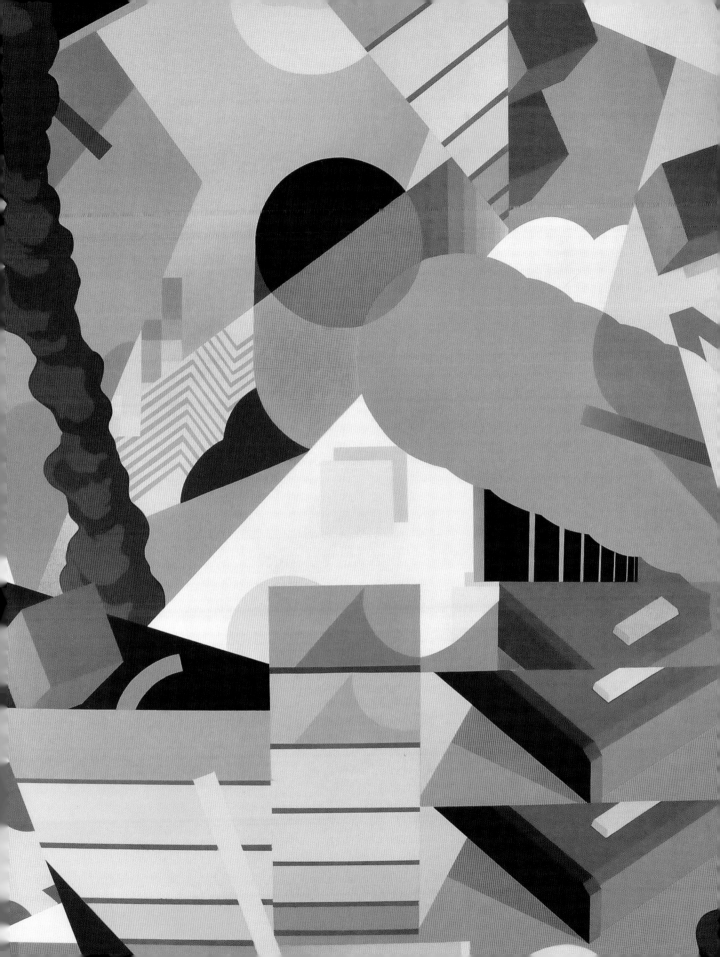

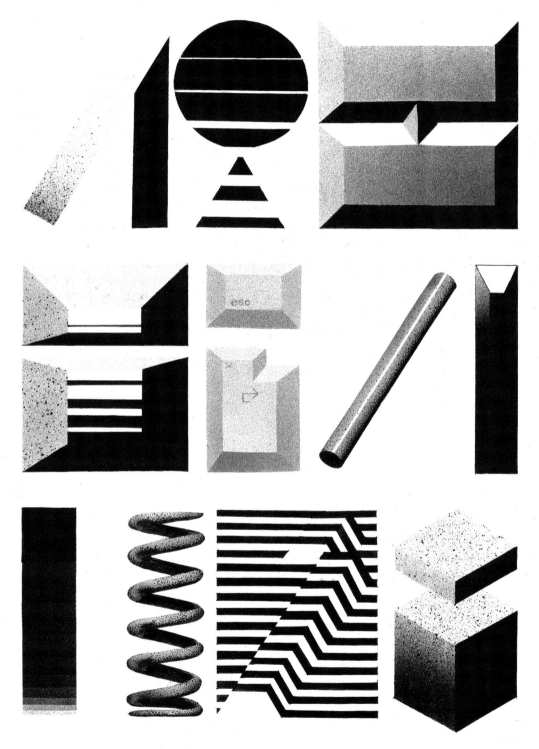

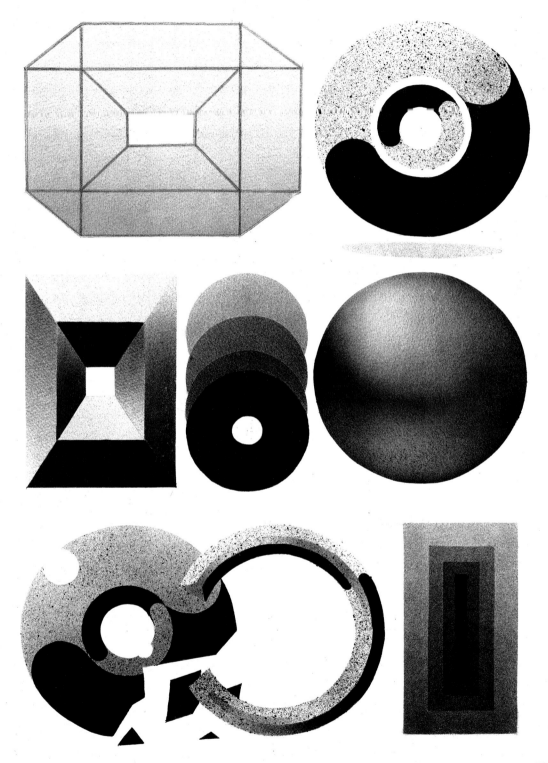

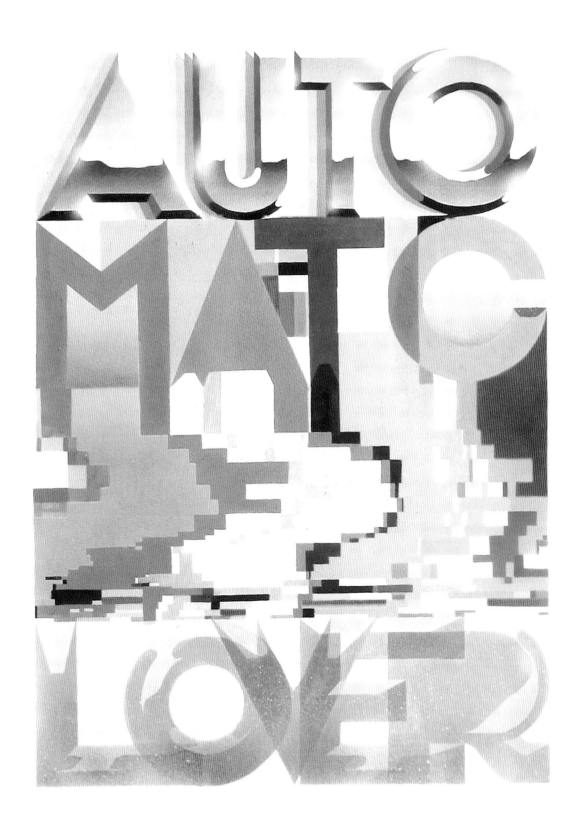

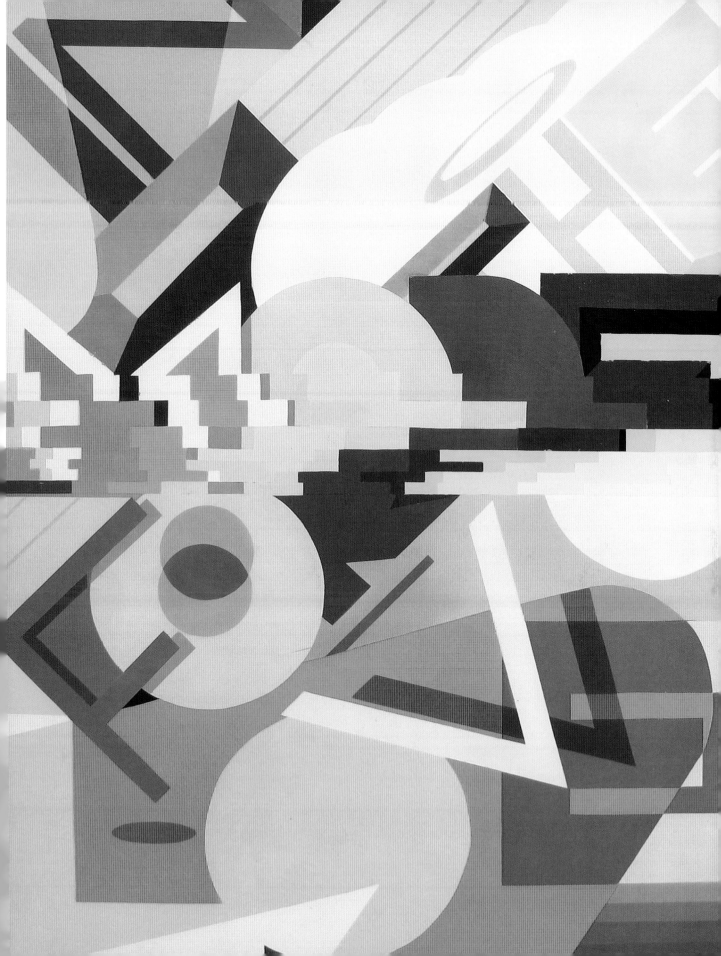

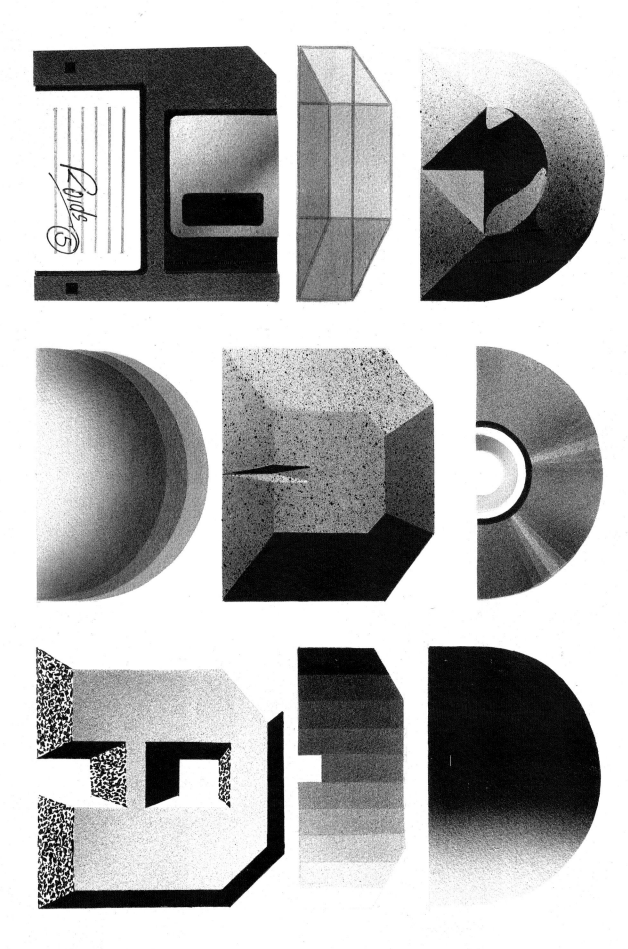

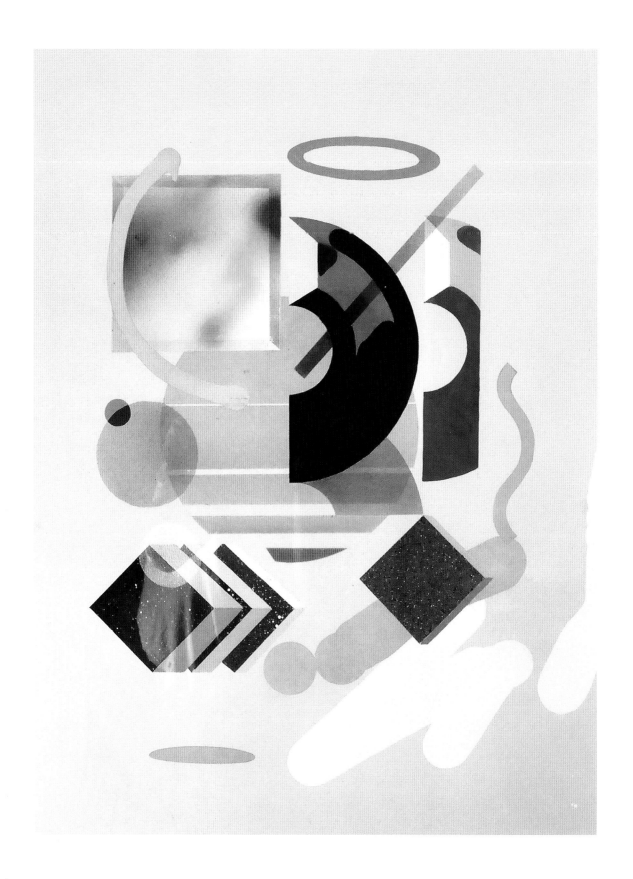

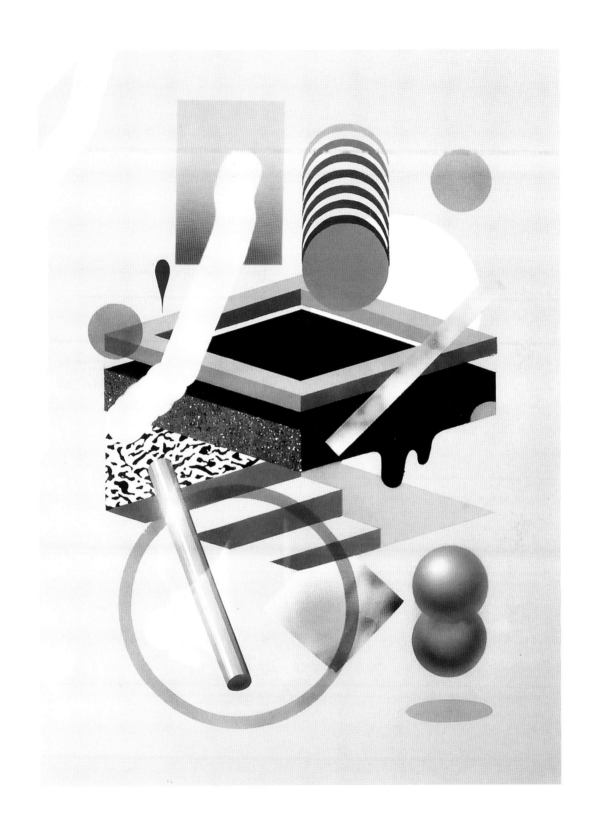

JOHN VAN HAMERSVELD

RANCHO PALOS VERDES, CA USA

John Van Hamersveld is an American graphic artist and illustrator. In the early 1960s, while attending Art Center College of Design by day, he began his professional career as art director of Surfer Magazine. By the mid-1960s Van Hamersveld's groundbreaking promotional poster for the cult surf film The Endless Summer was making the rounds, and a name for its creator in the process. Eventually his talents were directed towards concert posters promoting shows by the likes of Jimi Hendrix, Jefferson Airplane, The Who and more.

Van Hamersveld's iconic sensibilities were later put to good use as he created logos, typography and complete graphic identities for brands such as Gotcha, Fatburger, JIMMY'Z and Tower Records. His classic posters are available as fine reproductions through his Post-Future Art Company, while he continues his steady output of illustration and design through his Coolhous Studio in Rancho Palos Verdes, California.

FACT
1. Born 1941, Baltimore, MD.
2. Owns the Post-Future Art Company.
3. Created the classic poster for 'The Endless Summer'.

INDULGENCES Kaiser (Hospital) has them all for immediate health reasons.
NECESSITIES Lefthand, LAMY pen, iMac, cell and Google search.
STUDIO ESSENTIALS Day light, night light and time.
VISIONS Imagined thoughts from the unknown.
INSPIRATIONS Magazine stands and walks.
INFLUENCES I was a surfer which connected everything in many ways.
COLOR My photographs tell me about color.
UTOPIA Myself.
NOISE Lounge Music.
PSYCH Those experiences don't go away....

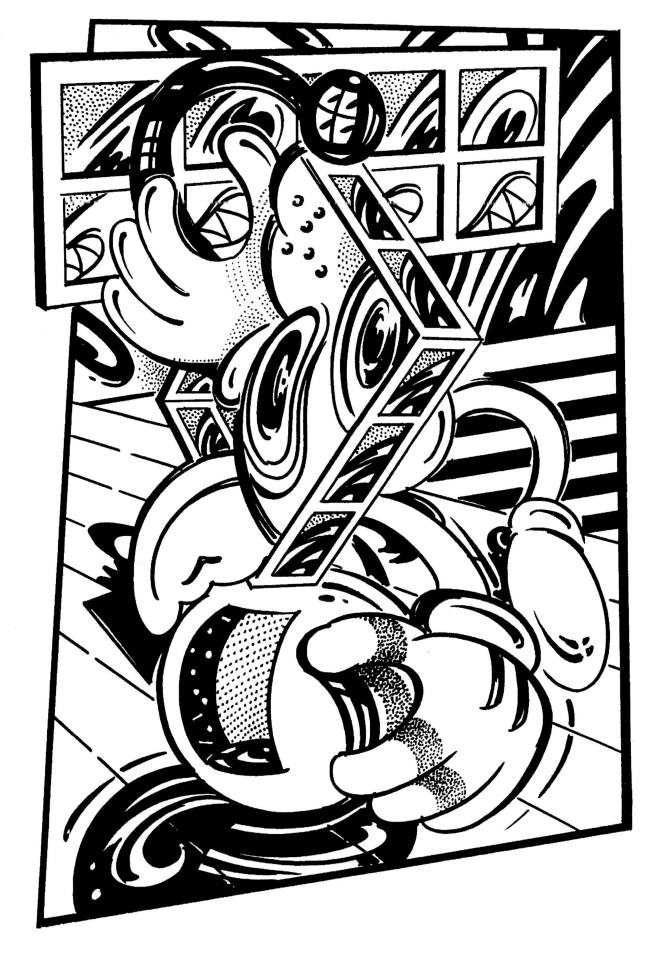

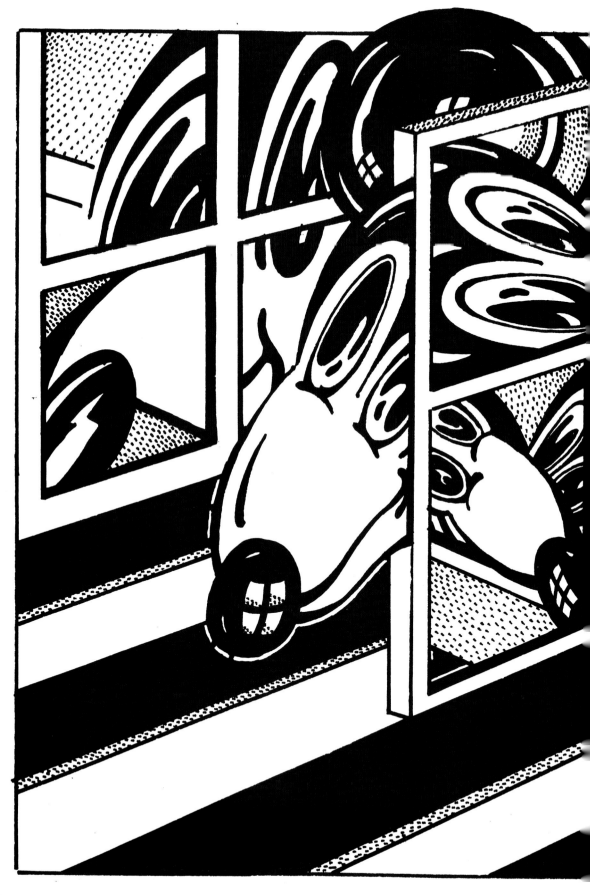

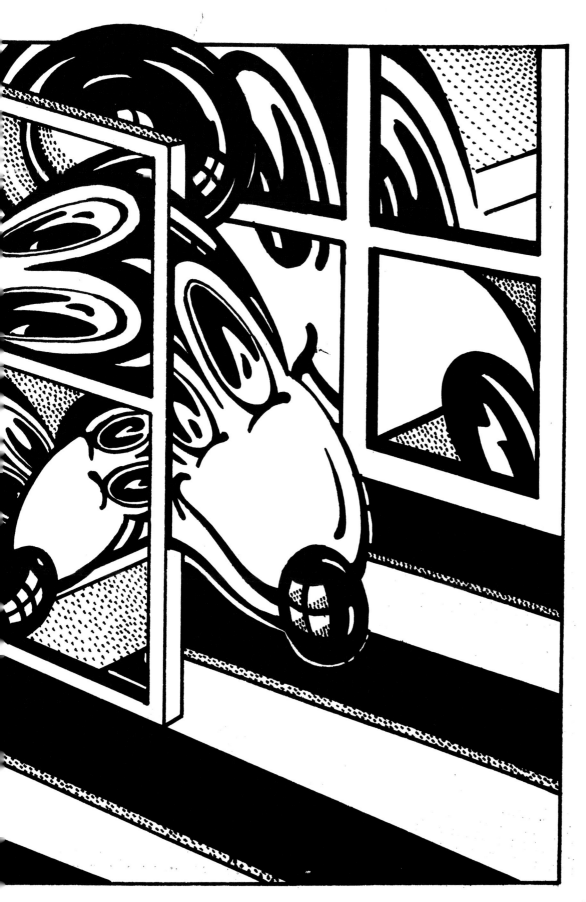

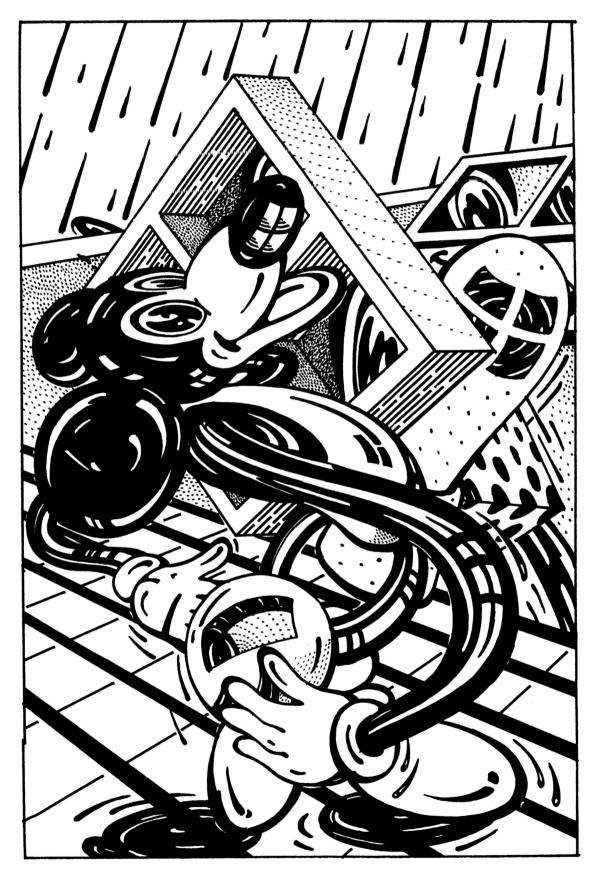

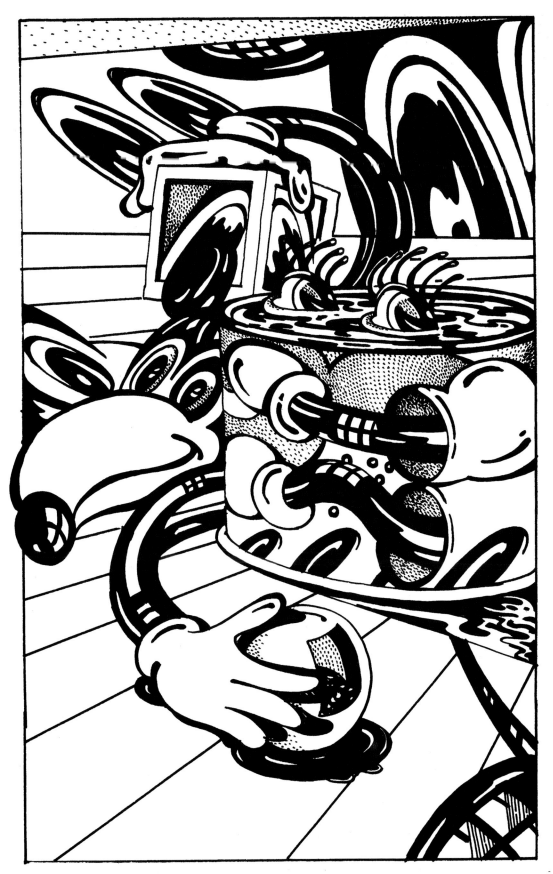

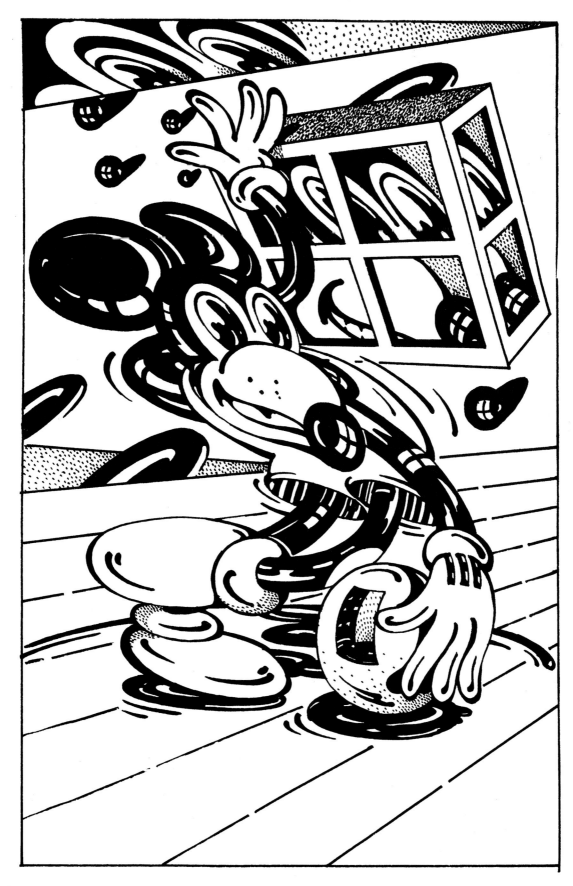

STEVEN HARRINGTON

LOS ANGELES, CA USA

Cited as the leader of a contemporary Californian psychedelic-pop aesthetic, Los Angeles–based artist and designer Steven Harrington is best known for his bright, iconic style that encourages a two-way conversation between the artist and viewer. There's a timeless quality to his playful yet contemplative work, which is inspired by California's mystique, vastly diverse landscape, and thriving mix of cultures. Embracing a multimedia approach, Harrington's portfolio includes large-scale installations made of plaster and stone, handscreened prints, limited-edition books, skateboards, and sculptures. Alongside his personal work, Harrington co-founded both the acclaimed design agency National Forest and pop- art brand "You&I." He has exhibited artwork in Los Angeles, New York, Paris, Berlin, Milan, Barcelona, Tokyo, San Francisco, Chicago, Philadelphia, Montreal, Melbourne, and Dallas.

FACT
1. YOU
2. &
3. I

INDULGENCES A lot of rap music all the time.
NECESSITIES Family, friends, food, cognac and our cat Tucker.
STUDIO ESSENTIALS Warmth, sunshine and positive vibrations.
VISIONS You are I, I am you, we both are one.
INSPIRATIONS The Herman Miller Library.
INFLUENCES Bill Withers, Hemmingway, Charles M Schulz, people that will be relevant forever.
COLOR Seafoam green.
MEDIUM Anything that you can draw with.
UTOPIA Behind a pencil.
NOISE David Byrne, J-Dilla, Arthur Russell, The Congos and Django Reinhardt all played at very loud levels at once.

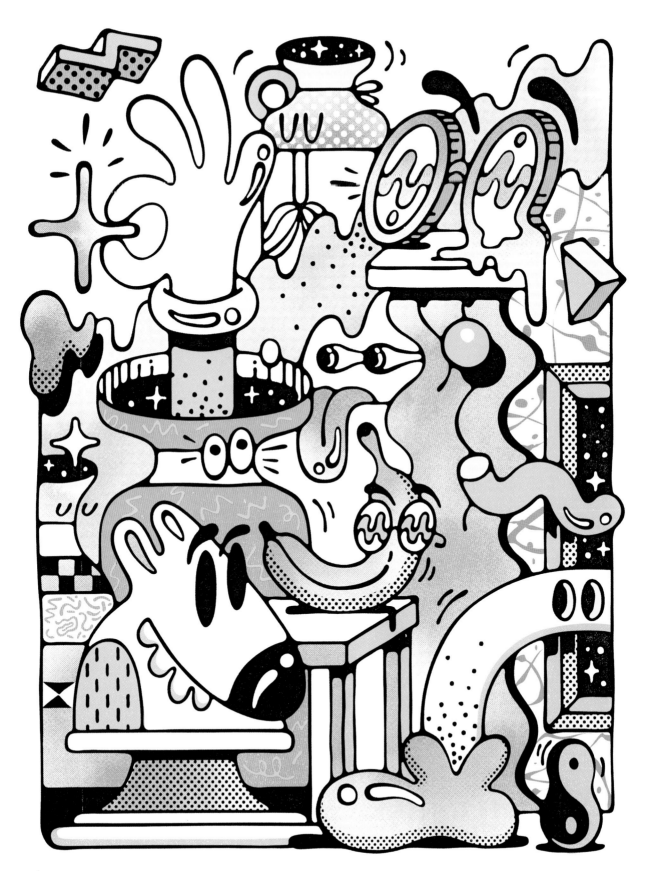

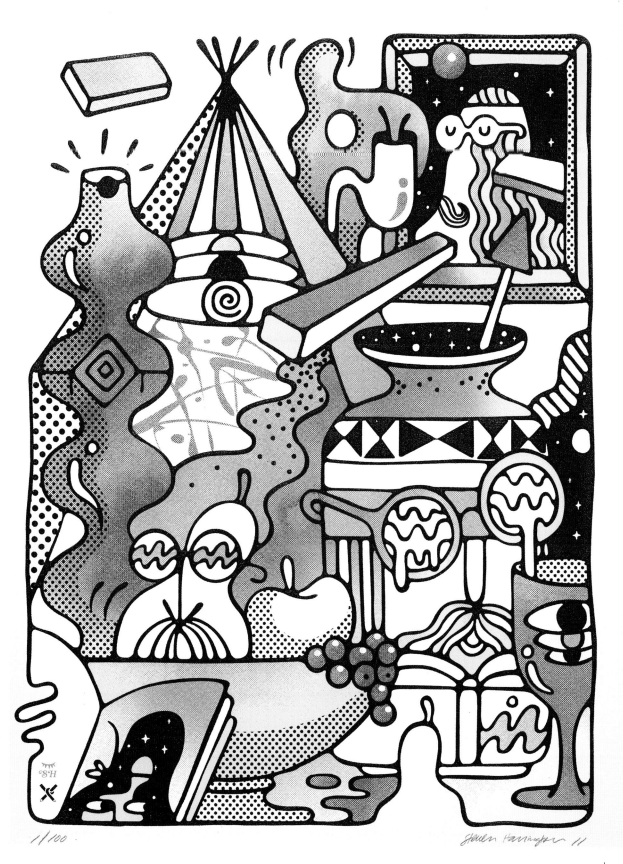

1/100

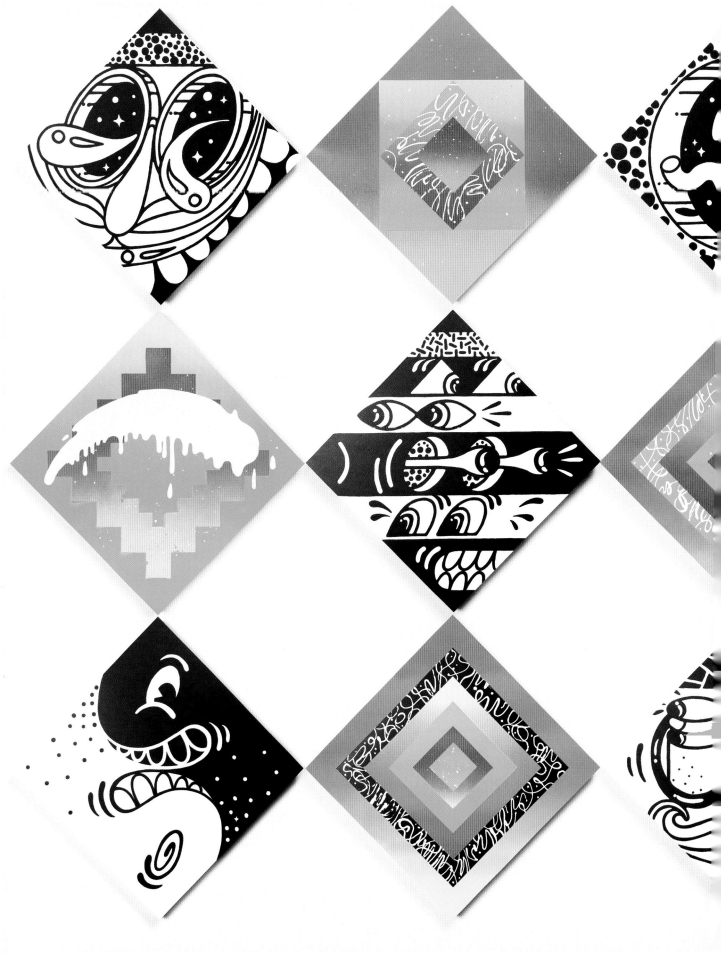

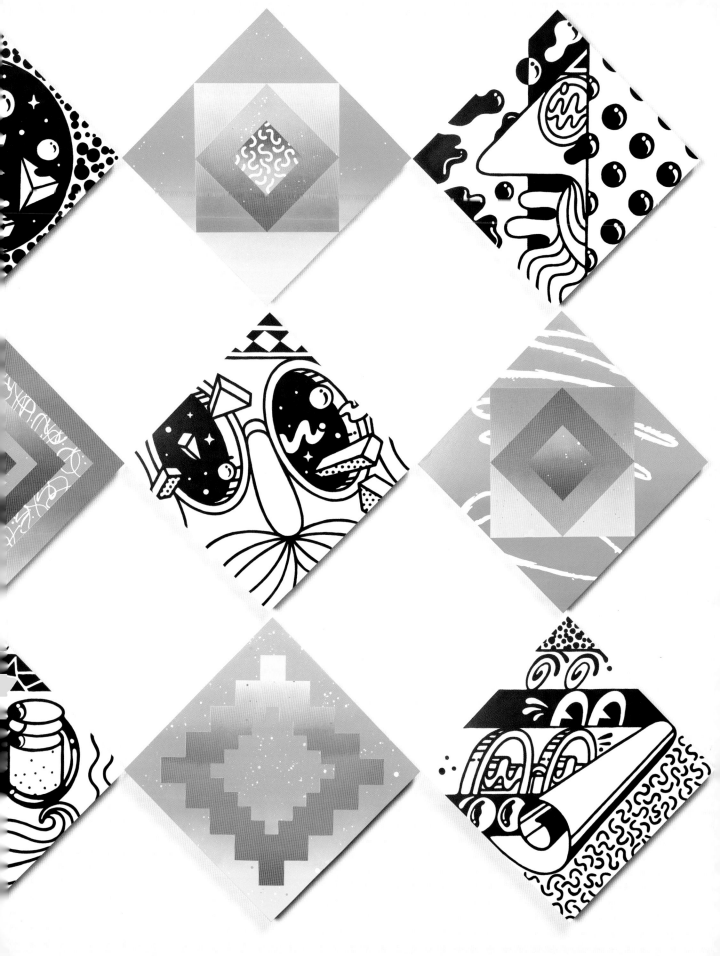

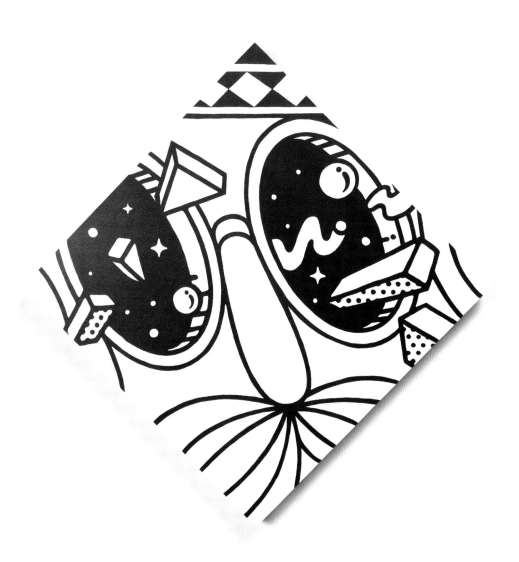

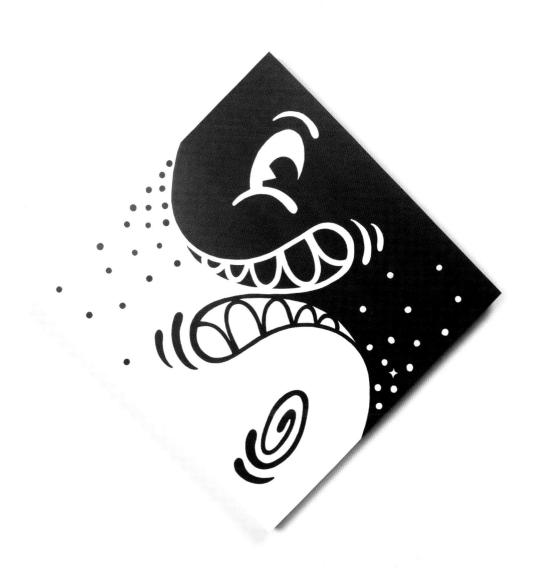

KATHERINE TROMANS

WEST MIDLANDS, UK

Katherine Tromans is an imaginative and colourful designer who lives and works in Birmingham. She is an Illustration graduate from the Arts University at Bournemouth.

FACT
1. My mum was an art teacher and taught me to draw and paint from a young age. At the age of four I used to scribble on the walls of my house in crayon when mum wasn't looking and used to sign it with my brother's name! (He couldn't draw yet, he was only one!)
2. I tend to drink approximately 6 cups of tea a day.
3. I really like watching motorsport, and I follow Formula 1.

INDULGENCES Vintage dresses, art prints, going to gigs, shows and exhibitions.
NECESSITIES Tea, sweet snacks, my music, camera and my sketchpad.
STUDIO ESSENTIALS My iMac, graphics tablet, paints, good quality sketch paper, pencils and my A3 scanner.
VISIONS If I dream it is very rare, but I tend to make up for it in day dreaming!
INSPIRATIONS Old Sci-fi books mainly, as I love the colours and abstract subject matter. I also really like the work of outsider artist, Laure Pigeon; as well as the work of Roger Dean, Linn Olofsdotter and Cicely Mary Barker.
INFLUENCES I love nothing more than to go outside with my camera and take pictures of the different elements of the landscape. I love drawing detailed and colourful flora, as well as rock faces and precious stones.
COLOR I always tend to stick to pastels; particularly peach, dusty pink, lemon and sky blue. I love the way these colours melt together.
MEDIUM Acrylic, watercolour, ink, pencil and digital.
UTOPIA The forest.
NOISE I tend to listen to a range of music, I really like electronic rock like Daft Punk, M83, The Flaming Lips and Tycho as I find this quite moving and inspirational to listen to while I draw. The Tron soundtrack is particularly good to listen to!
PSYCH I tend to find certain songs trigger colours in my mind while I'm working.

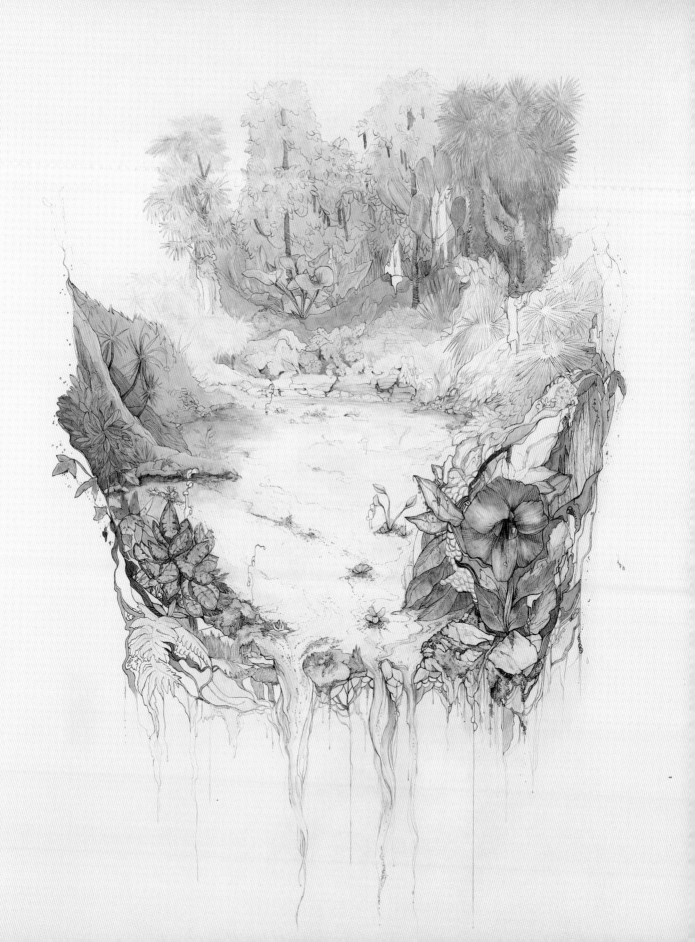

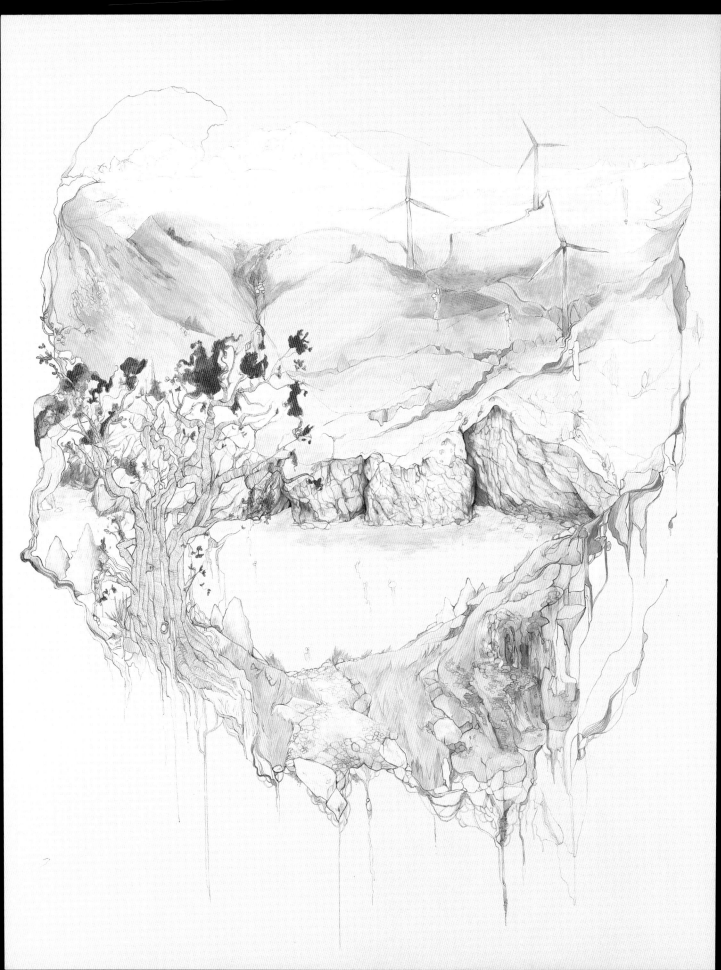

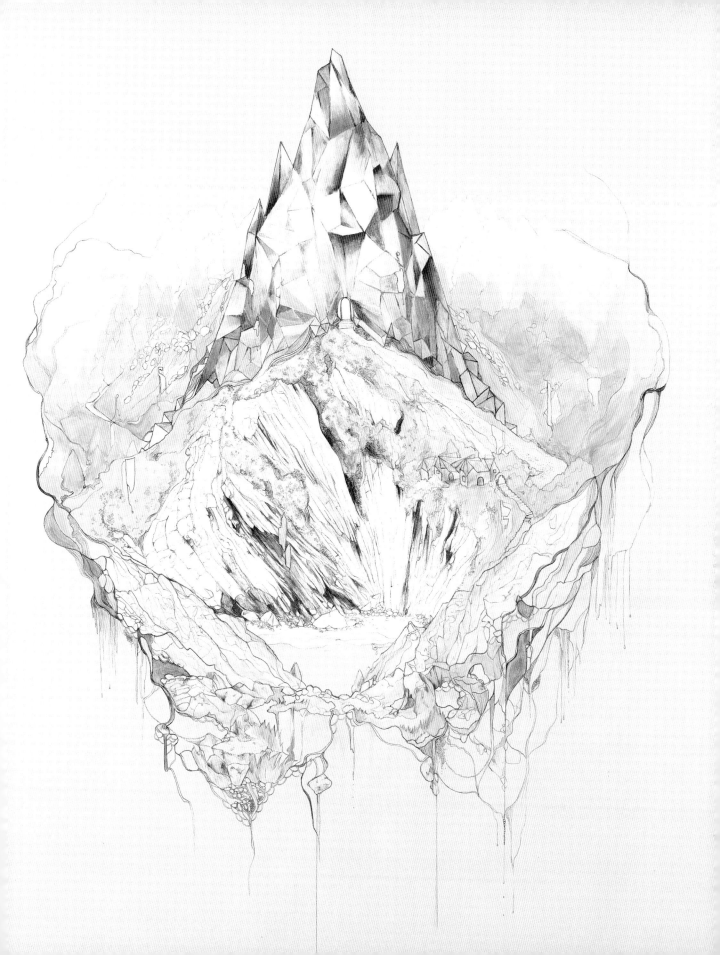

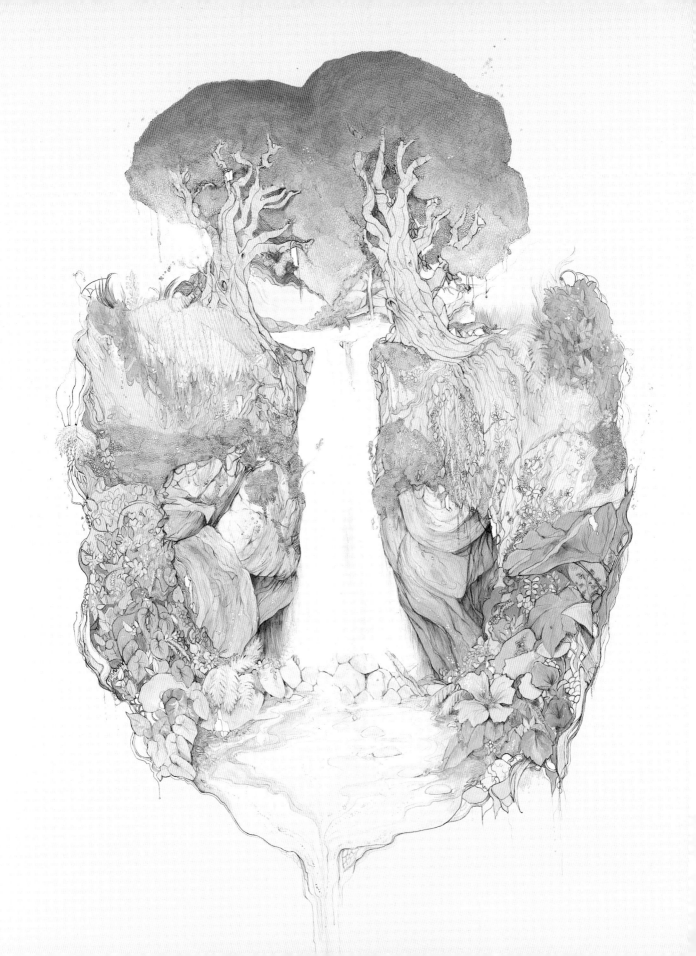

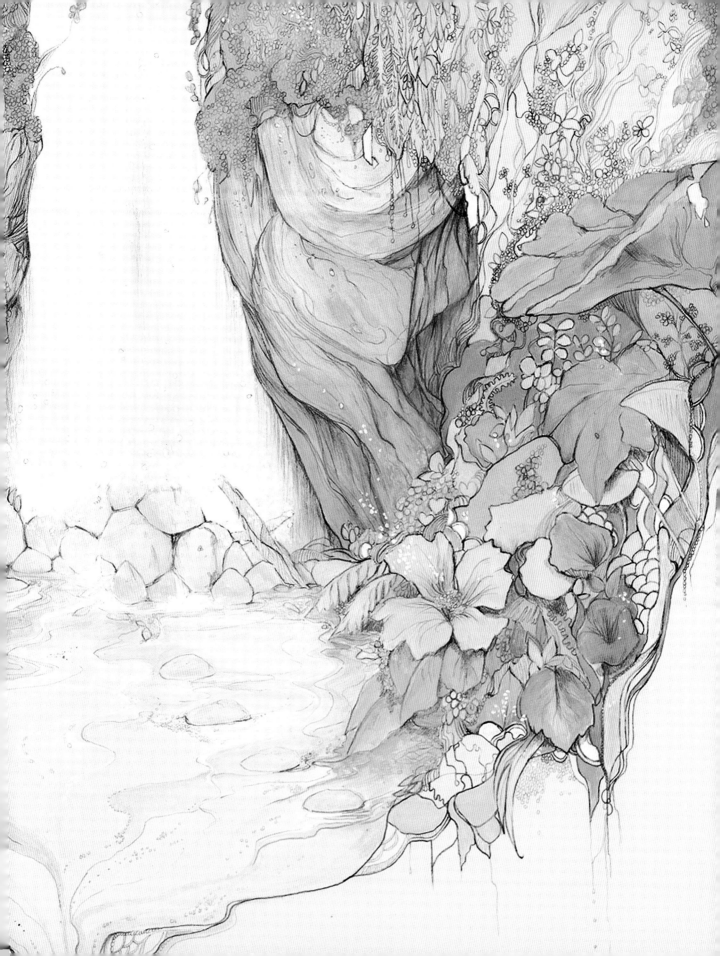

KELSEY BROOKES

SAN DIEGO, CA USA

Kelsey Brookes is a former biochemist who attributes his raw style to an education system "that refuses to teach scientists to draw." Science's loss is art's gain. The work's potency arguably lies in the way its clash of ancient and ultra- modern references downplay the sex and death, which are featured heavily in the work. Brookes describes his art as "an unrefined and, some would say, unskilled mix of sex, comedy and animals which is derived from a true passion for all three, except not necessarily all at the same time."

FACT
1. Idealism and perfection are not human traits.
2. Connecting with nature and with this moment are a good daily practices.
3. Eating healthy and exercising are a good idea.
4. Your path is your guru.

INDULGENCES Surfing and muffins.
NECESSITIES Family, friends, nature, meditation, education and surfing.
STUDIO ESSENTIALS Early starts, south facing windows and long walls.
VISIONS An entire world only smaller, migraine auras, and floaters.
INSPIRATIONS Human visual system during hallucination (natural and induced).
INFLUENCES Surfing, Richard Davidson, Wade Davis, Alexander and Ann Shulgin, Albert Hofmann, Richard Evans Schultes, Oliver Sachs, VS Ramachandran.
COLOR The more colors the better or no color at all. Either way.
MEDIUM Acrylic on canvas.
UTOPIA See necessities above.
NOISE Silence or The Great Courses, NPR, Google Talks, Radio Lab, National Science Foundation, Charlie Rose, Richard Dawkins Foundation, Center For Investigating Healthy minds. Wonderfest, World Science Festival, Librivox.
PSYCH Daily meditation, frequent migraine aura hallucinations. The older I get the less interested I am in inducing these experiences via exogenous means, but I did go through an experimental phase during college.

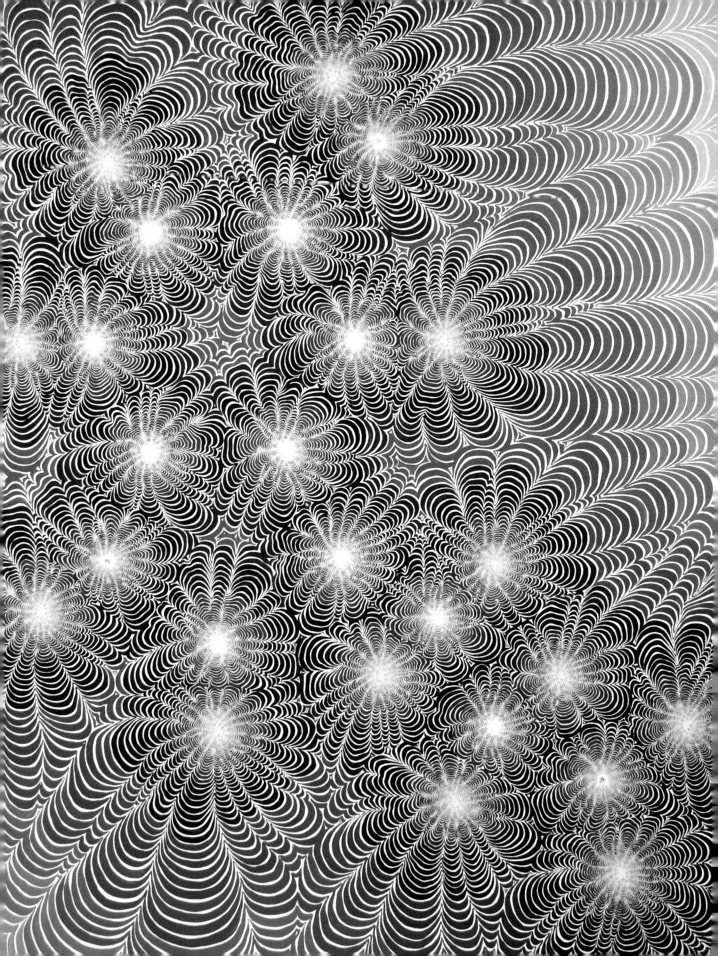

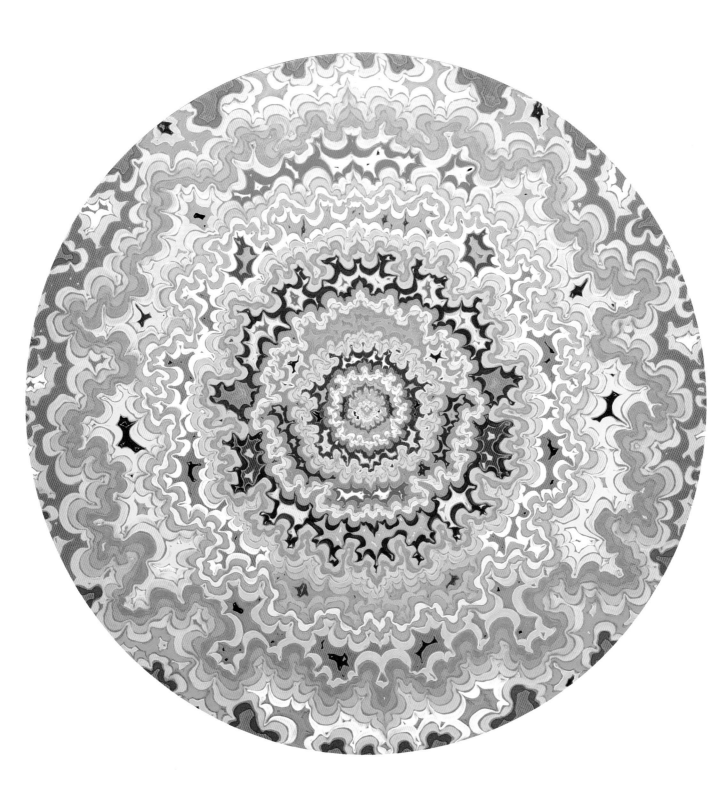

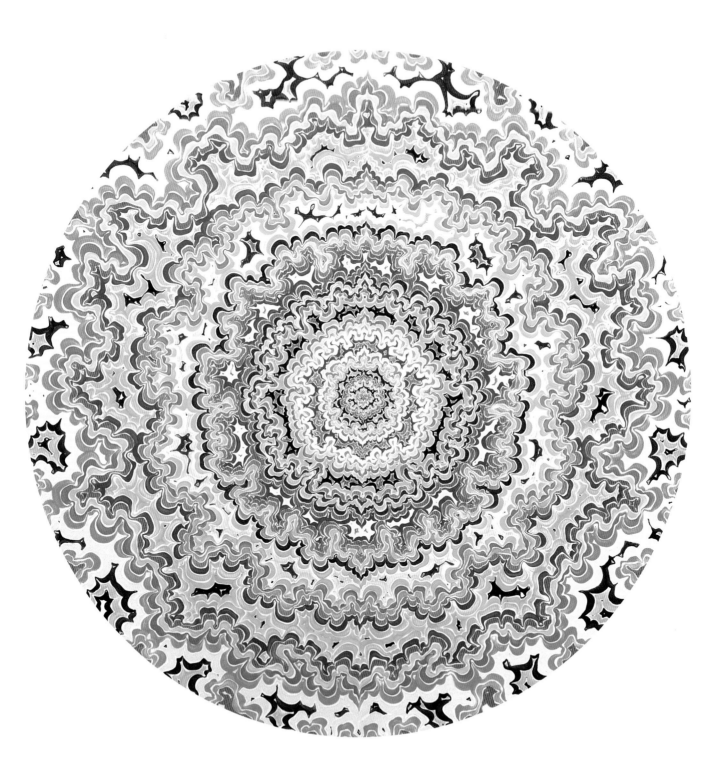

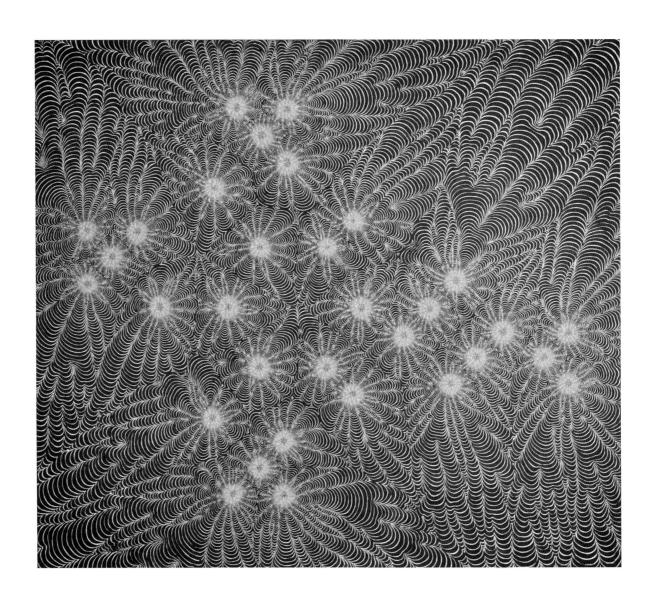

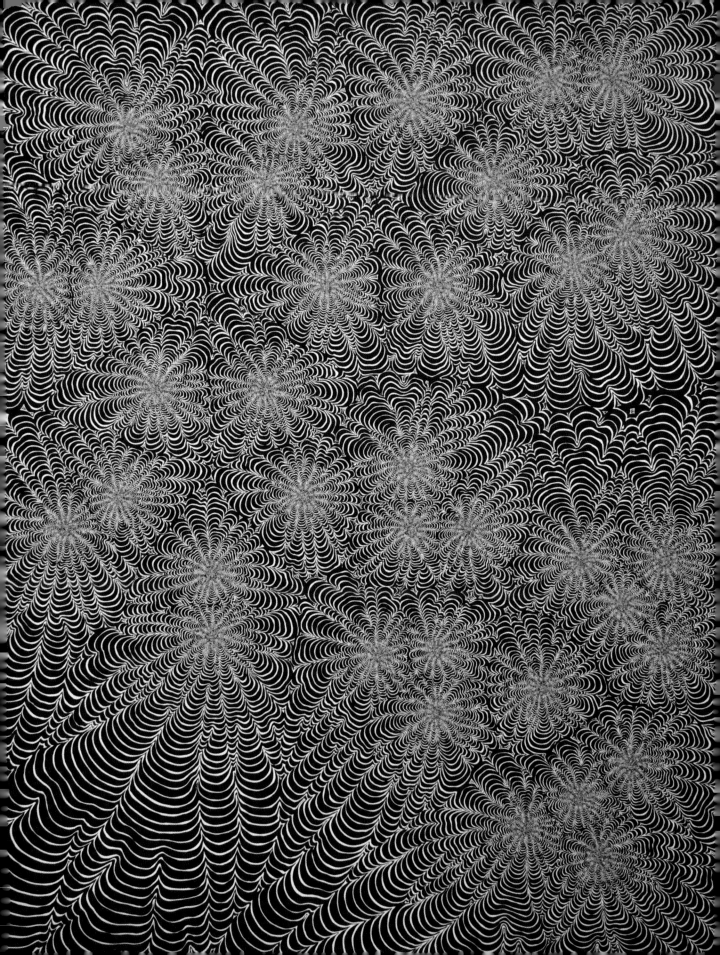

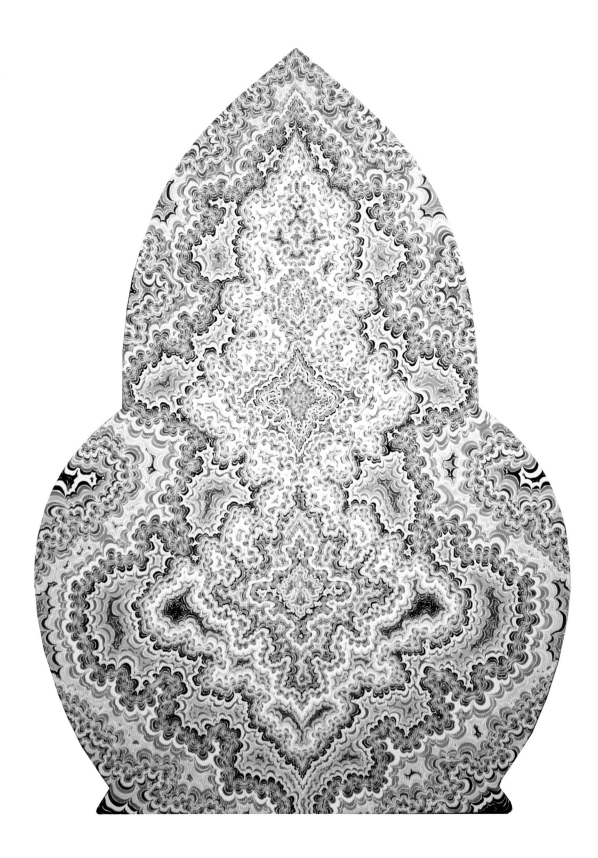

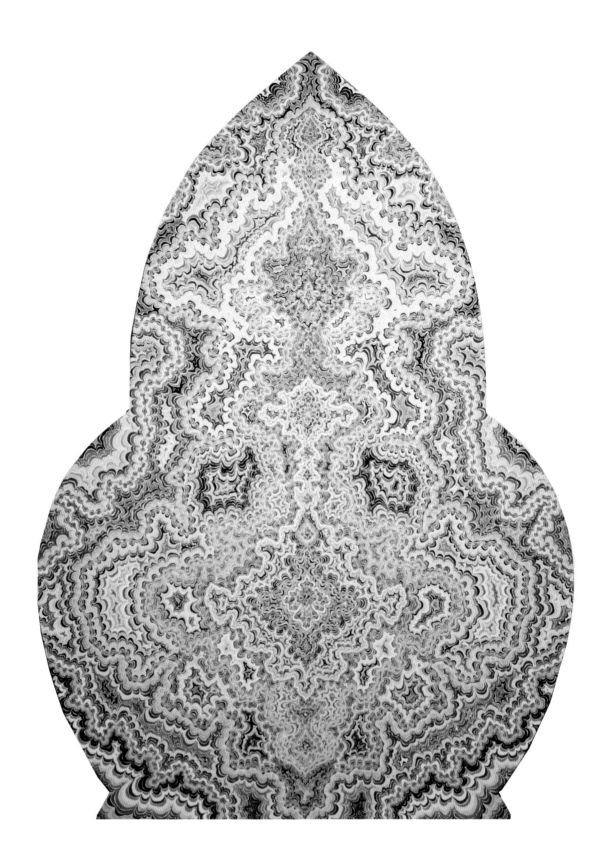

ALEX GREY

NEW YORK, NY USA

Alex Grey is a world-renowned artist, poet, and author. His books, Sacred Mirrors, The Mission of Art, Transfigurations, Art Psalms and Net of Being, trace the development of his work and the mystical experiences that have shaped his personal, spiritual, and artistic life. His artwork is on view at CoSM, Chapel of Sacred Mirrors, a 40-acre interfaith church 65 miles north of New York City, that celebrates creativity as a spiritual path.

Why Visionary Art Matters

1. Visionary mystical experiences are humanity's most direct contact with God and are the creative source of all sacred art and wisdom traditions.

2. Mystic visionary artists distill the multi-dimensional, entheogenic journey into externally crystallized theophanies, icons embedded with evolutionary world views. Since mystic visionary artists paint the transcendental realms from observation, their work offers a growing body of evidence substantiating the divine imaginal realms and by extension, Spirit itself.

3. The mystic state described by visionary artists includes images of unity, cosmic oneness, transcendence of conventional space and time, a sense of the sacred in having encountered ultimate reality, positive affect, vivid color and luminosity, symbolic pattern language, imaginal beings and infinite geometric jewel-like vistas.

4. For pilgrims to the sacred inner dimensions, visionary art provides validation for their own glimpses, and proves the universal nature of the imaginal realms. Reflecting the luminous richness of higher spiritual worlds, visionary art activates our light body, empowers our creative soul, and stirs our deepest potential for positive, transformative action in the world.

5. Humanity's materialistic worldview must transition to a sacred view of Oneness with the environment and cosmos or risk self-destruction due to continued abuse of the life-web. Artworks can call us to imagine our higher unity as humanity evolves toward a sustainable planetary civilization.

6. Mystic Visionary Art is a product of the Primary Religious Experience. The word religion comes from the Latin religio, "reverence for the Gods," and the French, "re-ligare" meaning "to tie back." The Primary Religious Experience is a personal connection with Source that "ties us back" to our own divinity.

7. Entheon means a place to discover the God within. Entheon, Sanctuary of Visionary Art at CoSM will honor and preserve visionary artworks that point to our common transcendental source.

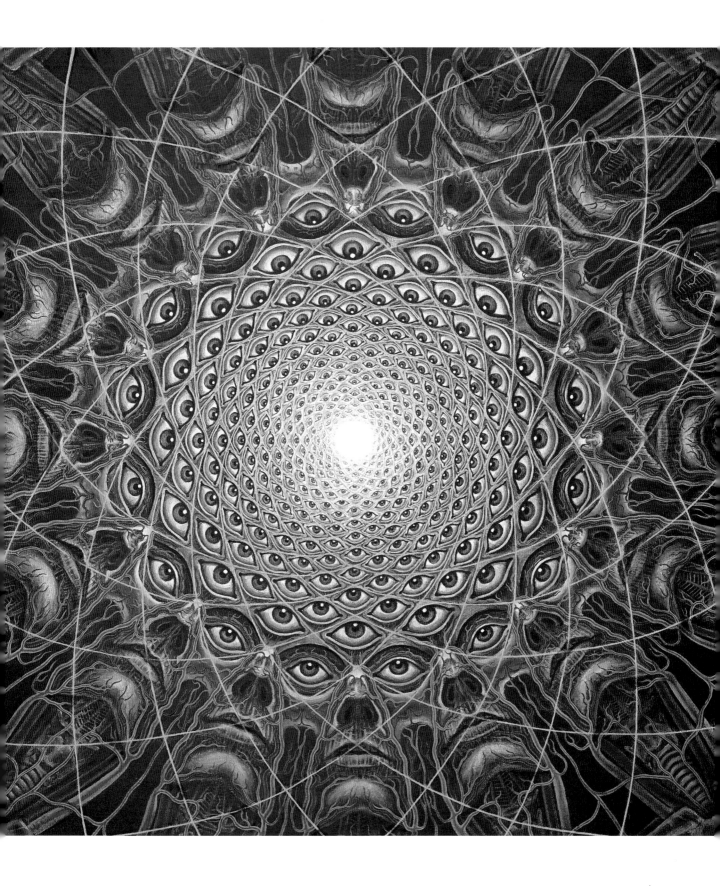

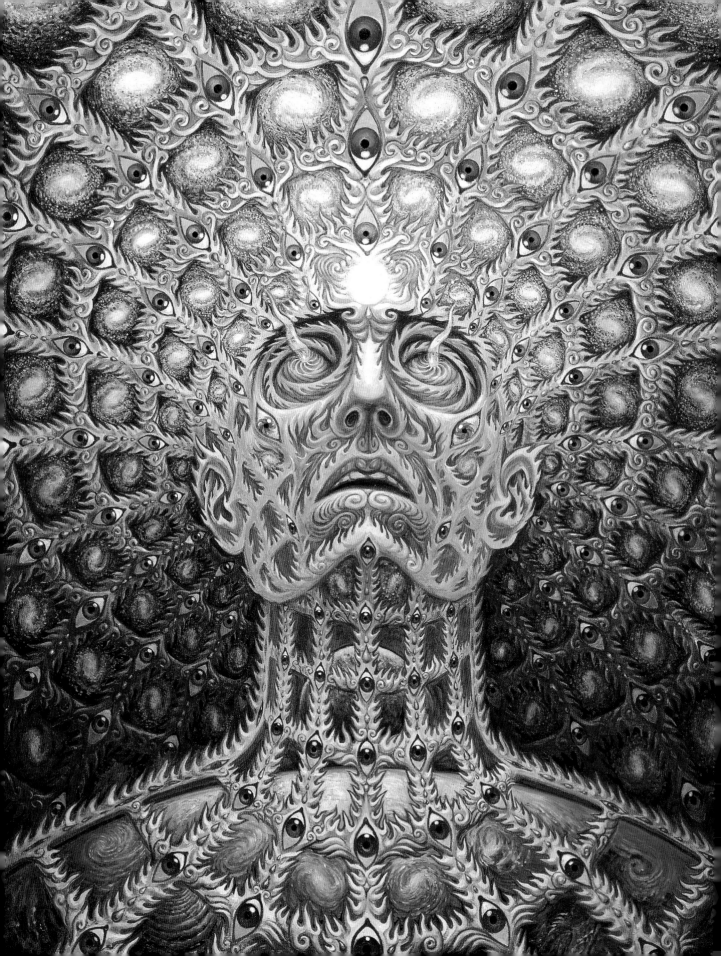

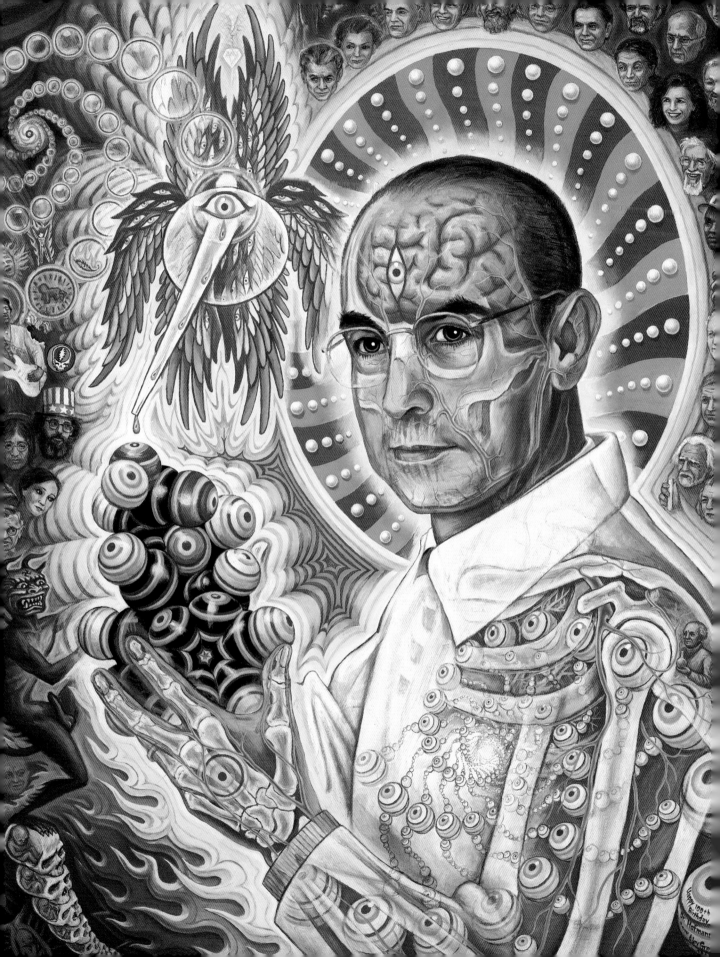

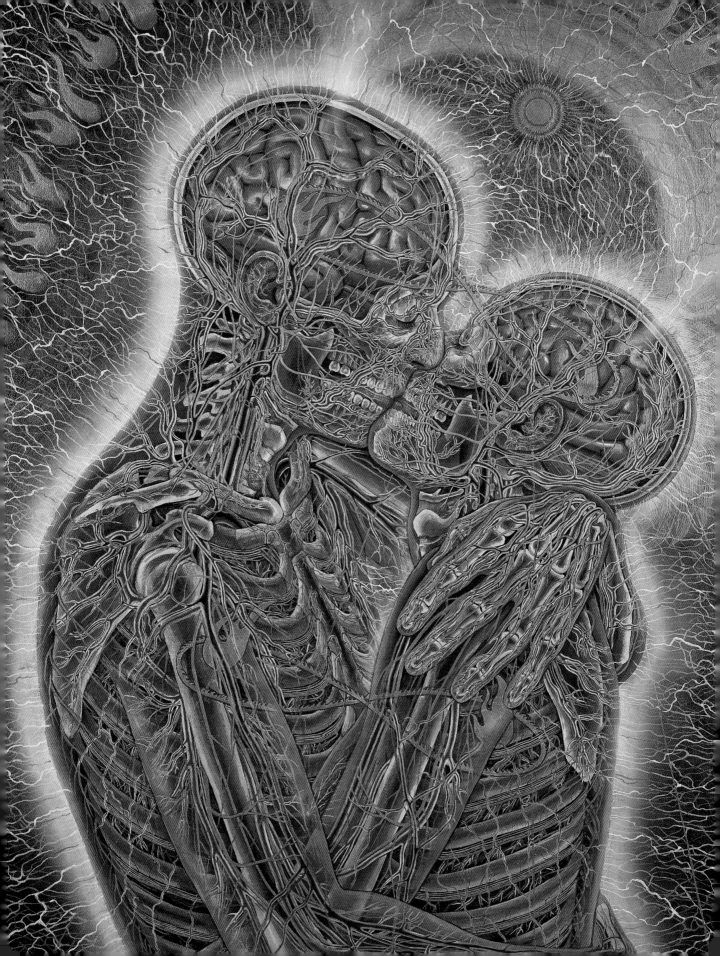

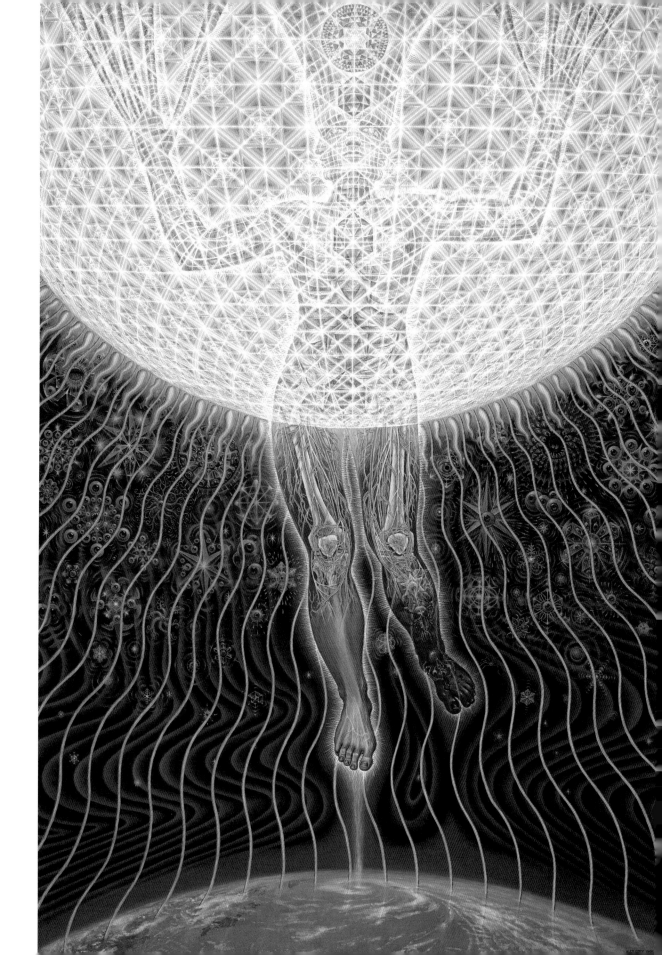

KYLEA BORGES

SAN FRANCISCO, CA USA

Kylea Borges was born and raised on the central coast of California. Most of her early years were spent camping in Big Sur or backpacking in Yosemite while acquiring an appreciation for nature as it was meant to be experienced. At a young age, Kylea started experimenting with collage with the influence of her grandmother and played with it on and off through the years. In her current works, the artist brings together her observations from nature and textiles and marries them in an elegant marriage of natural geometry.

FACT
1. When I was nine I broke my two front teeth in a swimming pool on New Year's Day.
2. 'Wayne's World' is still my favorite movie.
3. Tacos are miracle food.

INDULGENCES Bad reality TV, calimocho and pottery that looks like it was made by your mother.
NECESSITIES Headphones, tacos, tacos, my dog, tacos.
STUDIO ESSENTIALS 56 exactos, several clear rulers, 4 cutting mats, a variety of shape templates and a stack of old magazines... just add jams.
VISIONS Shapes, symbols, colors, patterns, space...
INSPIRATIONS Artists that have influenced my work would include Bruce Conner, Jess, Ray Johnson and John Baldessari, Yayoi Kusama among countless others.
INFLUENCES Lately I've been really into crop circles, but also am inspired by vintage textiles and patterns, pyramids, space, quilt patterns, optical art and cats on pyramids in space.
COLOR Gold, orange, bright blue... and black of course.
MEDIUM Paper!!
UTOPIA The forest.
NOISE Favorite bands to listen to while working / on my way to work or on public transportation: OM, Witch, //Tense//, WITTR, Electric Wizard, Happy Mondays, Gatekeeper, Nitzer Ebb, PTV, Front Line Assembly and Nausea.

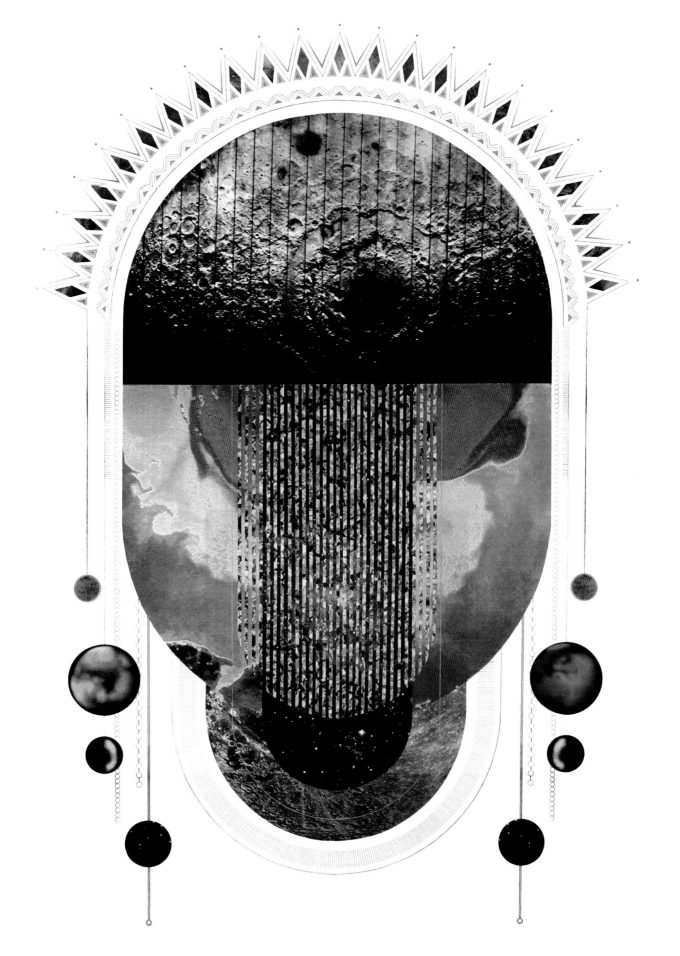

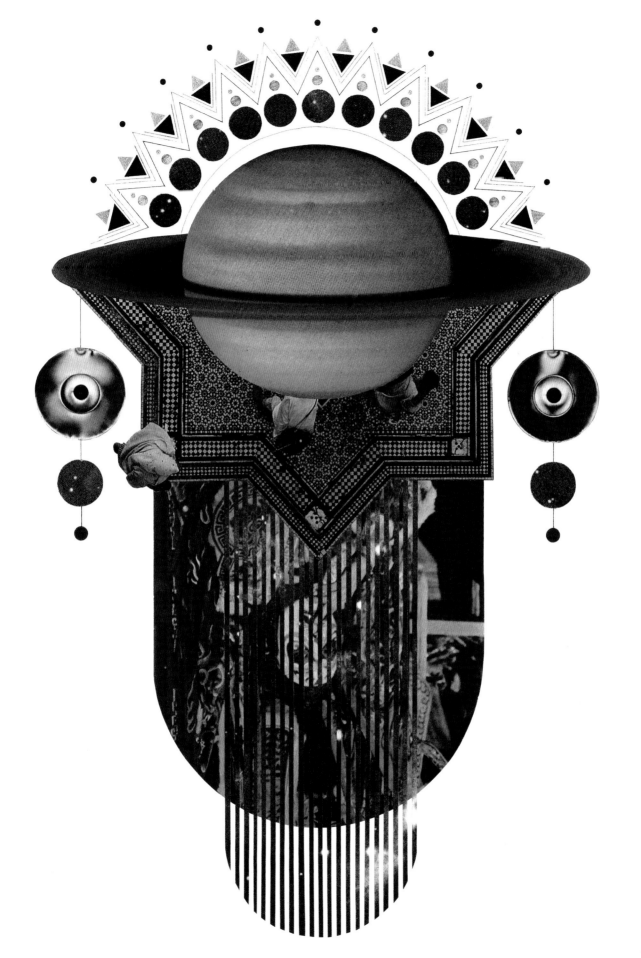

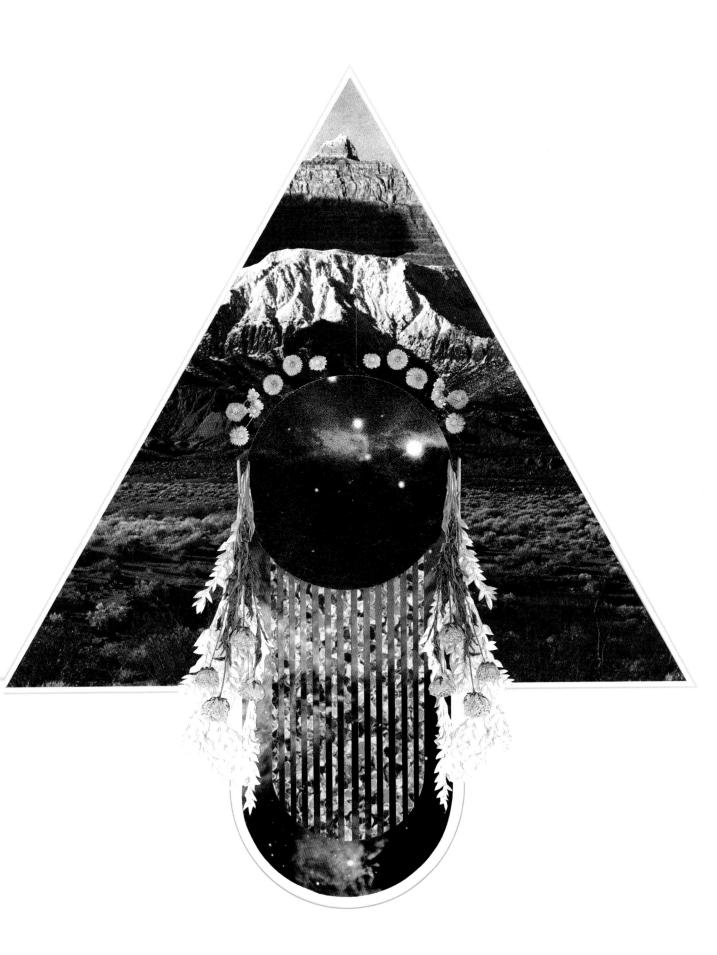

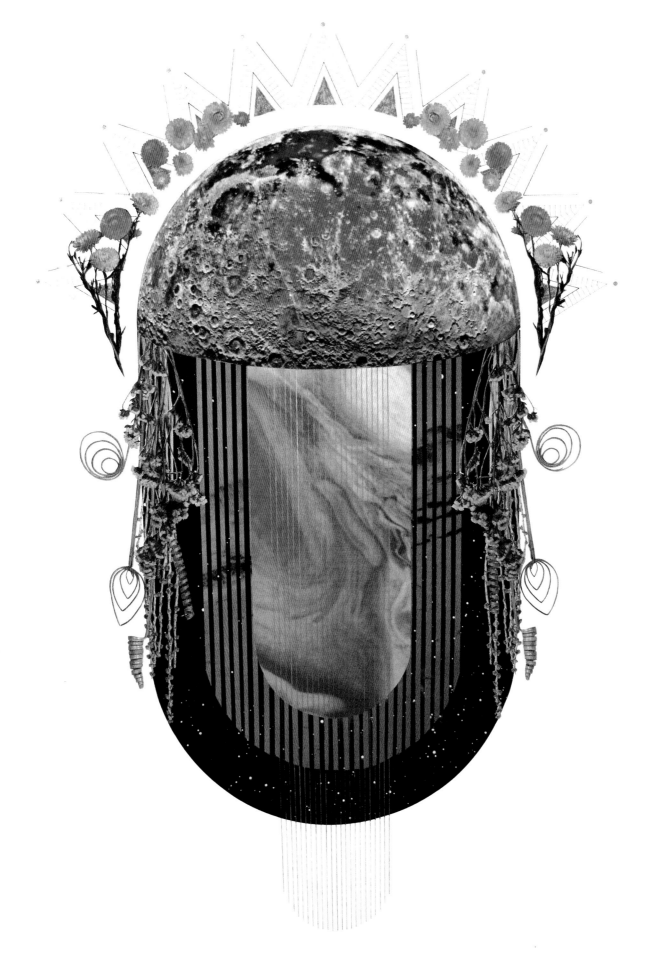

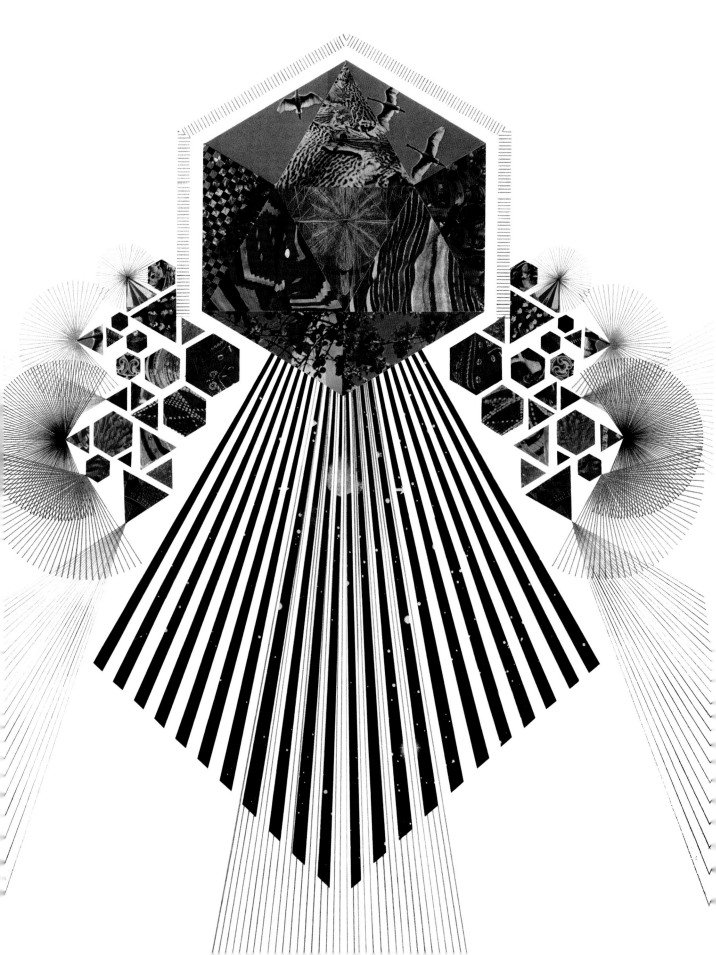

ERIC SHAW

BROOKLYN, NY USA

Eric Shaw's most recent gouaches present a pop-suprematist take on conventional portraiture. In these highly stylized paintings, bold shapes come together to form inscrutable human faces, expressive of an almost robotic emotional ambivalence. Reified brush strokes float motionlessly across the surface of the paintings, held in place by abstract armatures that defy dimensionality. Landscapes reduced to swaths of blue and green give a vague sense of place to these anthropomorphic forms, and architectural cues act to thematize the viewer's conflicting impressions of depth and flatness.

The psychedelic compositions create multiple levels of depth within Shaw's geometrically defined super-flat style, particularly within his abstract works. The paintings are self-referential, allowing common motifs and gestures to form part of his distinctive vernacular.

Eric Shaw's work is playfully reminiscent of 1980s graphic design and early digital animation, but never succumbs to the pitfalls of direct referentiality. Imagine El Lissitzky equipped with a Quantel Paintbox, imbuing his inner demons with a touch of technicolor confection and good cheer.

FACT
1. Born in 1983.
2. Is an entirley self-taught artist.
3. Has shown at Space 1026- Philadelphia, Park Life- San Francisco, Yes Gallery- Brooklyn, Pen to Paper- Berlin and Double Break- San Diego.

INDULGENCES Expensive alcohol.
NECESSITIES Shoes, keys, phone, coffee and food.
STUDIO ESSENTIALS Coffee, kombucha, coconut water.
VISIONS Stepping into Instagram accounts.
INSPIRATIONS Plants and architecture.
INFLUENCES Being a bad drummer and working on my calf muscles.
COLOR All color.
MEDIUM Gouache on paper.
UTOPIA Studio.
NOISE Rap, rock, r&b, top 40, jazz, reggae.

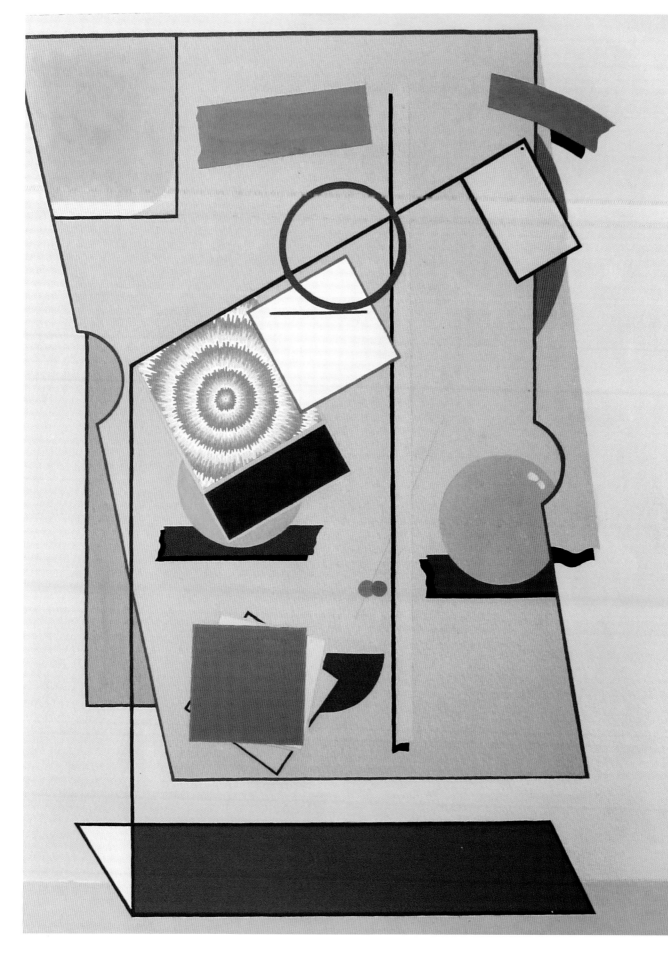

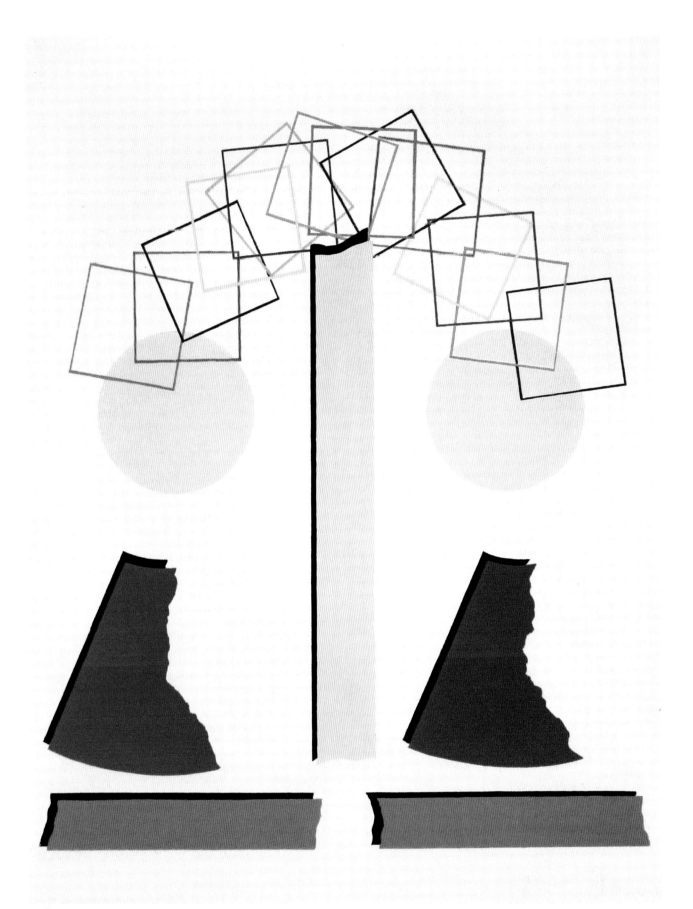

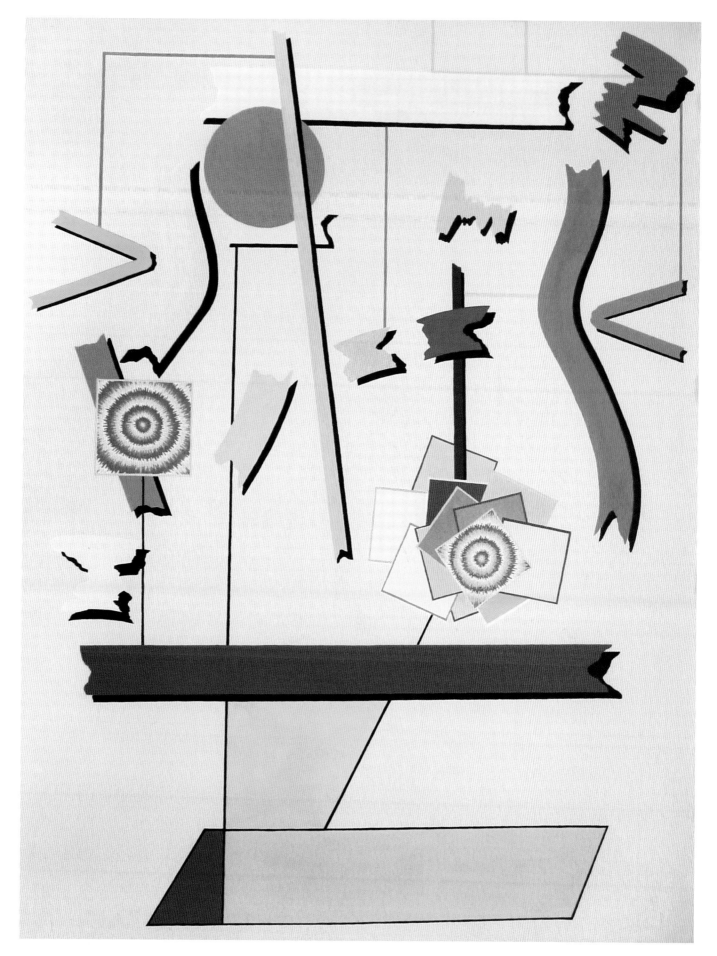

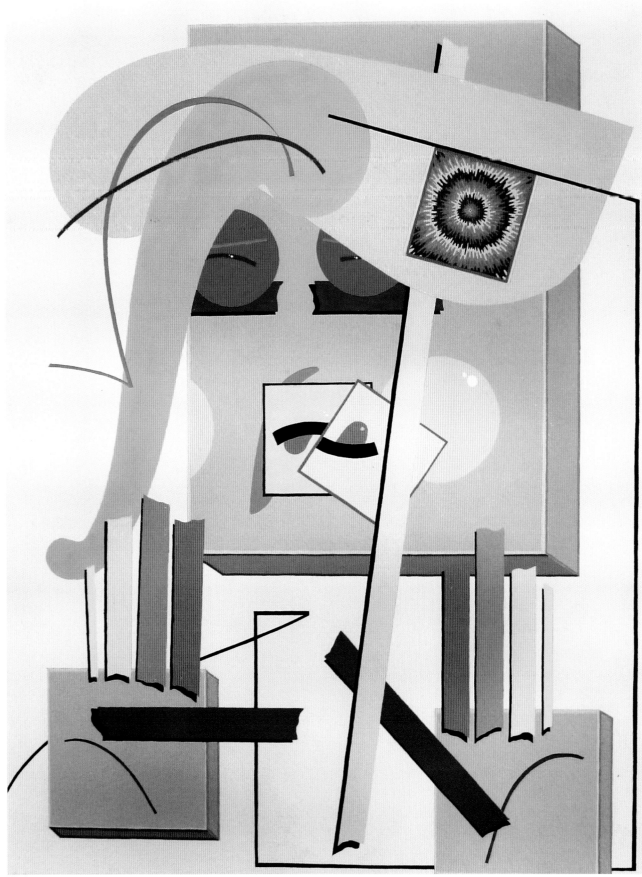

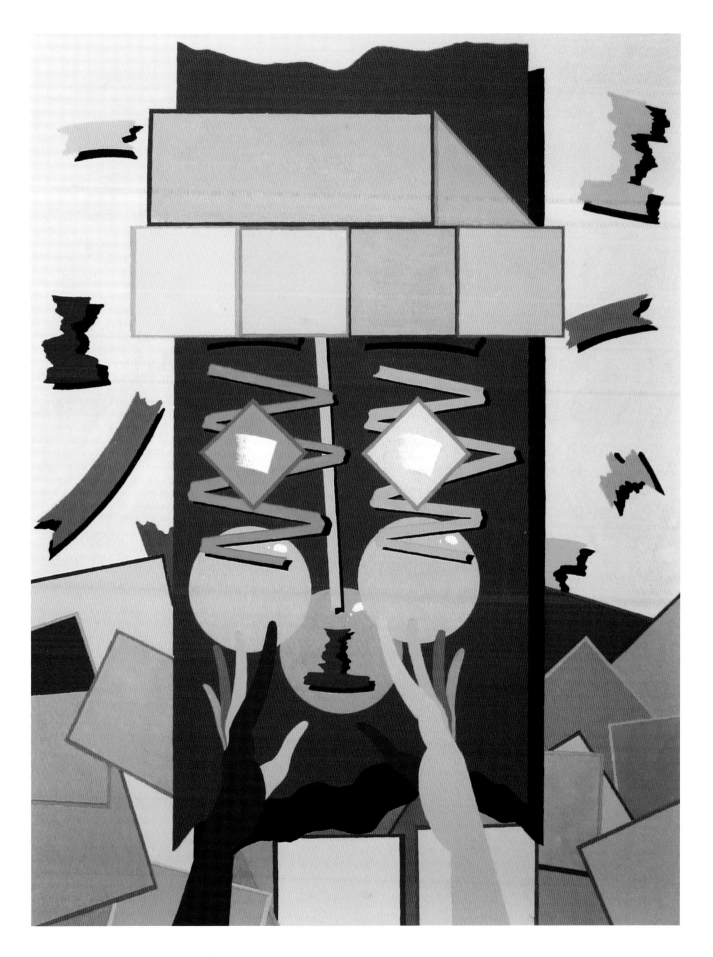

OLIVER HIBERT

SCOTTSDALE, AZ USA

American artist Oliver Hibert, was born in Seattle, Washington in 1983. Hibert has shown his paintings in numerous galleries, museums and retail stores around the globe. Hibert also prides himself as an illustrator / designer who has worked with many top-notch and commercial clients ranging from Nike to The Flaming Lips. Currently, Oliver Hibert resides in Scottsdale, Arizona on his desert farm of cacti and albino peacocks.

FACT
1. The act of swimming is strange.
2. U.F.O.'s are stranger than the act of swimming.
3. I cannot communicate telepathically with spiders.

INDULGENCES Coffee, cigarettes, green stuff, cereal, Nintendo.
NECESSITIES Coffee, cigarettes, green stuff, cereal, music.
STUDIO ESSENTIALS Coffee, cigarettes, green stuff, music and incense.
VISIONS Colorful, scary, amazing things.
INSPIRATIONS Anything full of color, bold, weird, dark, light, op, psychedelic, cartoons, etc.
INFLUENCES Eyeballs, creatures, rainbows, death, pyramids, mouths, lips, teeth, hands.
COLOR Lots of black and whites lately. My favorite color is orange, though, there isn't a color that I don't like.
MEDIUM Acrylic paint, wood, canvas, pencil, paper, digital.
UTOPIA Home.
NOISE Music, music, all of the time. Music, music, so many kinds. Depends on the mood, don't you know? The sound's always better, the higher you go..
PSYCH Yes.

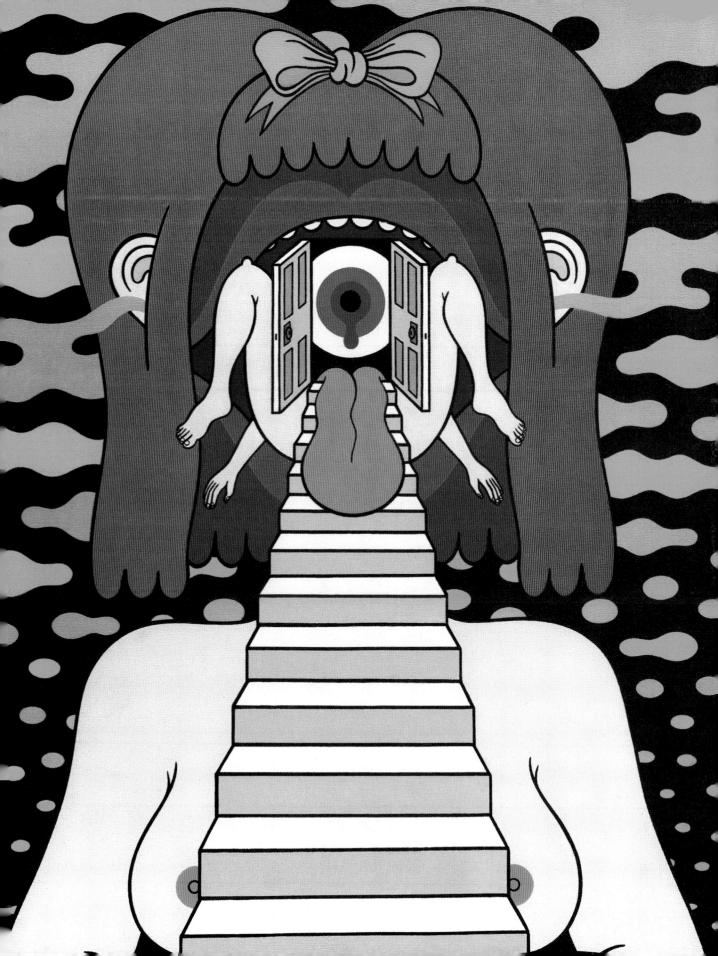

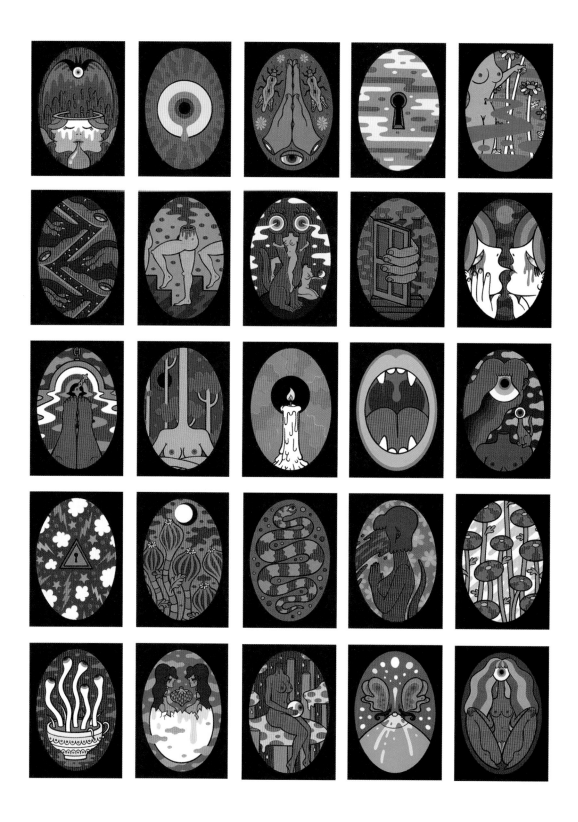

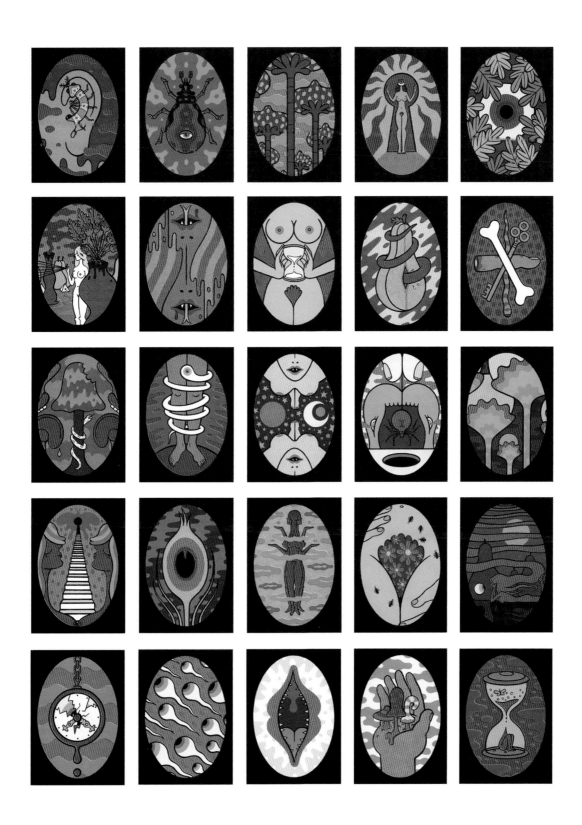

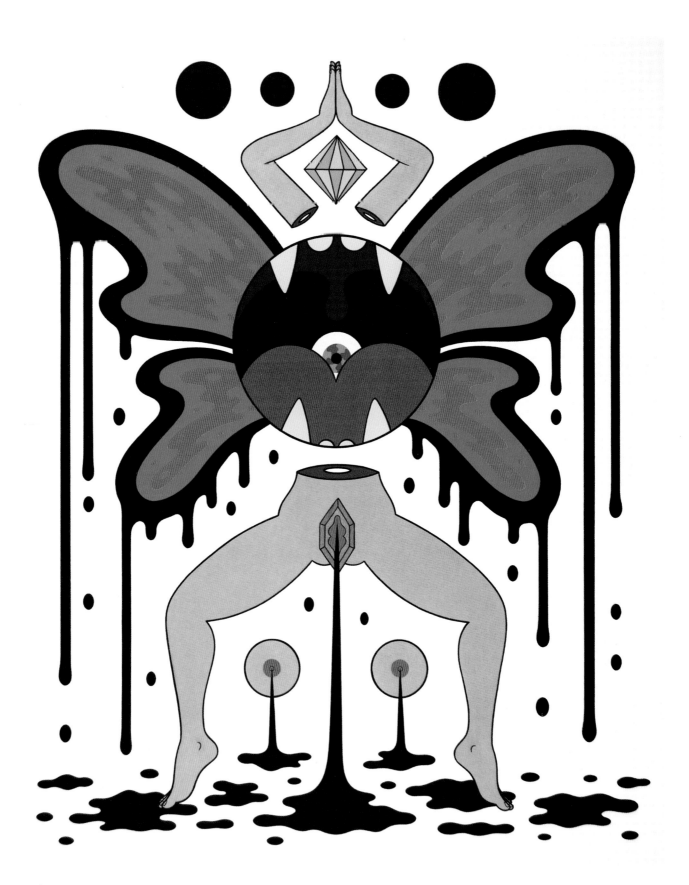

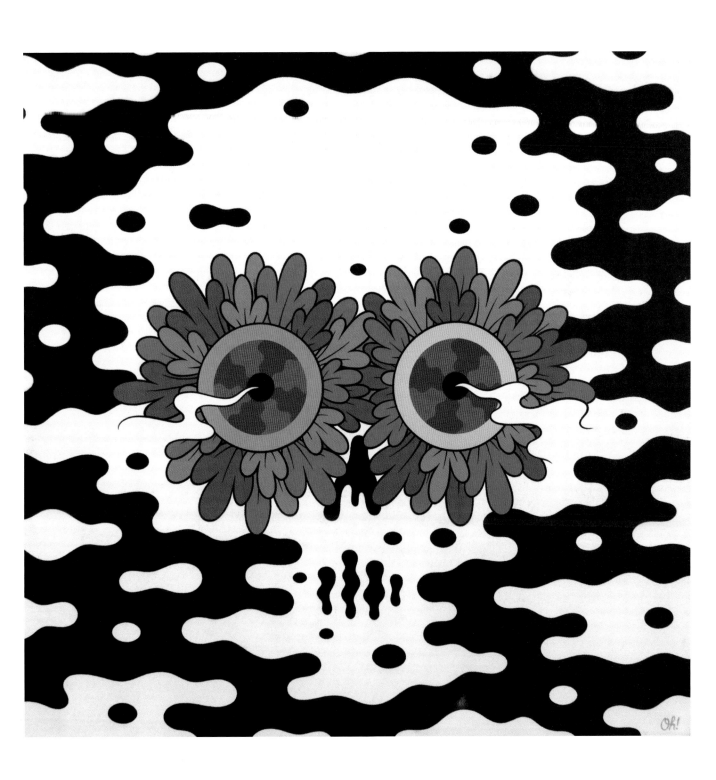

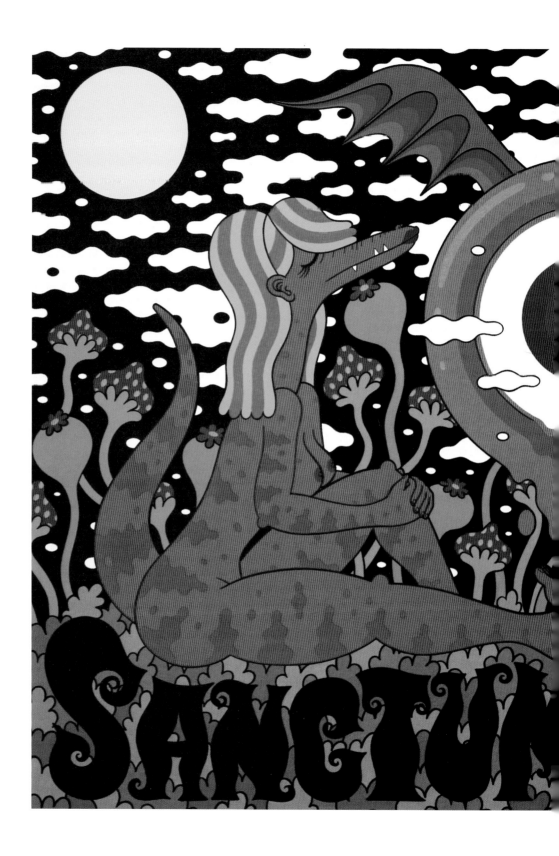

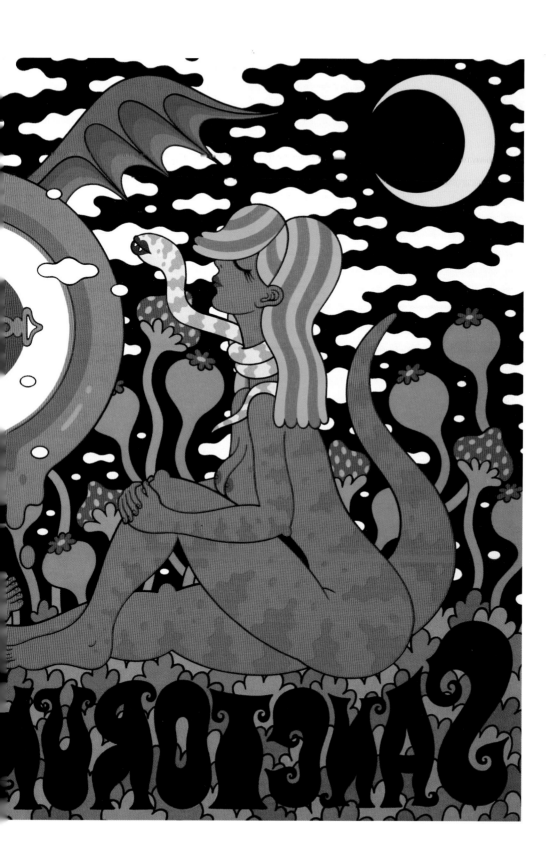

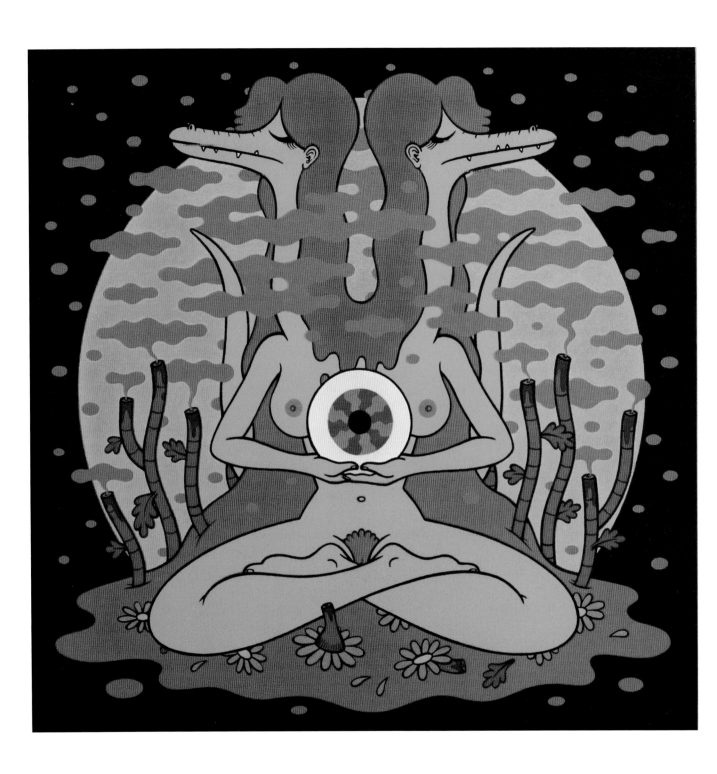

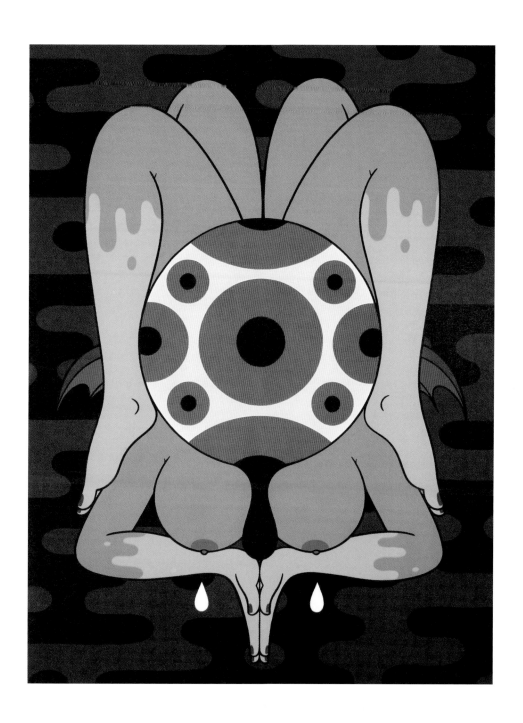

KEIICHI TANAAMI

TOKYO, JAPAN

Born in 1936 in Tokyo, Keiichi Tanaami went on to graduate from the Musashino Art University college of design. He is currently working as a professor at Kyoto University of Art and Design and has been since 1991.

Tanaami continues to create an inexhaustible array of works including paintings, sculpture, and animation, exhibits at galleries and museums around the world, and has works housed at Hamburger Bahnof in Berlin, and boasts an international reputation that receives increasing acclaim every year.

FACT
1. Tanaami's works have appeared in magazine features and on the covers for Wallpaper (2007), WeAr (2008), Hot Rod (2008), and Dazed & Confused.
2. 2013 collaboration with Stussy.
3. Worked as Art Director for Monthly Playboy magazine starting in 1975.

INDULGENCES Drinking in the red-light district of Kyoto.
NECESSITIES Pencil (To record the dream and memory)
STUDIO ESSENTIALS Imagination and muscle.
VISIONS The present, past, future. I am seeing everything.
INSPIRATIONS The present, past, future. I am seeing everything.
INFLUENCES To get drunk and look around with the befuddled mind.
COLOR The three primary colors.
MEDIUM Cheap paper.
UTOPIA My studio in Tokyo.
NOISE Whatever makes sound.
EXPERIENCE The wartime in my childhood. The unimaginably cruel days during the air raid.

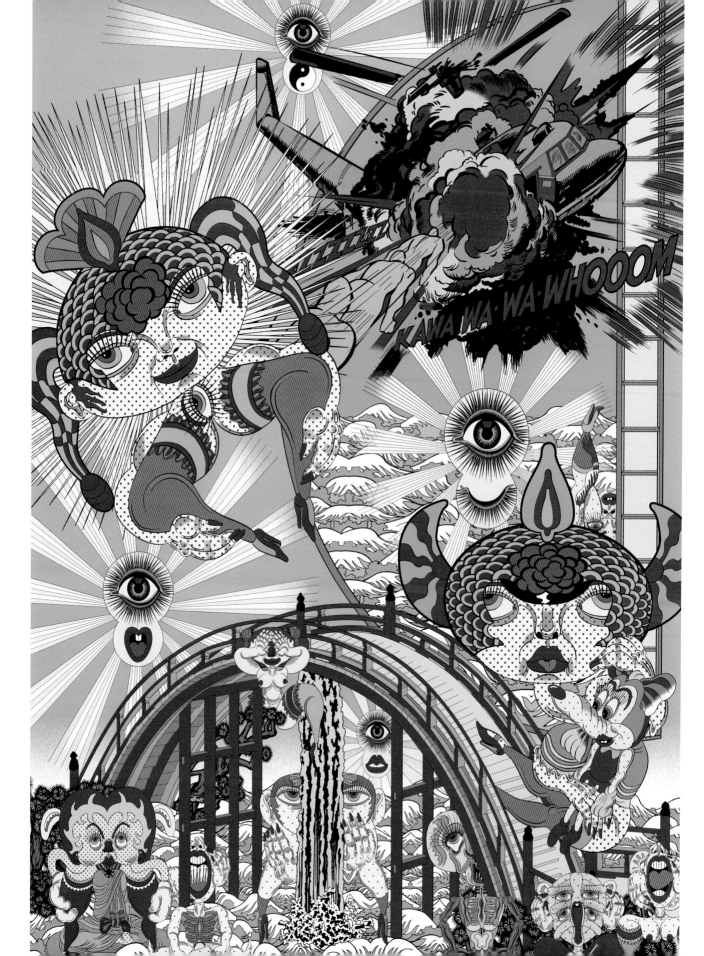

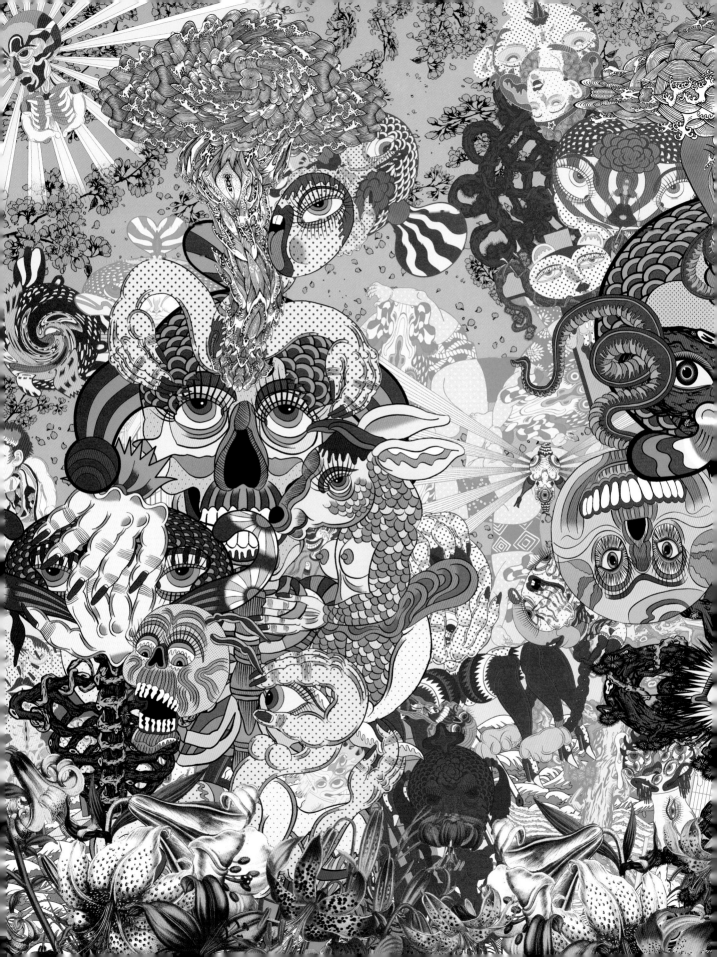

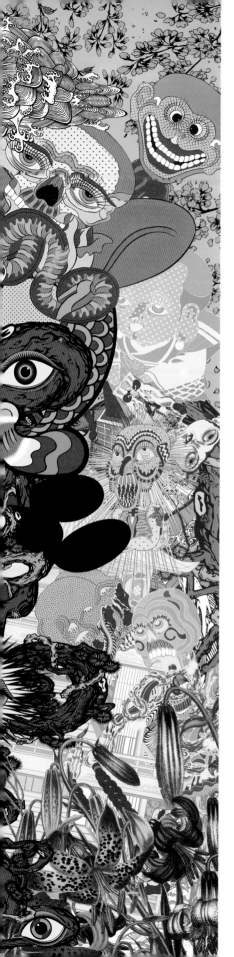

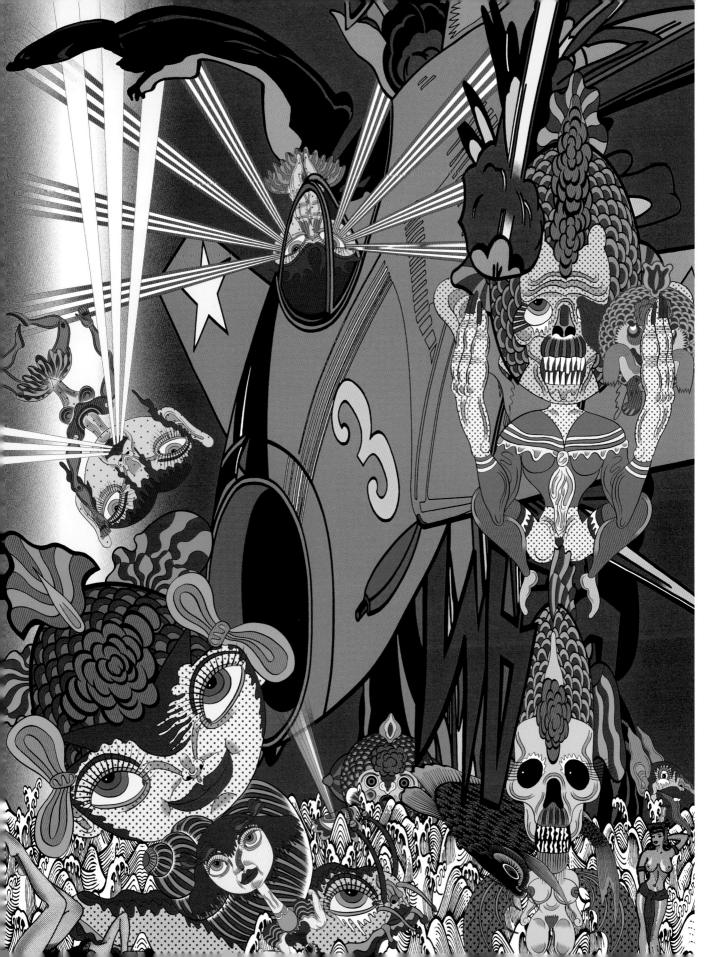

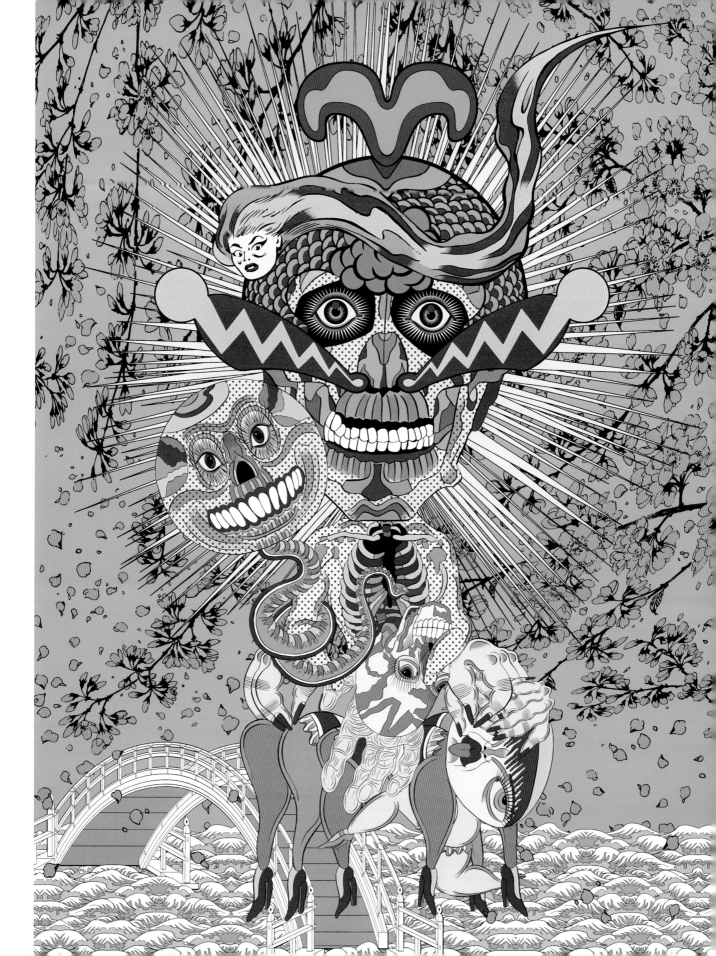

RYAN TRAVIS CHRISTIAN

CHICAGO-ISH, ILLINOIS USA

Ryan Travis Christian (b.1983, Oakland, USA) is a BFA graduate from Northern Illinois University. He has exhibited internationally at Ivory&Black, London, United Kingdom; Mohs Exhibit, Copenhagen, Denmark; Media and Moving Art Rotterdam, Netherlands and Halsey McKay Gallery, New York, USA. Ryan is currently living and working in Chicago, Illinois.

FACT
1. I once saw a dead demon in a pizza parlor parking lot.
2. I HATE January Jones, and wish that she would get no further acting work.
3. Being dead is going to suck.

INDULGENCES Smoking and drinking.
NECESSITIES Food, water, air, blood, bones.
STUDIO ESSENTIALS Music, light, paper, chair, hands.
VISIONS Mostly violent dreams, then dreams of betrayal, then dreams of silliness, and some sexy ones too from time to time.
INSPIRATIONS Forbidden Zone, old cartoons, patterns.
INFLUENCES Swimming, dogs, police, fireworks.
COLOR Black and/or white.
MEDIUM Graphite/eraser.
UTOPIA Bed.
NOISE King Crimson, any volume will do.
PSYCH Lots of acid in 8th grade.

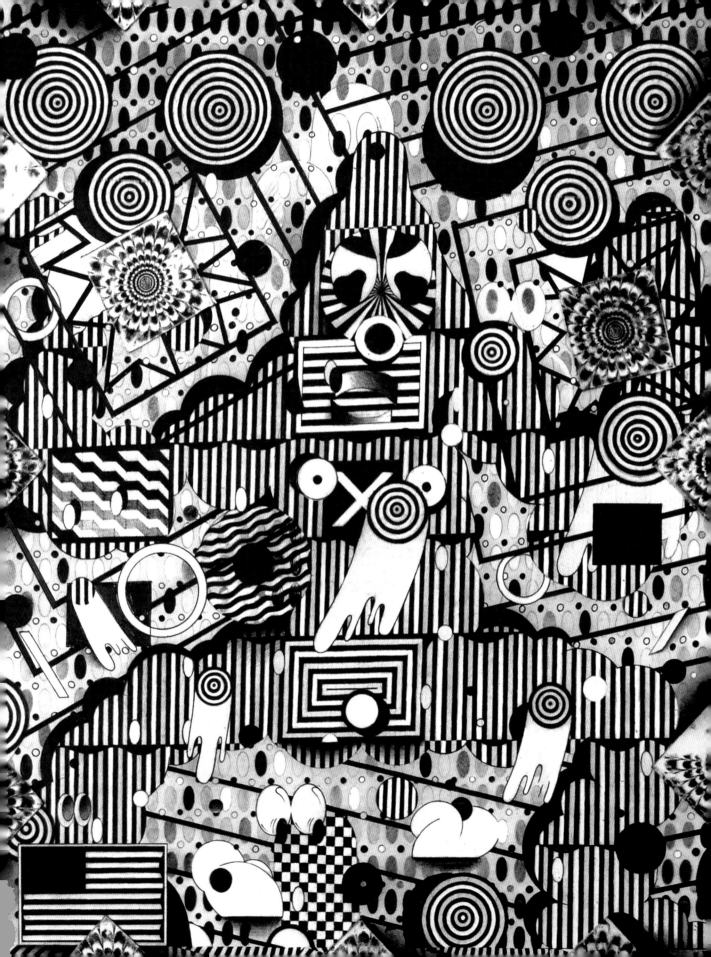

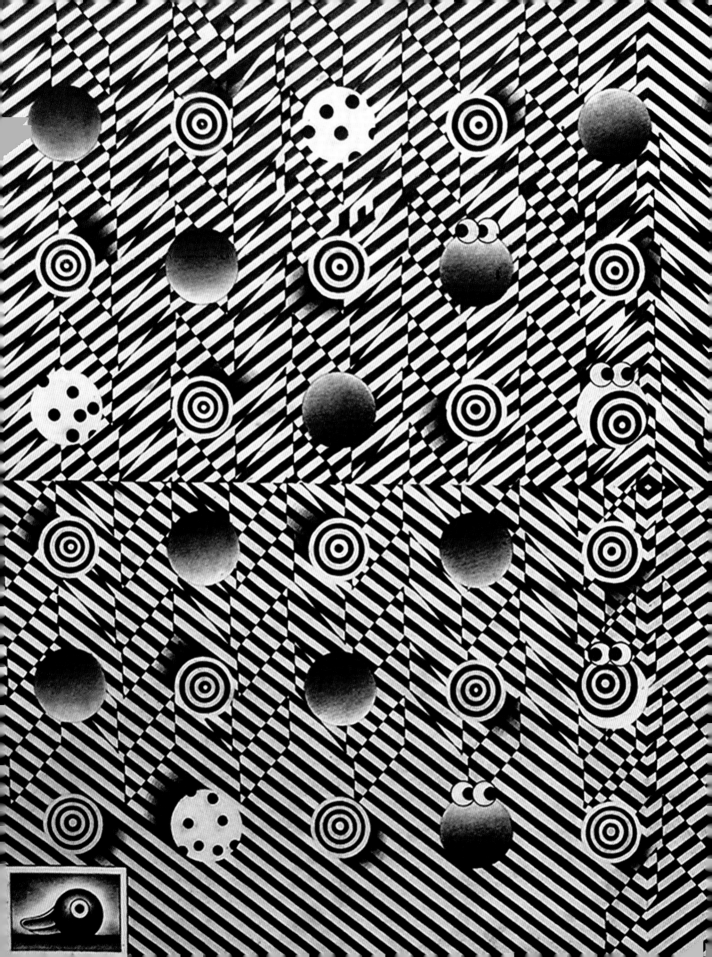

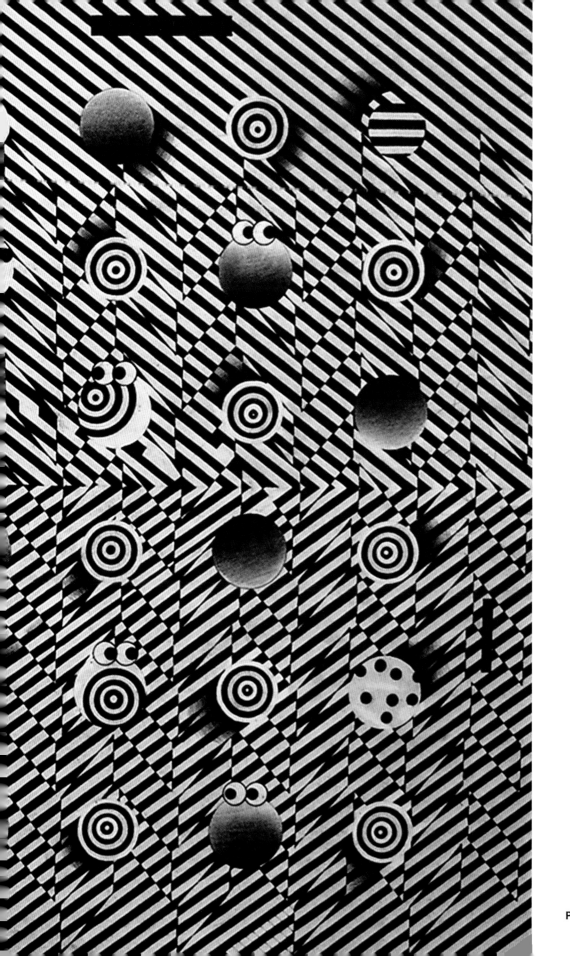

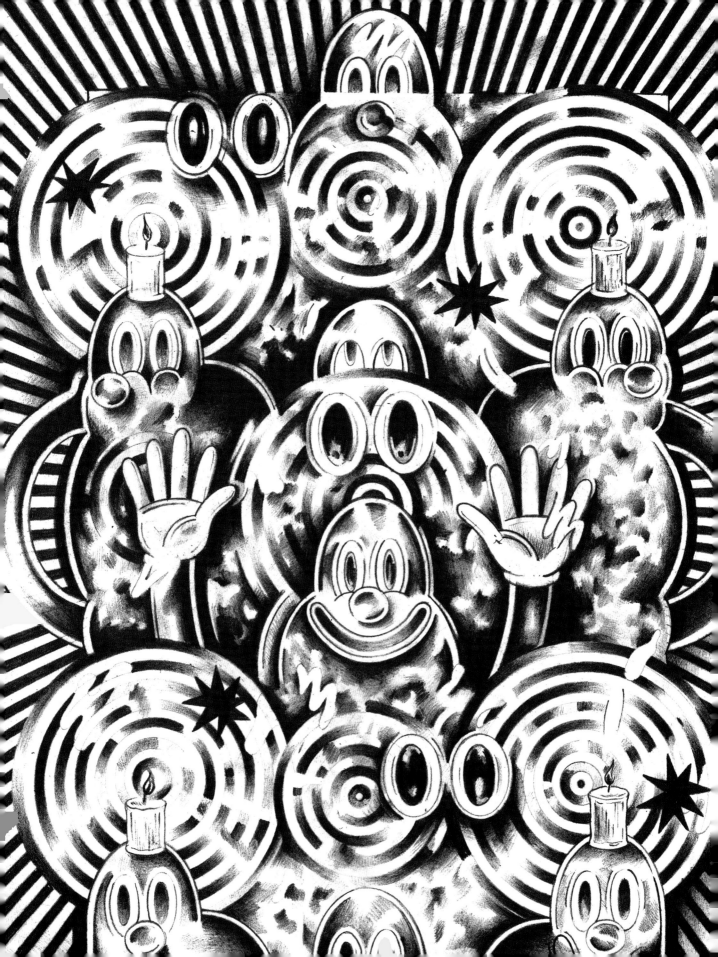

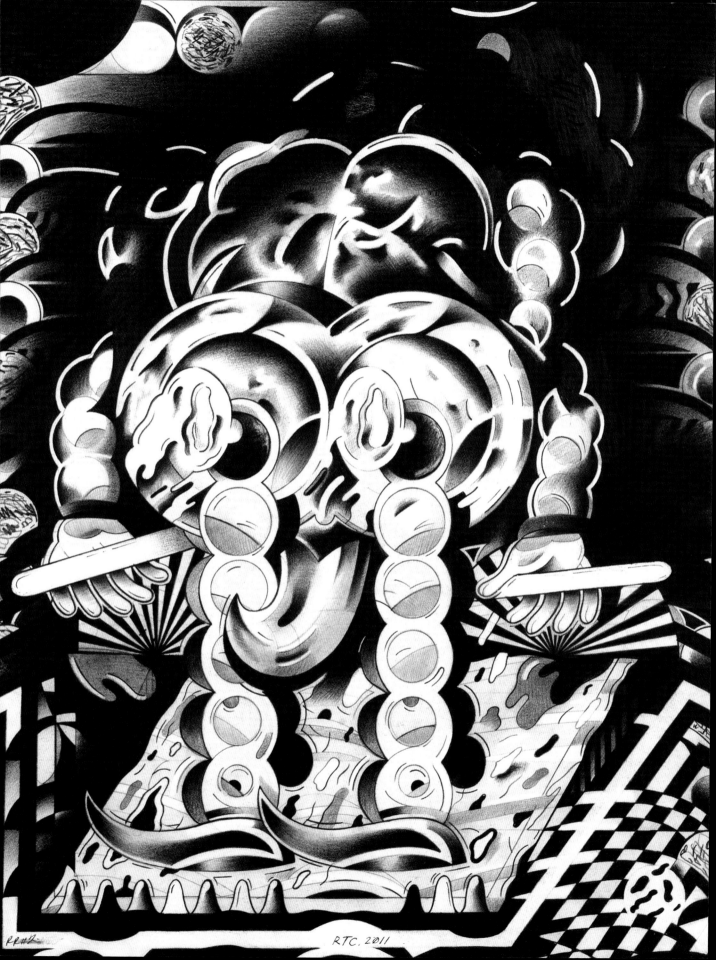

RTC. 2011

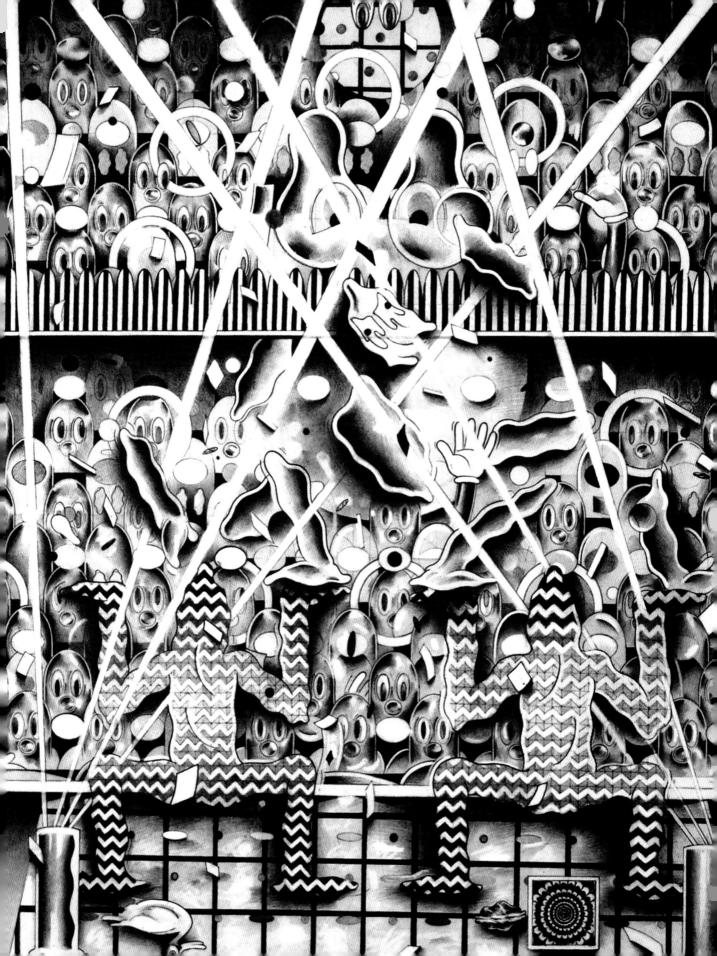

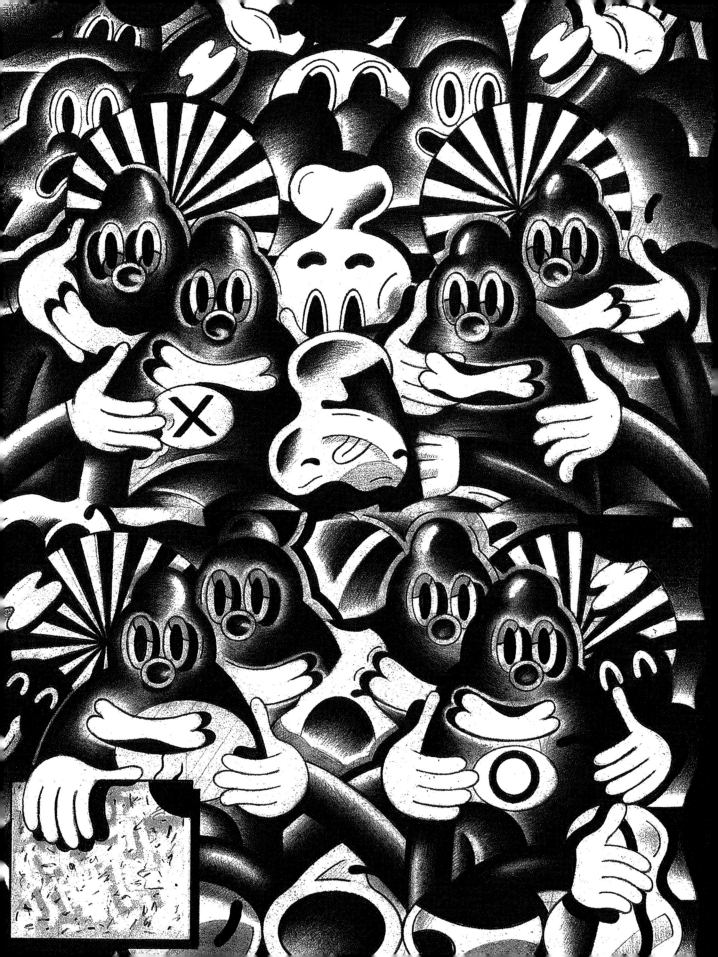

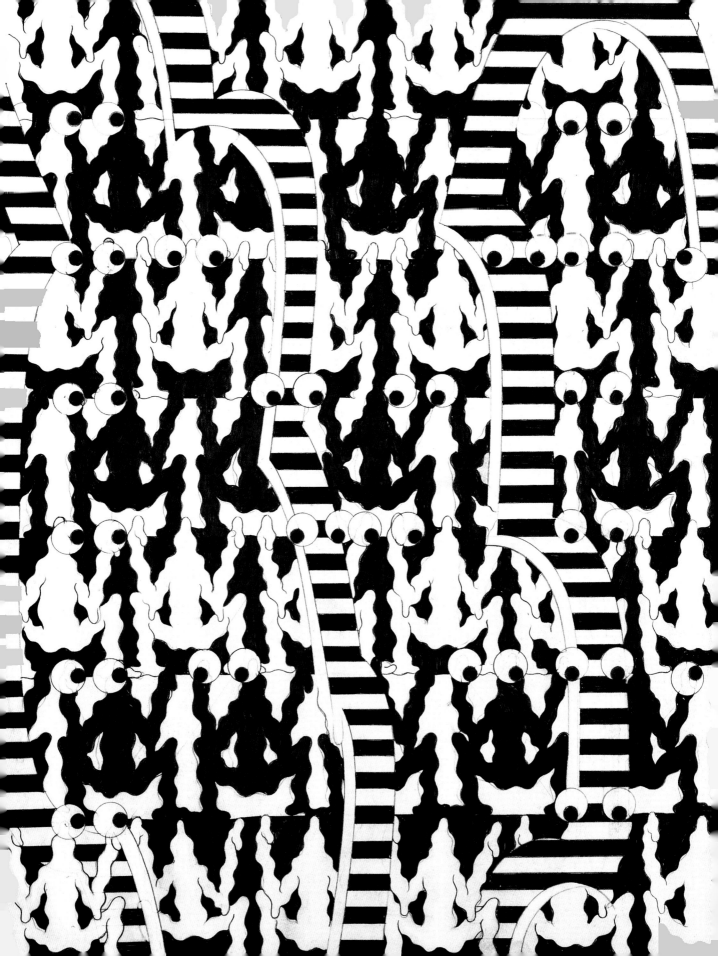

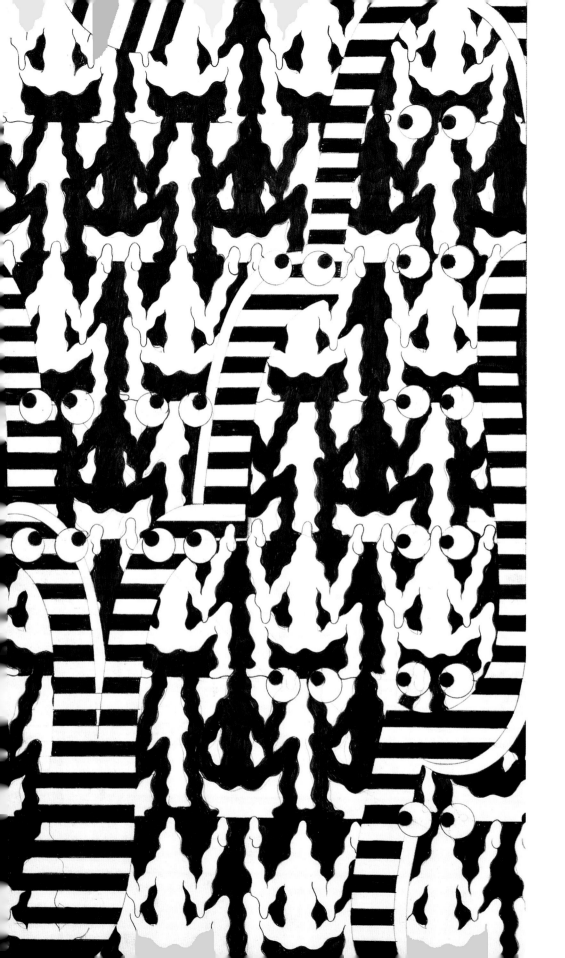

ANDY GILMORE

ROCHESTER, NY USA

A master of color and geometric composition, Andy Gilmore's work is often characterized as kaleidoscopic and hypnotic, though it could just as well be described as visually acoustic, his often complex arrangements referencing the scales and melodies in music.

Gilmore's journey toward this masterful style followed a long and winding road. He characterizes his pursuit of education as a tangled web, noting the bookstores, bakeries, and theaters where he worked were of more importance than the schools he attended in pursuit of his BFA, which he received from SUNY Empire State College.

FACT
1. The speed of light = 670,616,629 miles per hour.
2. Average distance of Earth to Sun. 92.96 million miles.
3. Average distance to the Moon is 238,857 miles.

INDULGENCES Coffee.
NECESSITIES Water, food, clothing, shelter, love.
STUDIO ESSENTIALS Pen and paper, a table and occasionally a computer.
VISIONS Flashing colors and fleeting forms.
INSPIRATIONS Moebius, Akira Kurosawa, Werner Herzog, Jan Svankmajer, Neo Rauch, Katsuhiro Otomo, Alan E. Cober, Ben Shahn, Miyazaki, Sergio Leone, Geoff Darrow, Josef Müller-Brockmann, William Morris, Louis Sullivan.
INFLUENCES I grew up on comic books, skateboarding and music. In time the focus has broadened to include film, mathematics, physics, music theory, cosmology, biology, ornithology, mythology and religion.
COLOR I can't say I have any particular color preferences. My relationship to color seems to change through the year with the seasonal environmental color changes.
MEDIUM Pencil, pen, paper, Photoshop, Illustrator.
UTOPIA Adirondack mountains, New York.
NOISE I listen to a wide variety of music at quite a loud volume while I work. As of late I have been listening to J. Dilla, Neu!, the 13th Floor Elevators, Total Control, Brian Eno, Wire, the Electric Prunes, David Axelrod, Ennio Morricone, Lee Hazelwood and Adrian Younge.

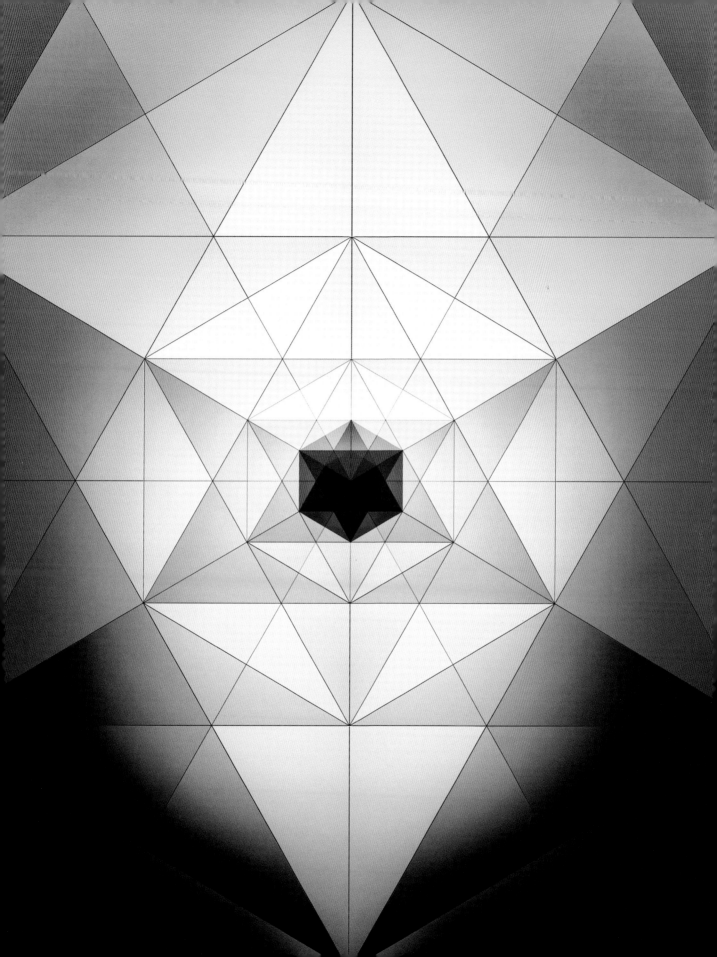

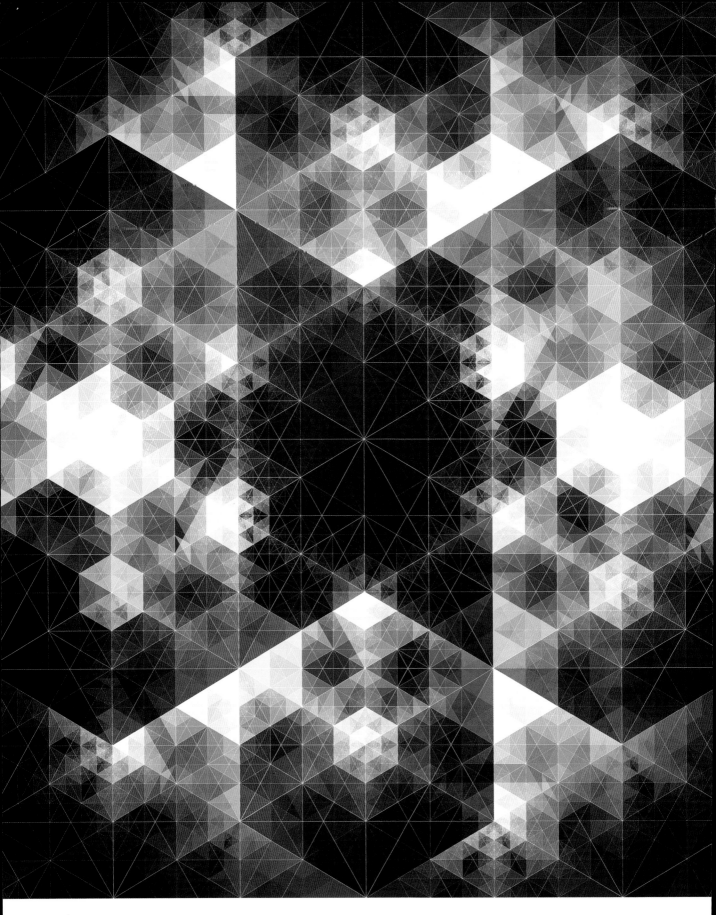

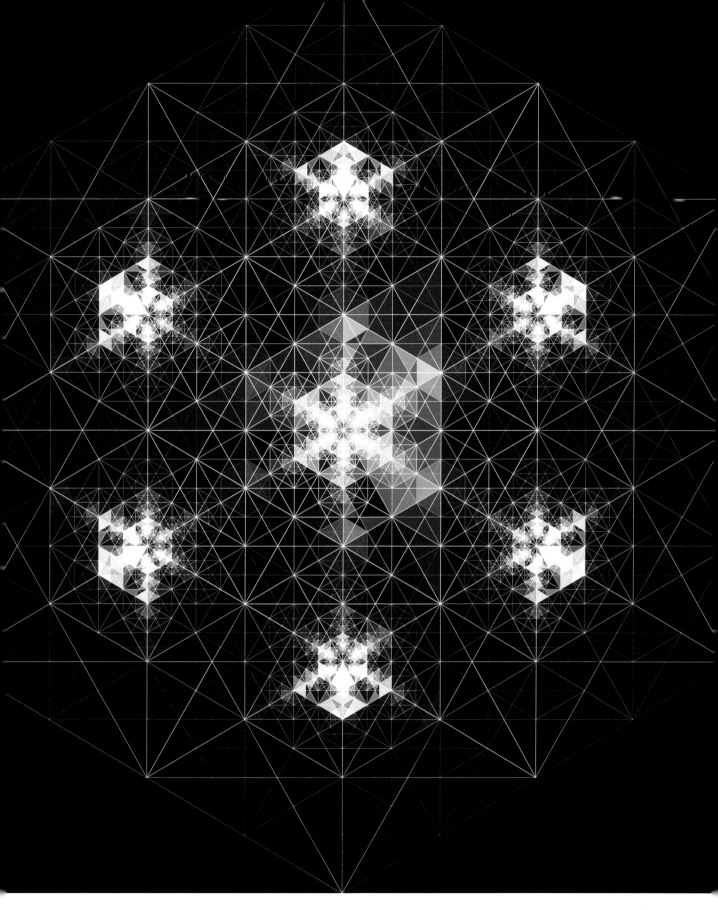

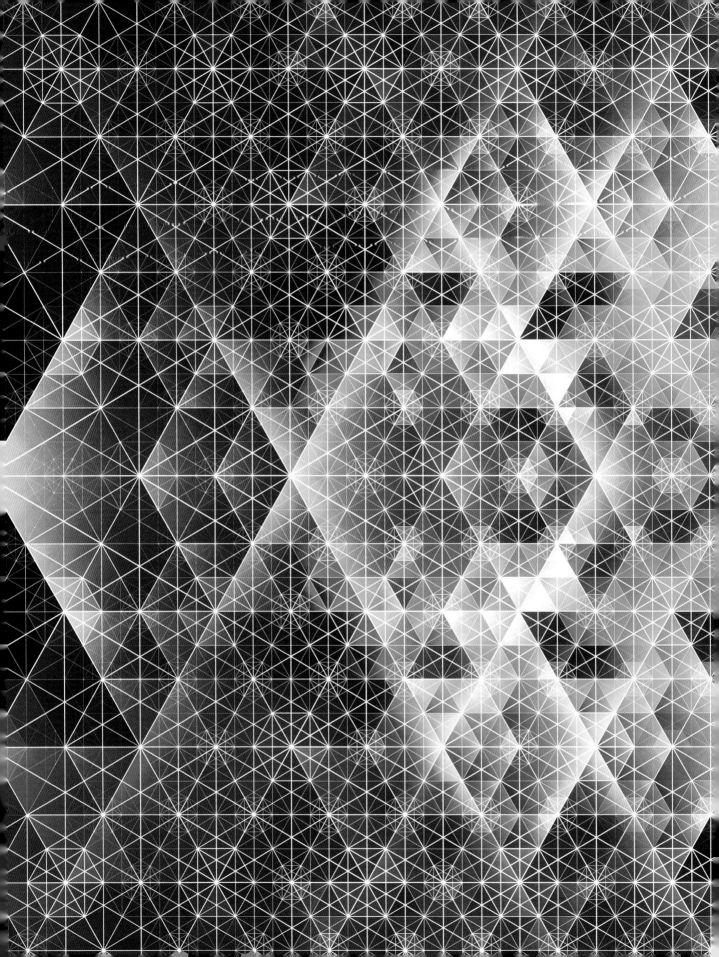

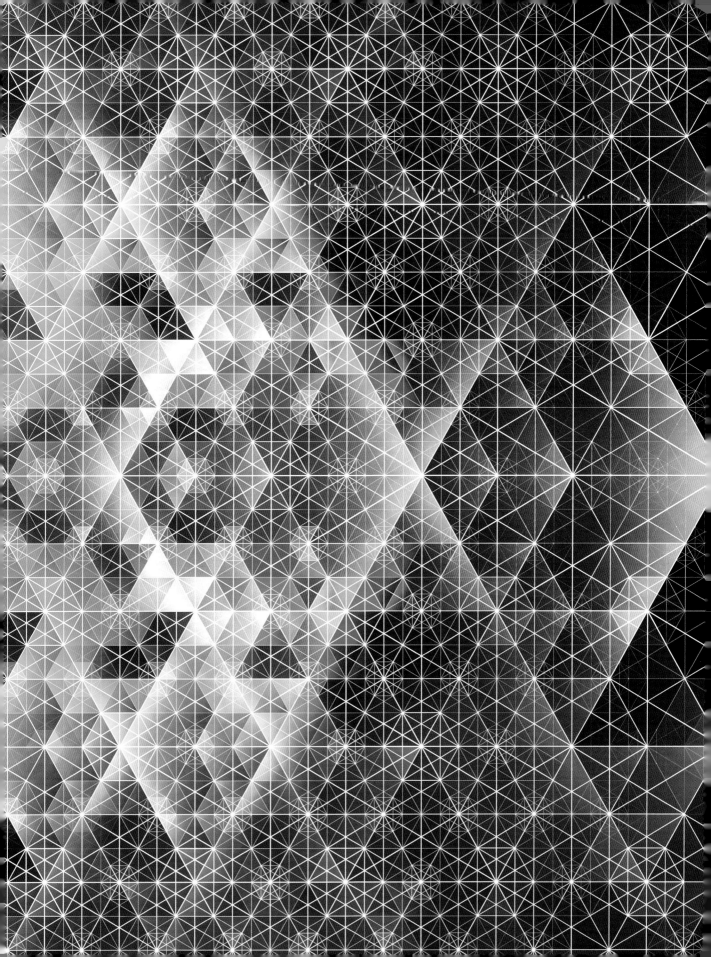

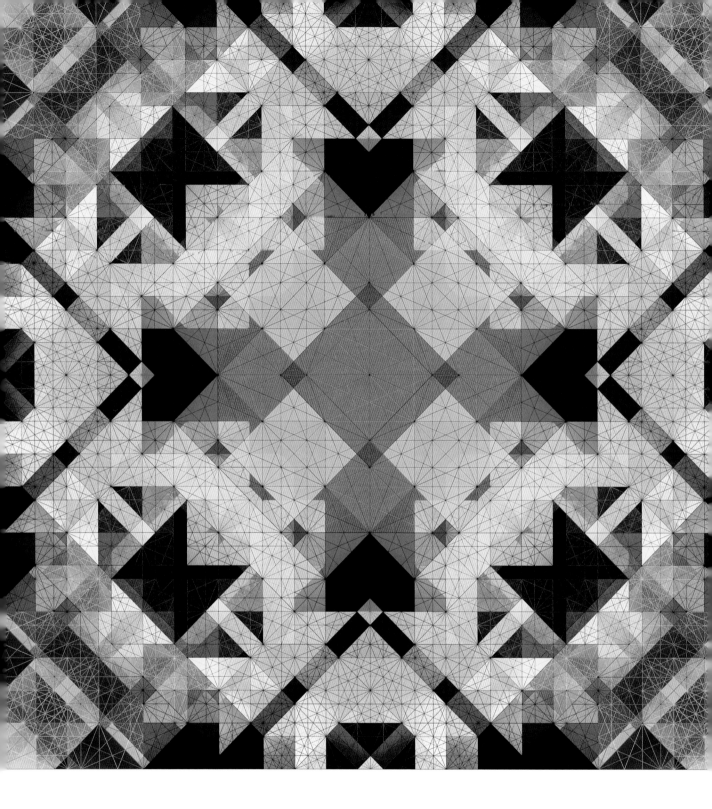

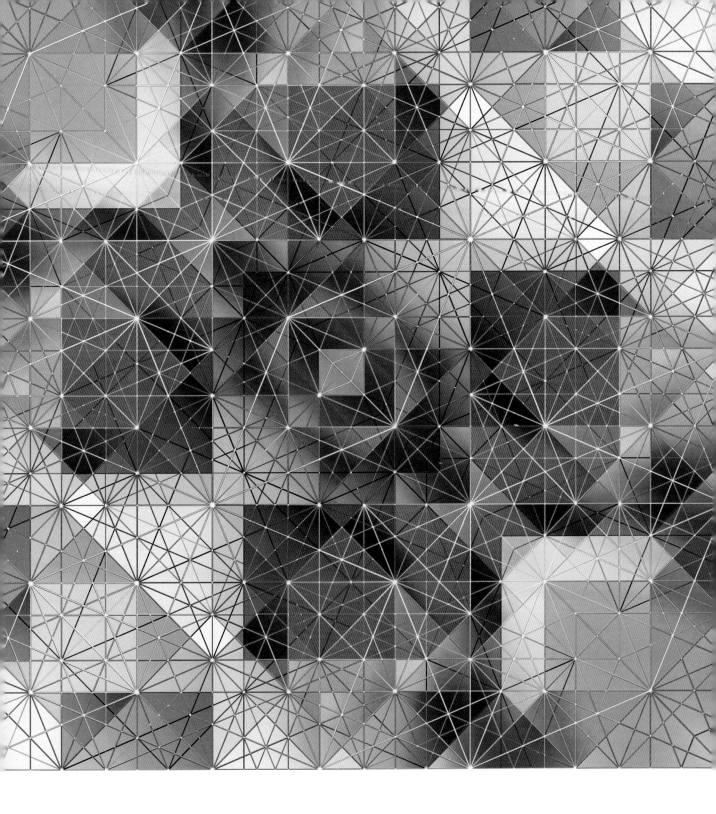

SKINNER

OAKLAND, CA USA

Skinner is a self-taught artist living in Oakland, California who has meticulously crafted a balance of extraordinary mural work, bizarre and antagonistic installations while maintaining a prolific commercial career. Influenced by 80's pop culture, human struggle, myths and violence, dungeons and dragons and the heavy metal gods, Skinner's mind is one of psycho social mayhem fueled by a calculated chaos. His work has been shown all over the world in various museums, universities and galleries. He has been an ambassador of the alternative arts movement in countries ranging from Russia, Cuba, Japan, Europe and all across the United States.

FACT
1. Earth is smoother than a bowling ball.
2. There are only 8-12 fatalities caused per year by sharks but over a 100 million sharks are killed per year to harvest their fins.
3. Two people die every second.

INDULGENCES Really good strong coffee, comics, weird books.
NECESSITIES Thai food, good coffee, great music, silence, time and space to do things that make me happy without stress.
STUDIO ESSENTIALS Quiet... At night I can get to a place of creativity that the noise of the world won't allow.
VISIONS When I am awake I can see a lot of beautiful things... ideas, potential and new places I see my creative spirit going. At night, only horrible dreams. I heard that my subconscious tendencies and parts of my REM sleep is affecting my depression and state of dreaming in a negative way. It's weird.
INSPIRATIONS Animals, old comics, weird artists, stories, memories, old rugs, drugs, laughter, films, stop motion animation, heavy music and drag queens.
INFLUENCES Trees, air, mountains, isolation.
COLOR I am actually really into black-light poster stuff right now and textures on the pieces I am doing digitally. Bright juxtapositions and things that don't make sense- or at least they shouldn't make sense but they do.
MEDIUM Inks, spray paint, air brush, acrylics.
UTOPIA Upper Sardine Lake at a hidden cabin my girlfriend takes me to.
NOISE Melvins, Miles Davis, High On Fire, Bjork, Uncle Acid and The Deadbeats, The Smiths, Black Sabbath, AC/DC, Zep, Tangerine Dream- now that Kozik got me into it.
PSYCH Take some Shrooms by the river lil buddy!!

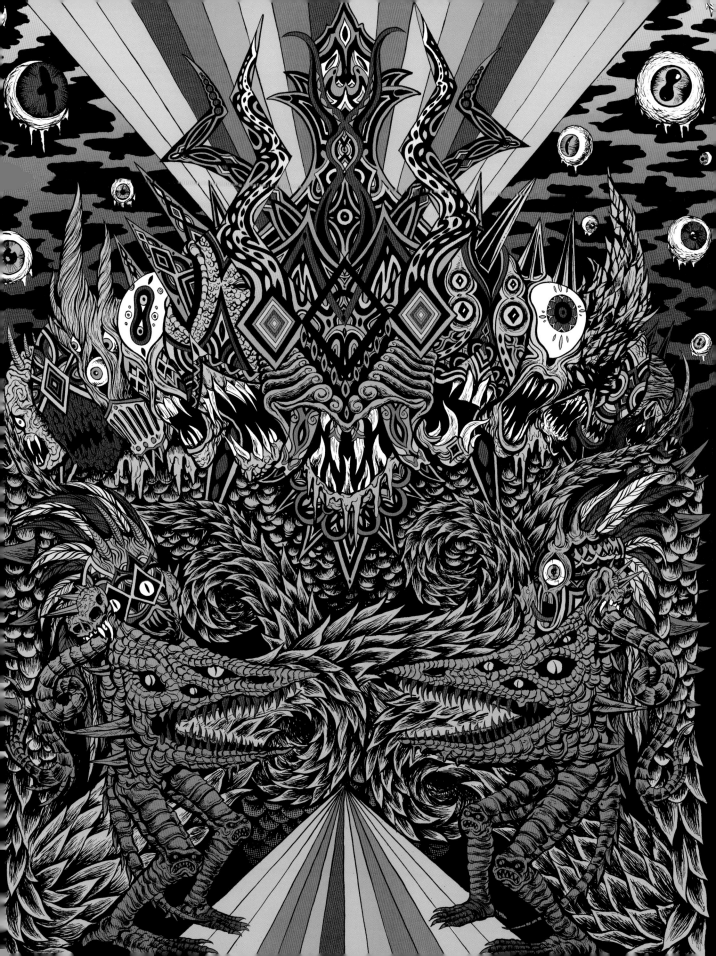

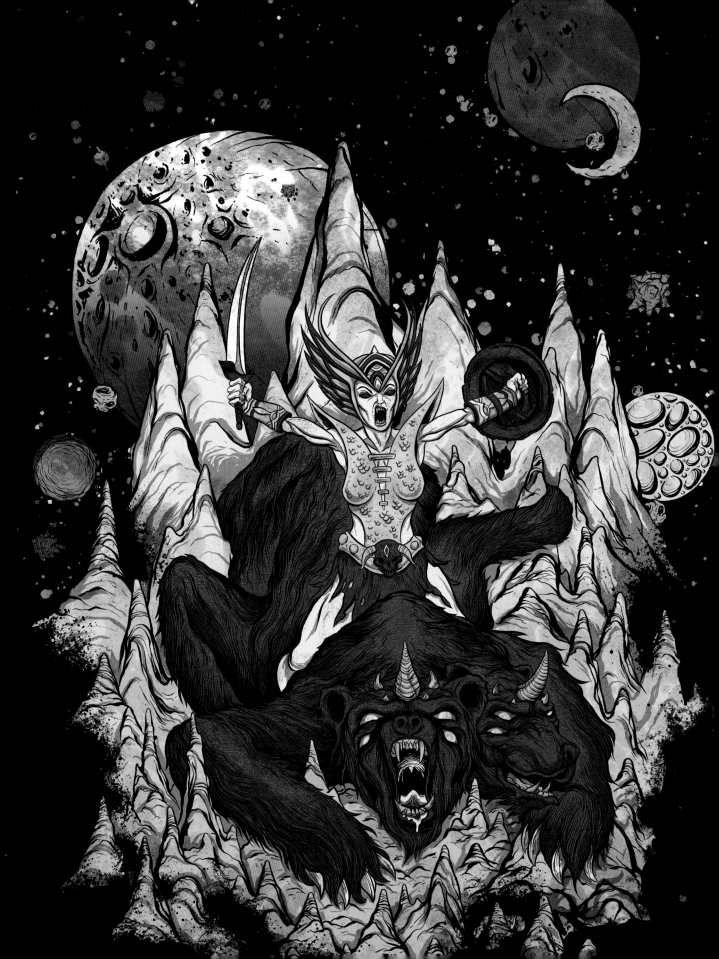

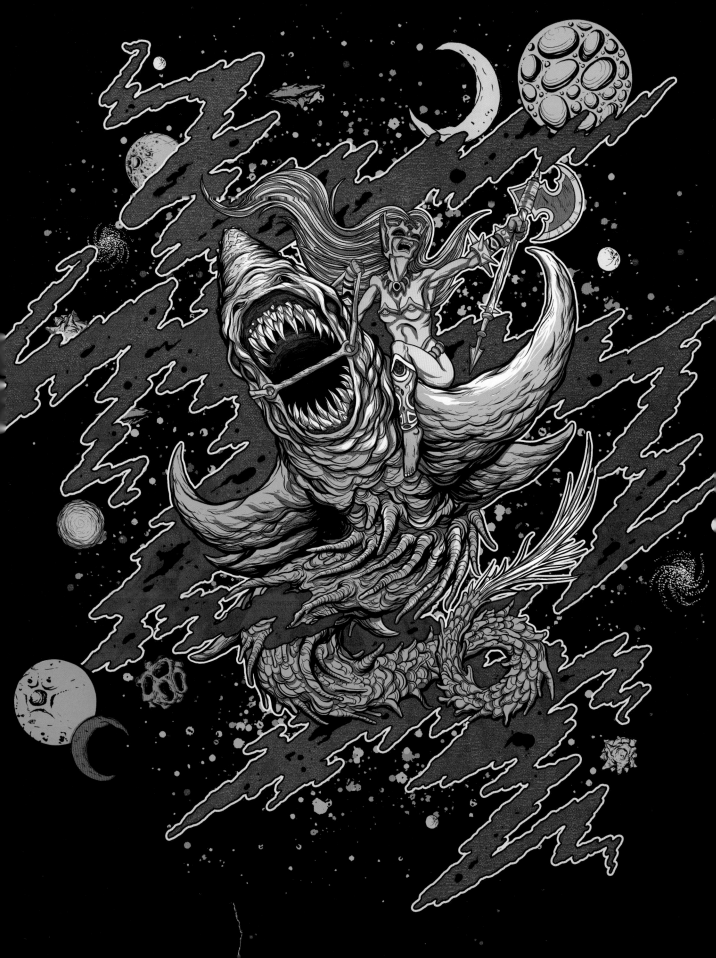

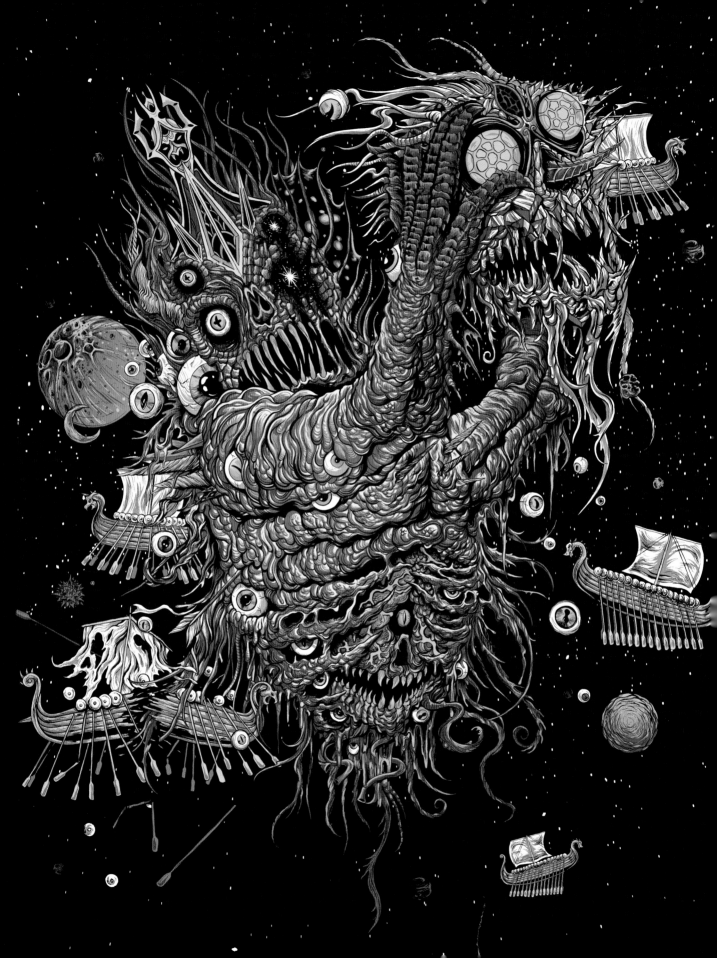

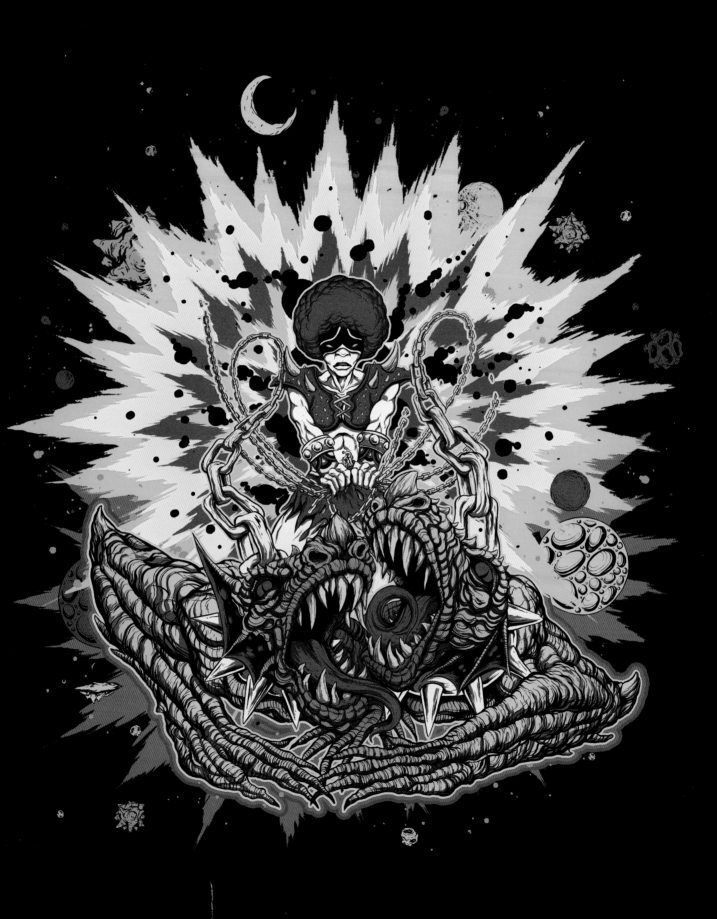

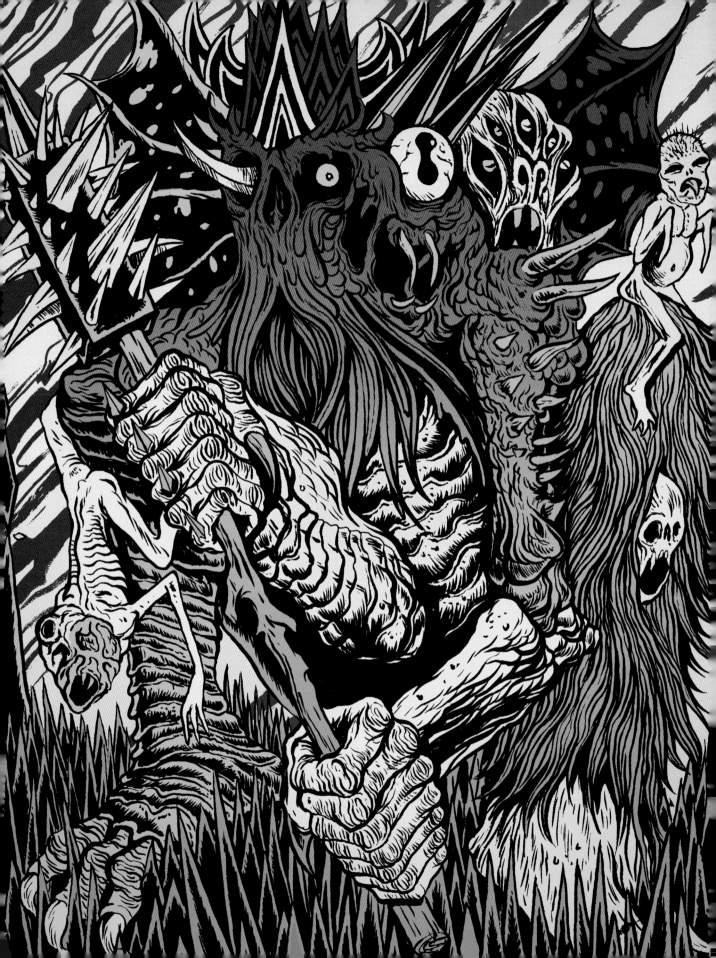

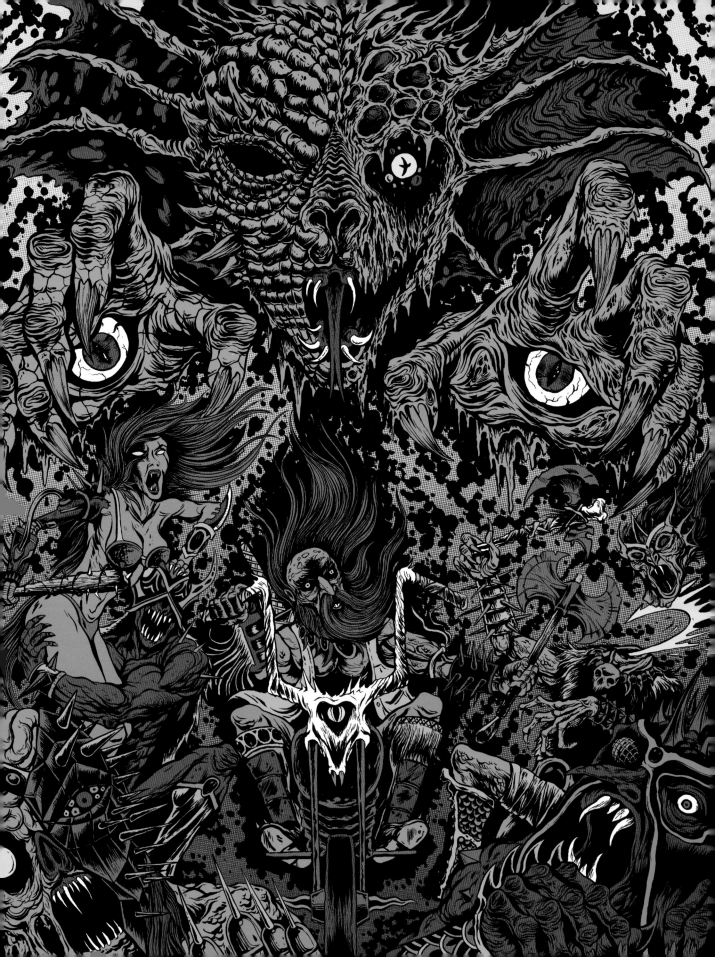

SCOTT BALMER

Dundee, Scotland UK

At a young age Scott Balmer knew that he wanted to do something in the creative field, considering the amount of time he spent scribbling away drawing all manner of things from made up monsters to devices of shear awesomeness, able to break through space and time itself. First he considered going down the animation route, then briefly flirted with the idea of graphic design but then he settled on the world of illustration where anything is possible with the power of the mind. Balmer usually works with many different styles and mediums but mostly focuses on creating beasts of magical and mystical wonder. His approach to his work is very retro in style but it is built up to accommodate a more contemporary setting. His work has been seen in many a newspaper and not forgetting magazines such as The Guardian, New York Times, Bloomberg BusinessWeek, Computer Arts, MIT's Technology Review and many more.

FACT
1. Jim Henson developed an allergy to fleece.
2. The chicken is the closest living relative to the T Rex.
3. A group of rats is called a mischief.

INDULGENCES Coffee, jaffa cakes, booze, Dark Souls and Tetris.
NECESSITIES My hands, my brain, a pencil, an eraser and my Gameboy Color.
STUDIO ESSENTIALS Pencils, pens, paper and power. Along with water to drink and something random playing in the background such as my prized Monkey!! DVD collection.
VISIONS Visions of cities densely populated with giant, bright colorful, stylized animal sculptures. Birds nesting in my hands and feet and strange bird-like people in vibrant colors.
INSPIRATIONS Old school illustrations as well as timely graphic design imagery, polish posters, old penguin book covers and the graphic capabilities of the zx spectrum. Generally interesting things that catch my eye.
INFLUENCES Right now I'm a bit partial to various shapes and forms used in climbing frames and other play park type structures.
COLOR I go with colors then decide on what its nearest neighbor should be, as long as the colors feel right together in the end.
MEDIUM A mixture of pencils, pens, paint, photoshop and illustrator plus a dash of printmaking from time to time.
PREFERRED PLACE Any place where the astral planes can be seen with clarity within the night sky.
NOISE I usually work in complete silence.
PSYCH Once I ran naked in a field in a sort of at-one-with-nature way, many moons ago.

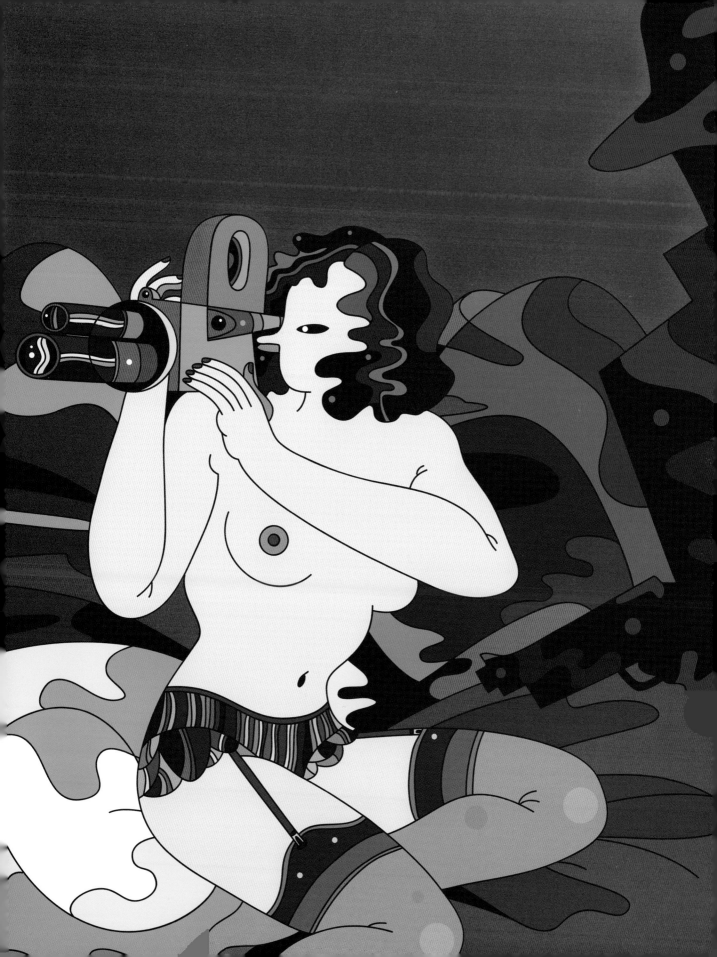

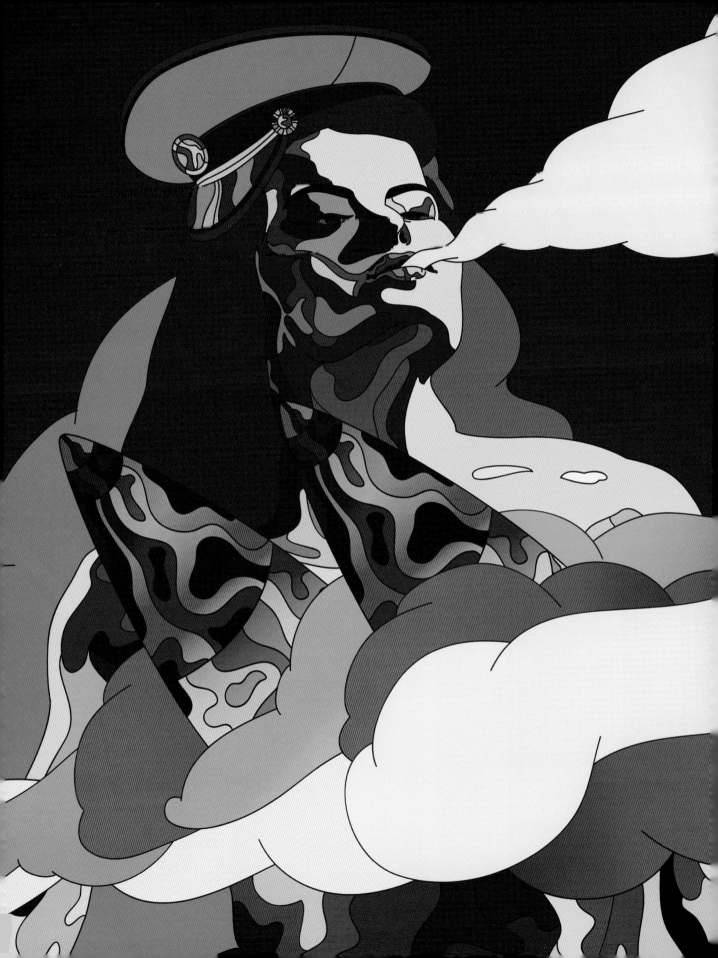

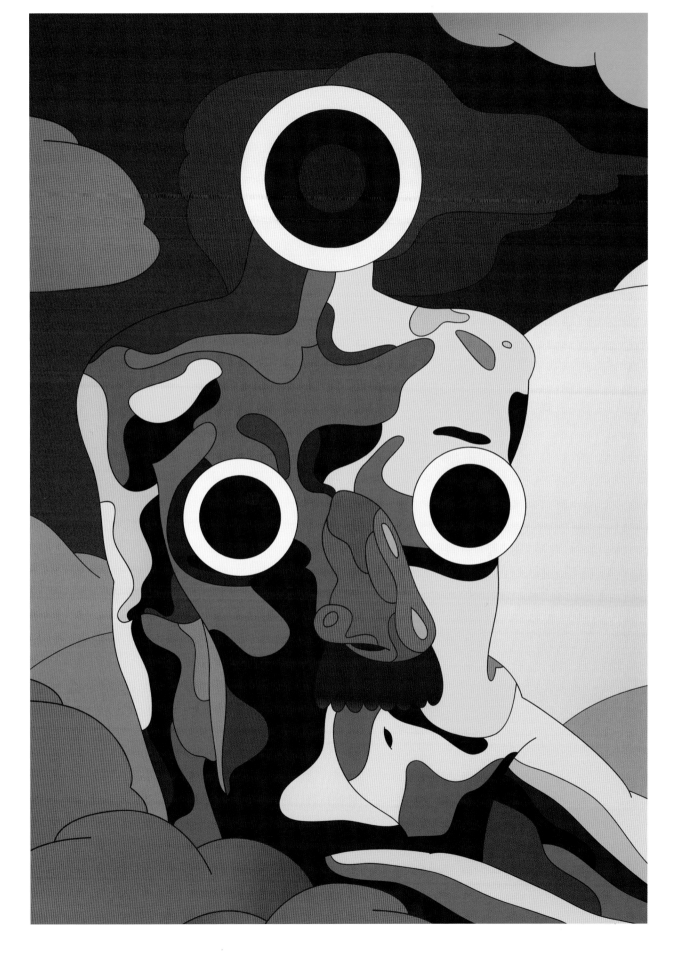

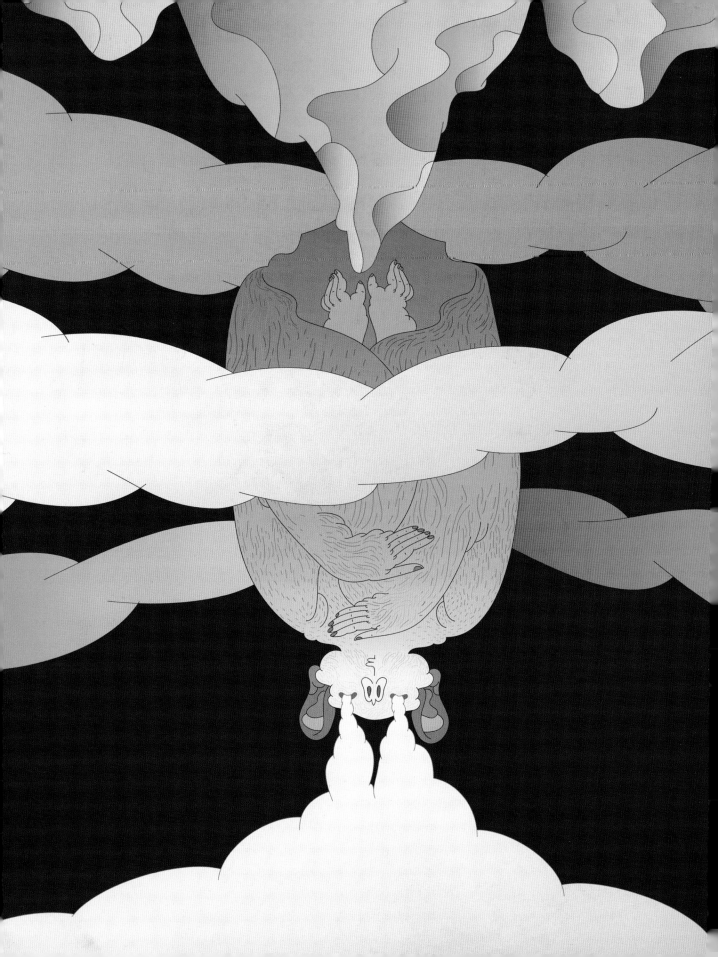

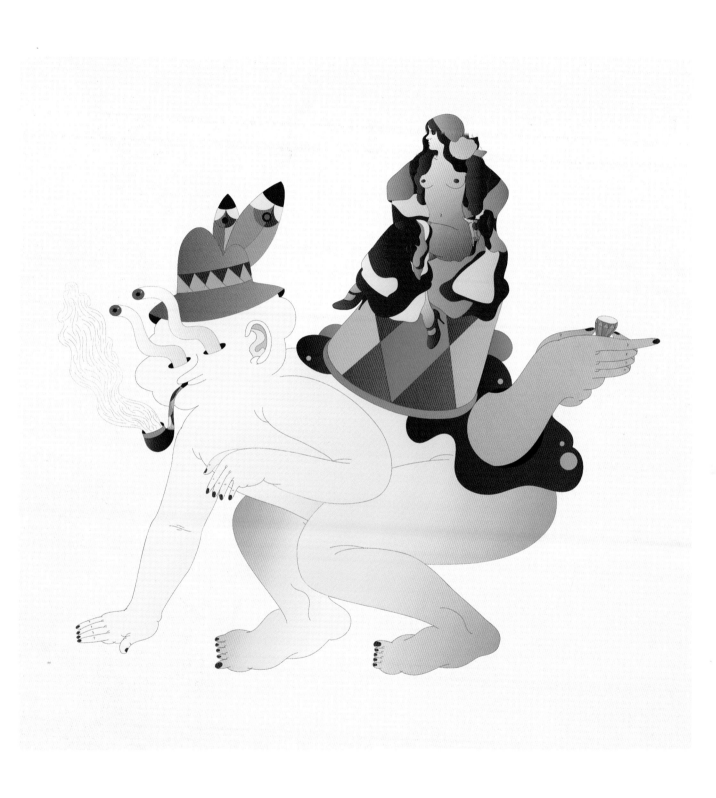

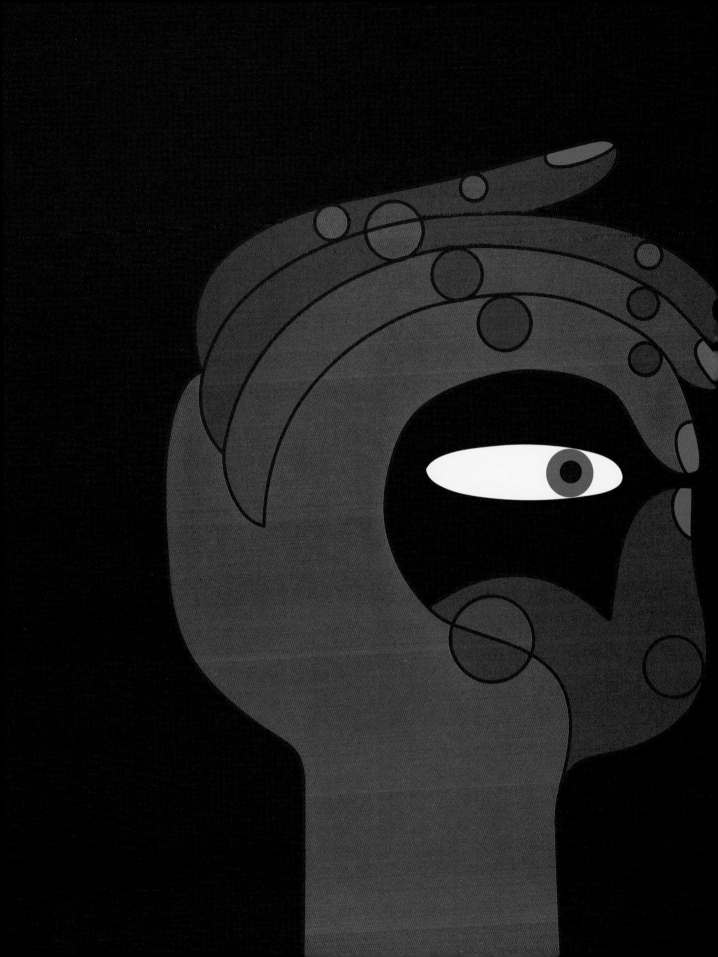

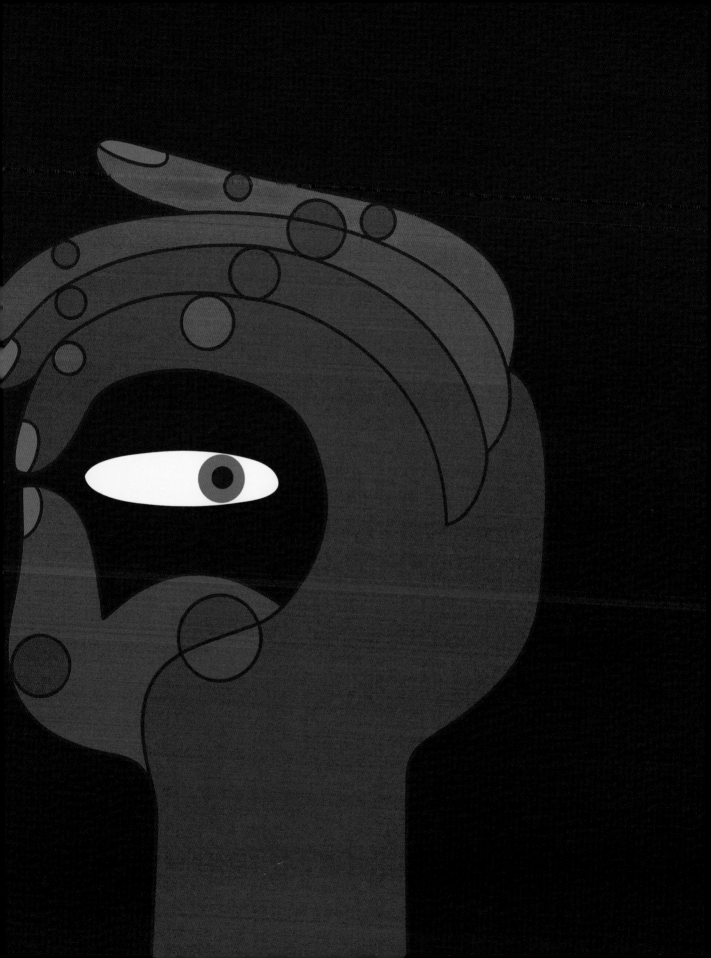

DAVID D'ANDREA

St Johns, Oregon USA

David D'Andrea's illustrations seethe with sinuous, accomplished line work and intentional rough edges. He combines the draftsmanship of the 1960s poster artists with a raw detailed grittiness to create an organic pen and ink style that is unmistakably his own. Through esoteric signs and symbols such as aviform in flight, sigillary calligraphy, disembodied wings, and skeletal forms, he seeks to perpetuate the avowal that is death, and in turn catharsis; to create archaic crests for modern battles.

FACT
1. I am very happy with where my work has landed me in this world. The correspondence, the exchange of new ideas, imagery and ambition. It is what I can offer up to the void, the akashic record, or whatever term you'd like to use. I am very thankful for that exchange, as it is the most important facet of my existence
2. Birds are commonly thought of as harbingers of death, which can be thought of as freedom of flight, the flight of the soul. I am interested in death in the "memento mori" tradition. I love this victorian idea that visual reminders of impermanence are used to strike a flame of creativity and spirit. By employing timeless imagery used in a modern way, I hope to update this symbology.
3. Et in Arcadia Ego (I too (am) in Arcadia)

INDULGENCES I am fanatical about art history. I collect books and records. I sometimes see them as a material indulgence, even though they're so important to my everyday inspiration. The nature that surrounds me in the Northwest is incredible. I try to get out and immerse myself as often as my schedule allows.
NECESSITIES Travel, coffee, inspiration, and good conversation are necessary for my psychic upkeep. I feel very fortunate to have chosen quite a simple path in life.
STUDIO ESSENTIALS India Ink, brass nib, brush, board and Macbook are my daily tools. My studio also houses a Risograph GR3770, Chandler and Price letterpress, and a table top Caxton Press.
VISIONS My love for eternal symbols is apparent in much of my work. The death's head as a memento mori, birds as transcendence of the spirit, the cross as earth-bound man, etc. All these symbols have been done over and over through time. I love the tradition and universality of symbols or form constants. Entoptics are the phosphene shapes and symbols humans see when they close their eyes. They're recurring throughout time and cultures; cross, spiral, concentric circle, etc. I am most drawn to the cross.

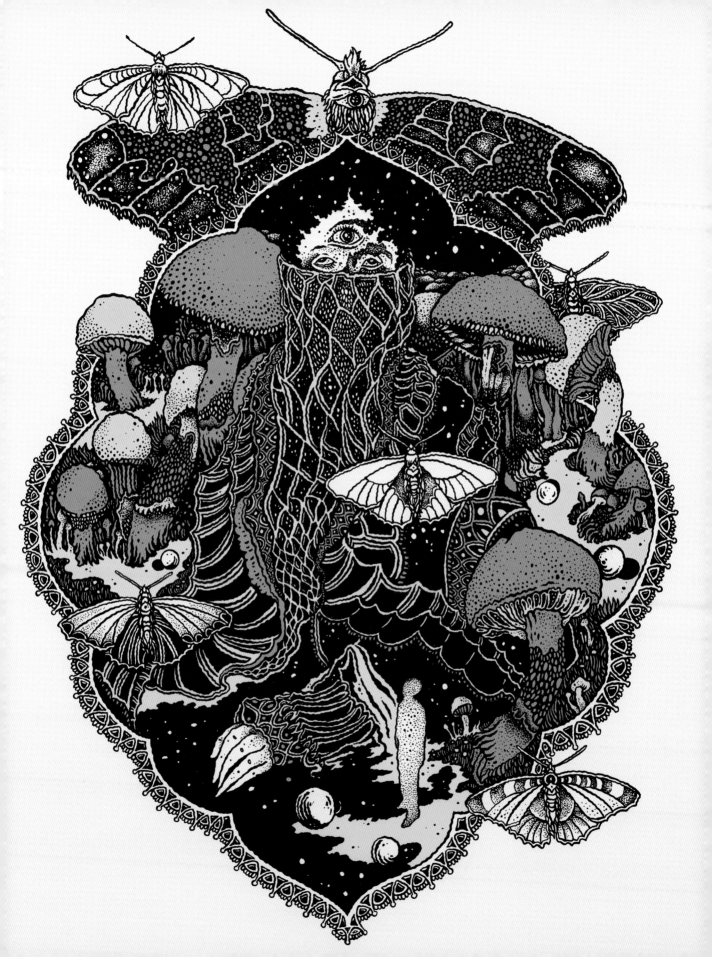

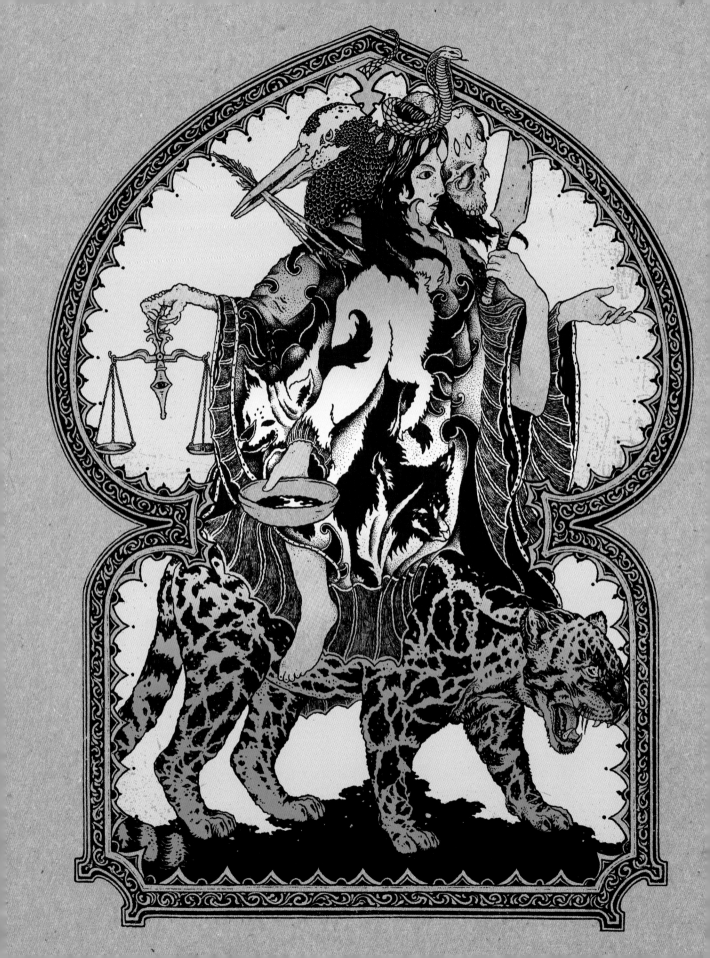

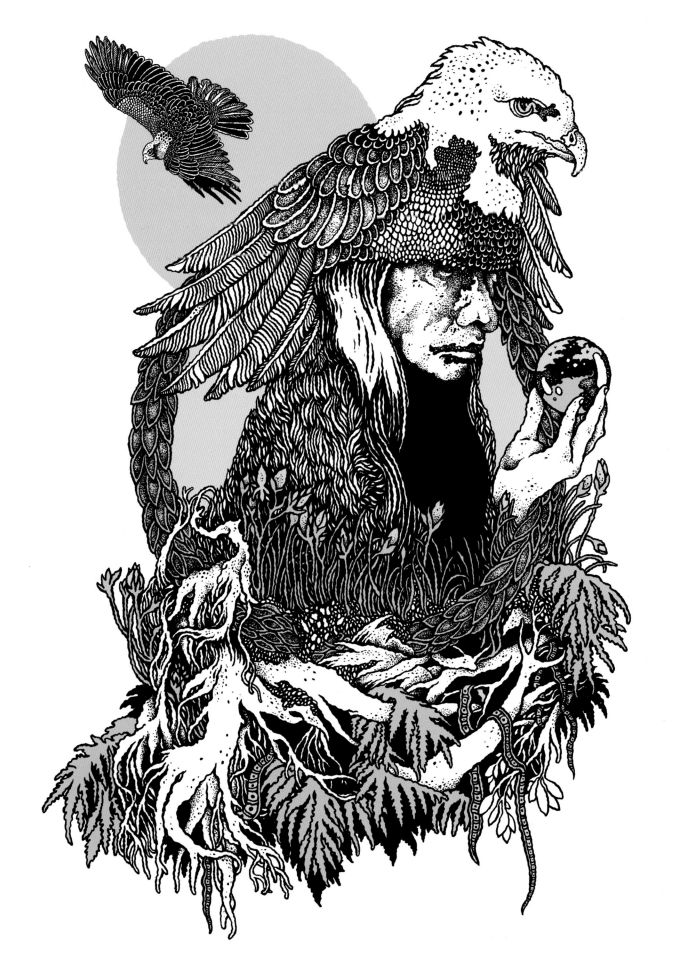

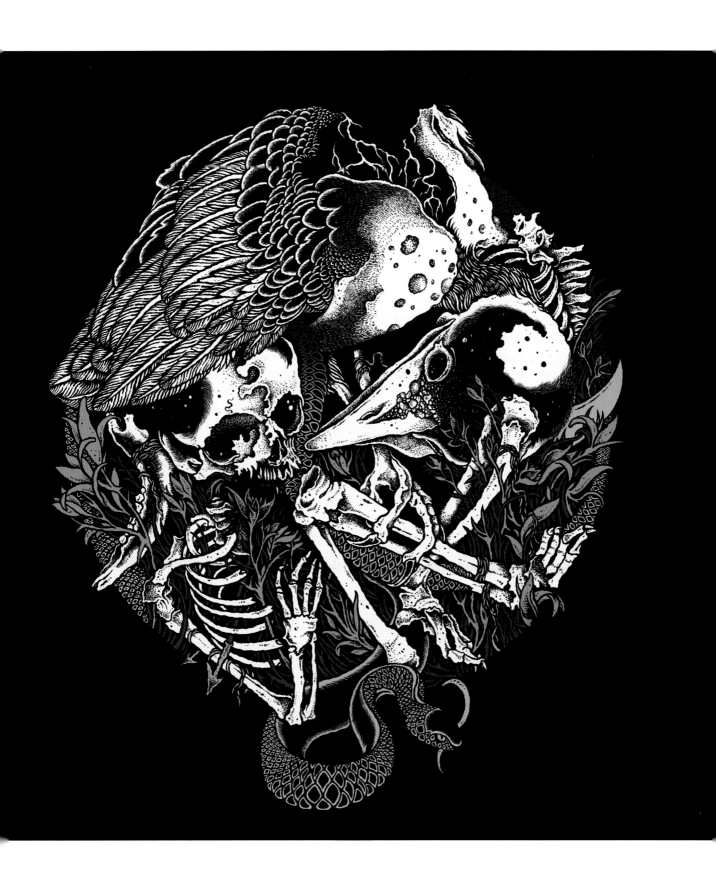

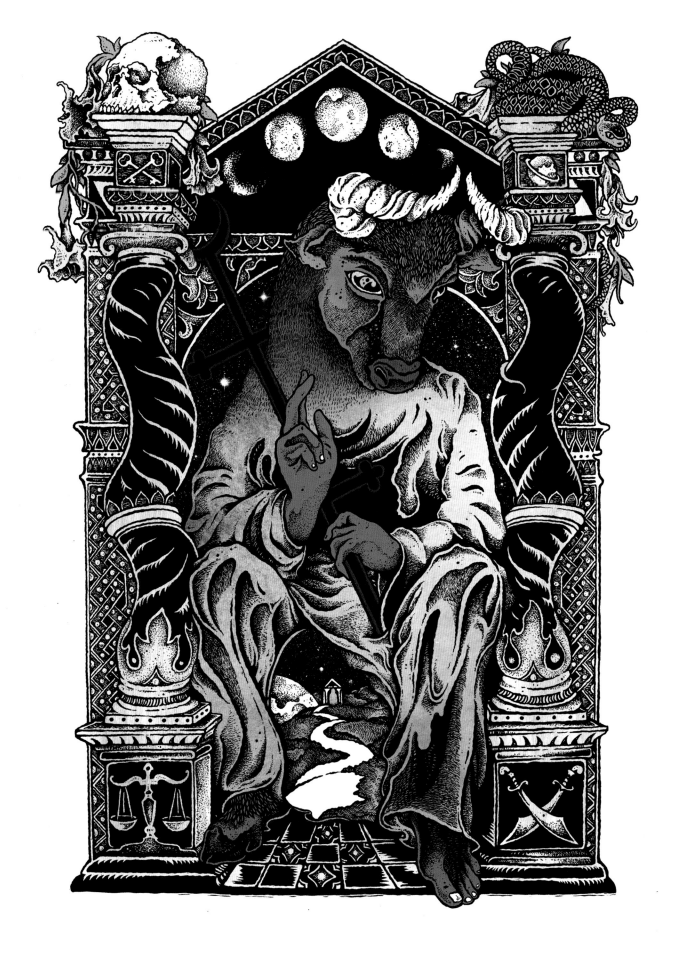

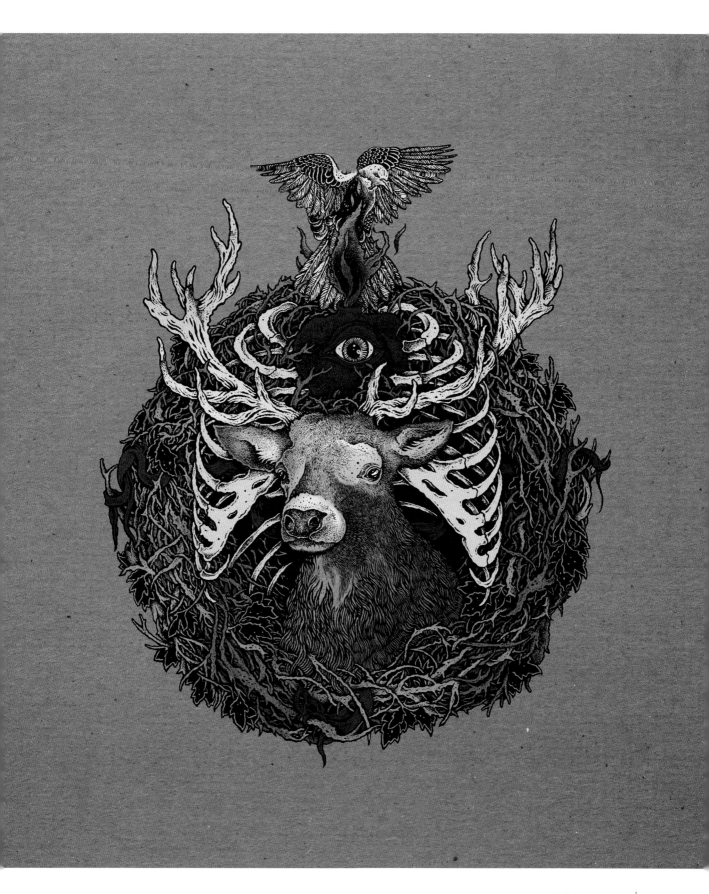

ALLYSON GREY

BROOKLYN, NY USA

An accomplished visionary artist, Allyson Grey's paintings invent a symbol system representing chaos, order and secret writing with tens of thousands of painted spectral squares that reveal paradoxes of particles and waves, cells and systems, entropy and inter-reflectivity, meaning and the ineffable. Allyson is co-founder/director of the Chapel of Sacred Mirrors, CoSM, a radically welcoming church and "collaborative social sculpture" in Wappinger, New York.

Wife and partner of internationally renowned artist, Alex Grey and mother of film actress Zena Grey, Allyson was born in Baltimore, Maryland and received a Master of Fine Arts degree from Tufts University. She has edited and co-written six books, CoSM's annual Journal of Visionary Culture and countless interviews and articles. Allyson taught art the Boston Museum School, Tufts University and at Omega Institute for 23 years. Co-leader of a growing community, Allyson has spoken widely at conferences and symposia including the World Psychedelic Forum in Basel, Switzerland and the Women's Visionary Congress in California. Grey's paintings have been exhibited widely, have been commissioned for numerous painting installations, with many works included in both corporate and private collections.

FACT
1. DOB - March 3, 1952.
2. Born in Baltimore, Maryland.
3. Lives at CoSM in Wappinger, NY since 2009 and in Brooklyn, NY since 1984.

STUDIO ESSENTIALS Time, space, art materials & content -- chaos, order & secret writing.
MEDIUM Two bodies of work -- painting and the collaborative social sculpture, CoSM.
UTOPIA With my beloved Alex at CoSM, Chapel of Sacred Mirrors.
NOISE Sounds of nature out my window at CoSM.
PSYCH Yes.

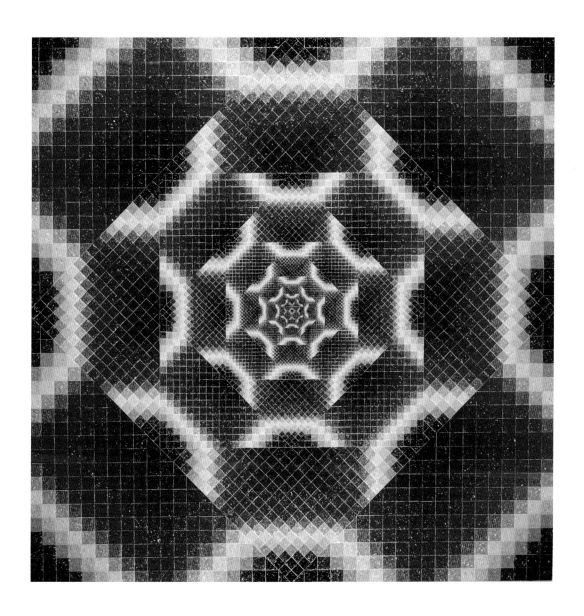

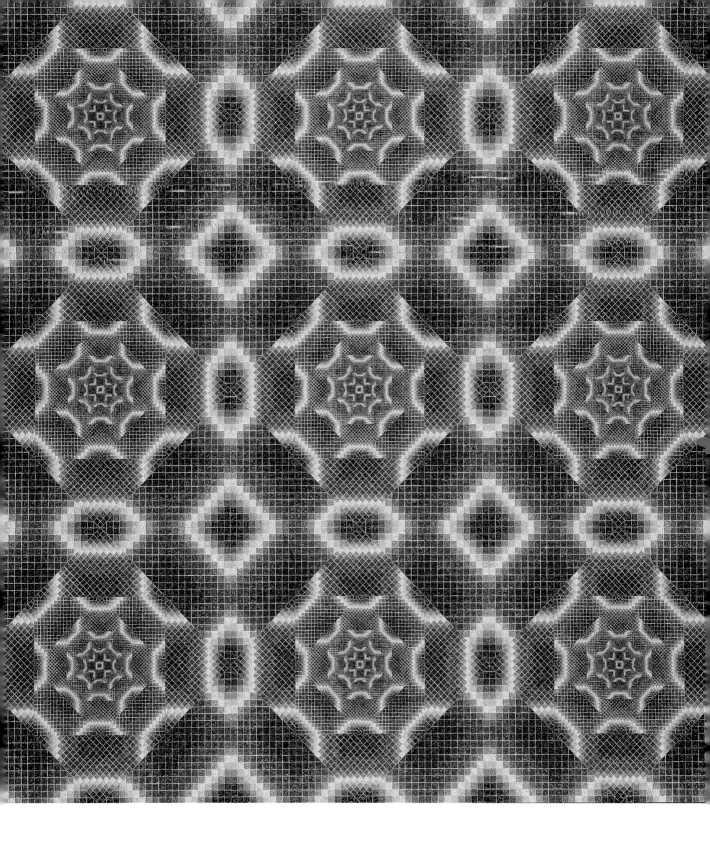

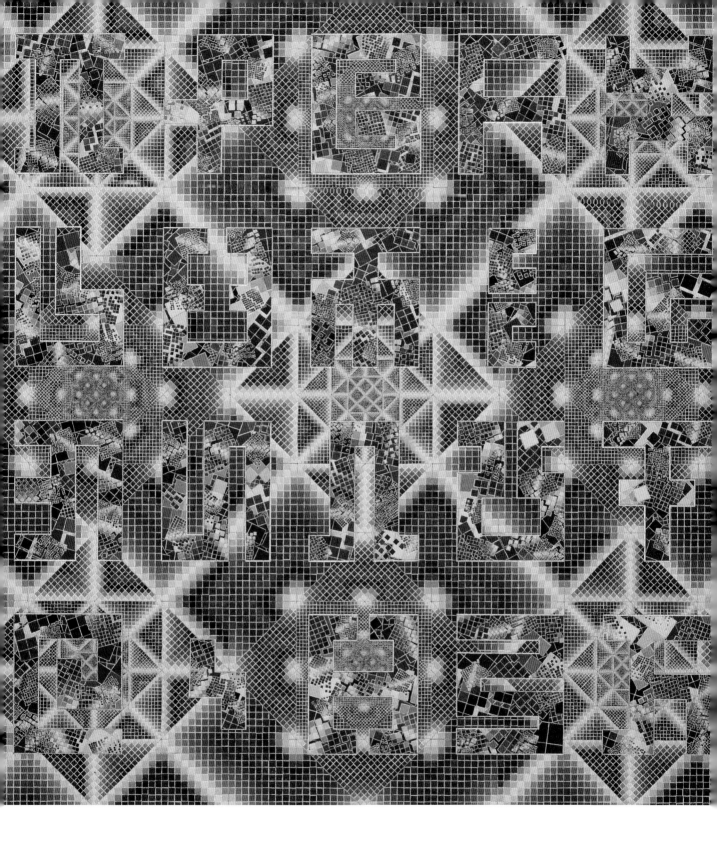

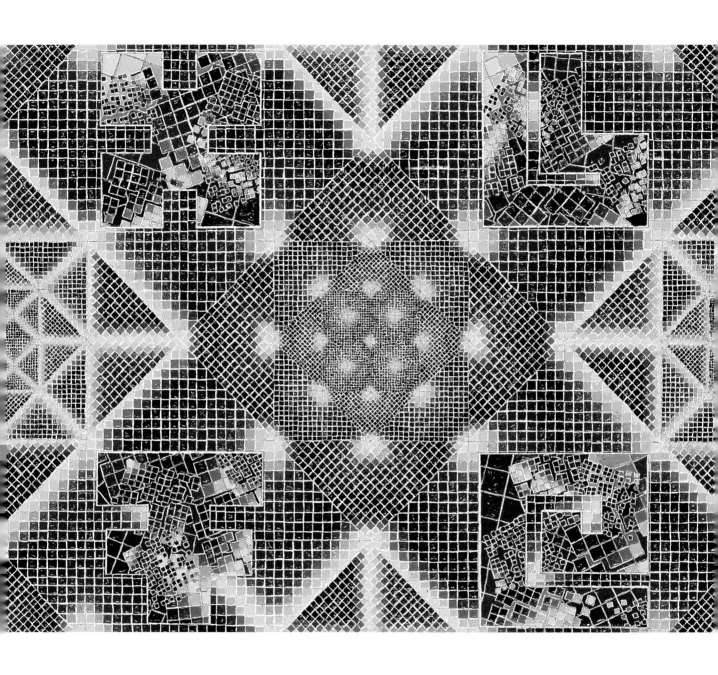

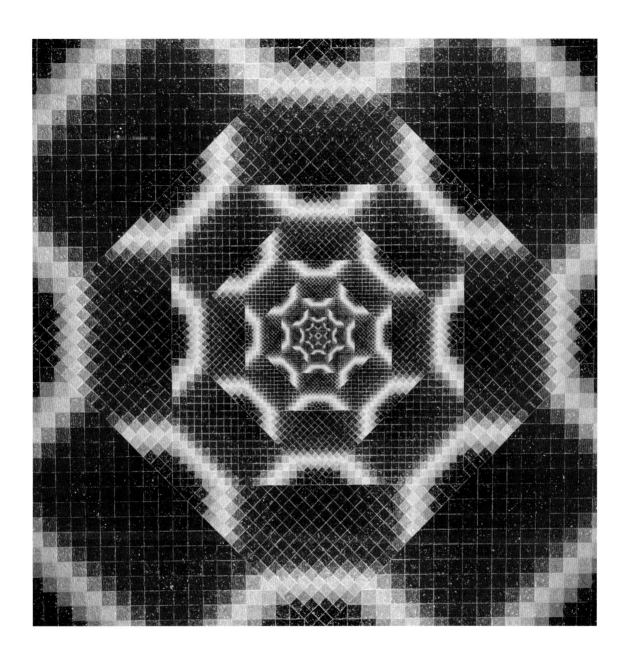

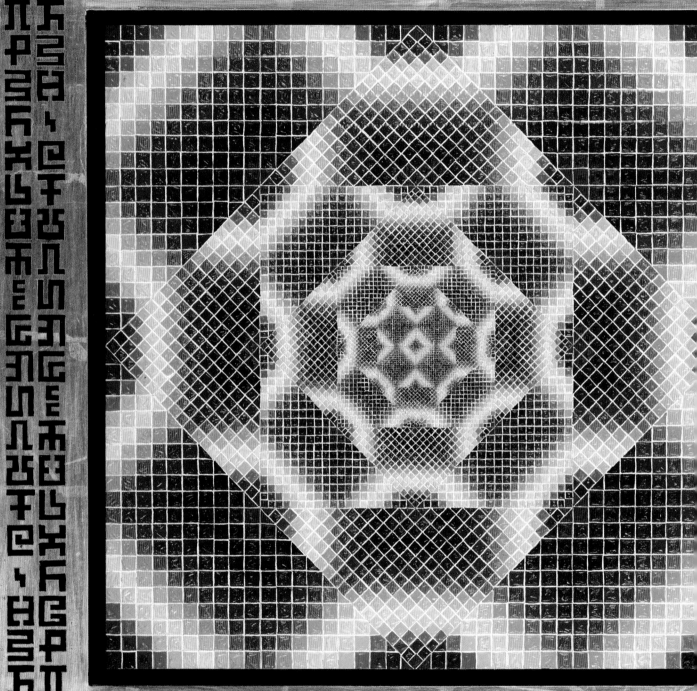

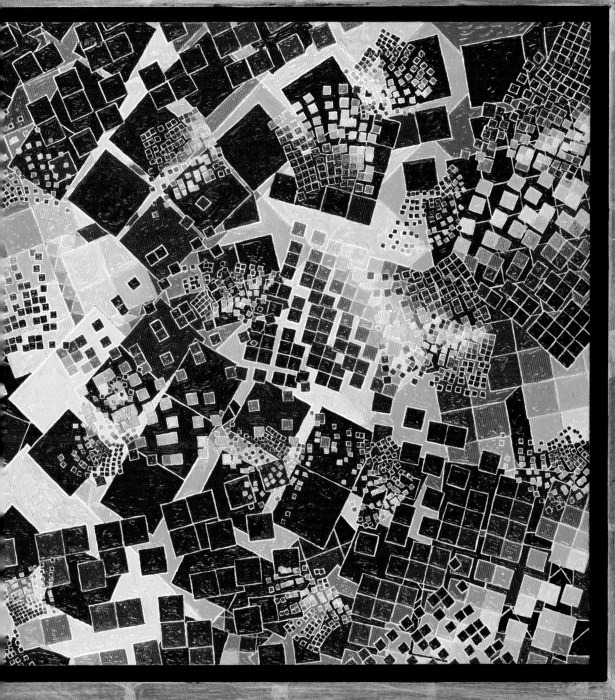

ARTIST INDEX

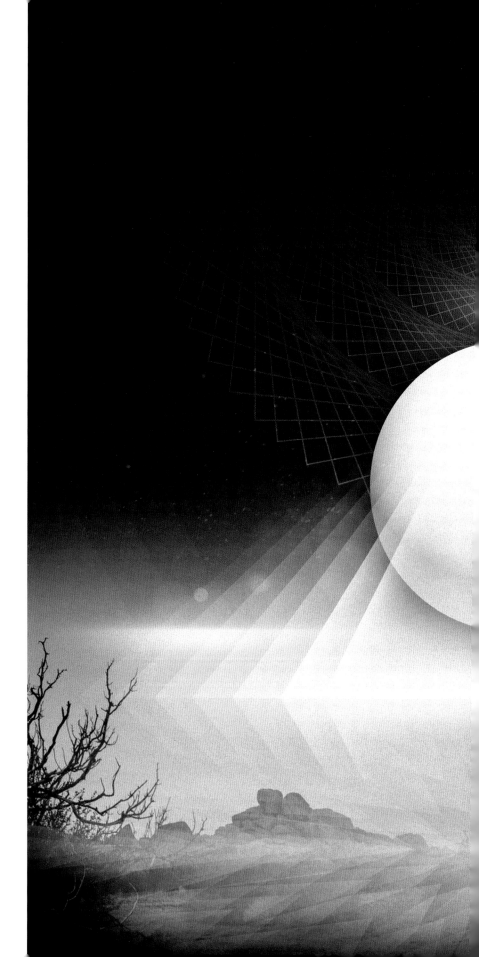

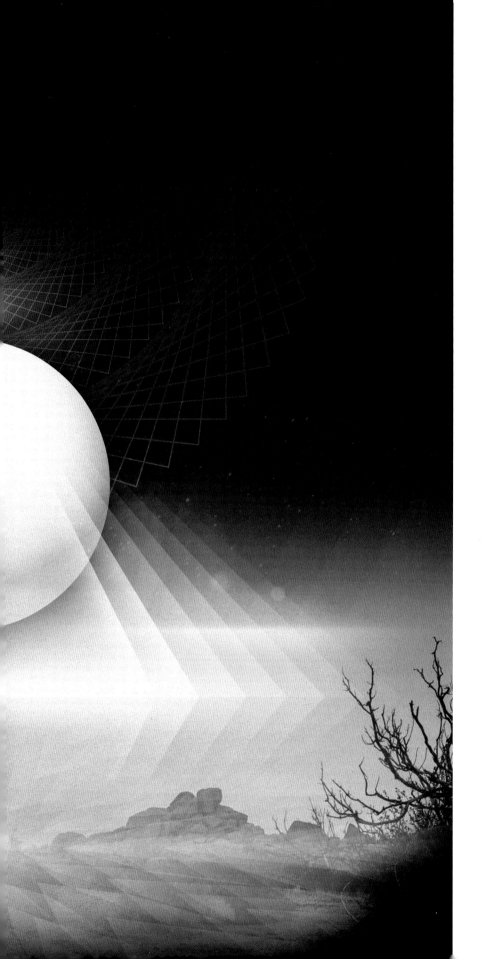

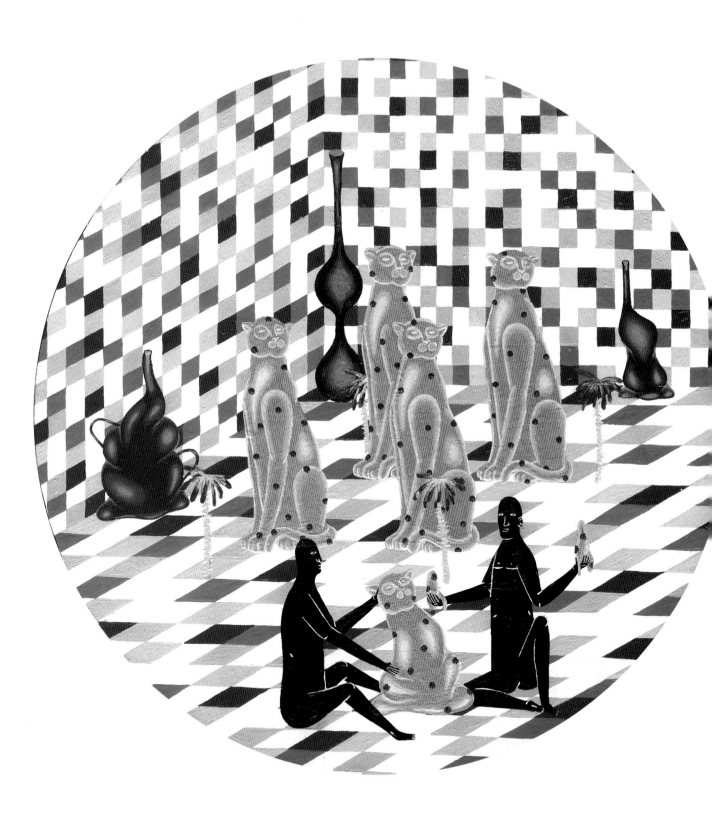

Image by: Mark Whalen
Previous Page: Jetter Green